P9-DOB-393

Photographer's Publishing Handbook

PHOTOGRAPHER'S PUBLISHING HANDBOOK

HAROLD DAVIS

images
PRESS INC.

Photographer's Publishing Handbook
Copyright © 1991 Harold Davis. All rights reserved.
No part of this book may be reproduced in any form or
by any electronic or mechanical means, including
information storage and retrieval systems, without
permission in writing from the publisher, except by a
reviewer, who may quote brief passages in a review.

First Edition.
Library of Congress Catalog Card Number: 90-84349

ISBN: 0-929667-07-7

Published by:
Images Press
7 East 17th Street
New York, N.Y. 10003
212-675-3707
Printed and bound in the United States of America

Cover Photograph: *Denali, the Great One, Alaska*
© Harold Davis 1984. This photograph is well-known as
a Wilderness Studio poster.

Edited by: Jeanne Stallman

Designed by: Jennifer Lawson

1 2 3 4 5 6 7 8 9 10

Visual Studies Workshop
Research Center
Rochester, N.Y.
May 1991 Gift of
the publisher

If I am not for myself, who is for me?

If I am only for myself, what am I?

If not now when?

– Hillel

Author's Note

In the beginning, I was (and still am) a photographer. Before that, law school, a degree in Computer Science, I was born, and another, longer, story.

My work as a photographer has taken me from Maine to the tundra of Alaska; I have photographed on assignment for clients ranging from real estate companies to environmental foundations.

As my work began to be published, I became interested in publishing and the process of offset reproduction. In 1981 I founded Wilderness Studio as a publishing vehicle for cards and posters featuring my work.

Before long, photographers and other artists came to me wanting to know how I had done it. I gave some workshops on self–publishing for artists. Eventually, I also wrote a short article on the topic and said to those who called, "Read my article. If you still have questions after that, feel free to call me back." The article and workshops led to my writing a book, *Publishing Your Art As Cards & Posters*, published by The Consultant Press. One book led to another, and Peter Gould suggested I tackle the *Photographer's Publishing Handbook*, for Images Press.

In distinction to *Publishing Your Art*, which is about how to publish any art (including photography) as cards and posters, the *Photographer's Publishing Handbook* is only about photography—but it covers a far broader range of end applications. Think of it as "Everything the photographer wanted to know about publishing but was afraid to ask." This includes how to create promotional pieces, how to market and sell stock photography for publication, how to create and sell a photography book proposal, what makes a good photography book, how to market said photography book, and much more. In keeping with my belief that fundamental understanding has practical value, I have tried to present not only the nuts and bolts material, but also the context of the underlying philosophies and trends in the photography, publishing and printing fields. In part, I have presented this material via interviews with prominent people in these fields. I have also relied on my own experience and secondary source research. Secondary source material that is suggested for further reading is mentioned in the appropriate chapters of the text. Full publication data for these books, along with a complete bibliography, will be found in the Resource Section at the end of the book.

Publishing photographs can be very demanding and unprofitable. Certainly, the economics of the matter makes the publication of quality monographs dubious in the absence of very unusual circumstances. However, cream will rise to the top, and

there will always be ways to publish fine work. Part of the intent of this book is to provide as wide an array of approaches and options as possible. The astute, creative and good photographer will be able to find publication markets for his or her work. Knowledge of the field can help to save valuable time and emotional energy.

Publishing your work is not only about sales, money or favorable notices. At the deepest level, it is a matter of leaving something permanent behind that may last as long as people care about visual imagery.

Ultimately publication can be one the most satisfying things that can happen to a photographer. It makes the work real, permanent and available to an audience. There are many possible approaches to publication, and this book will present this variety of possibilities along with the specific information you will need to succeed in getting your imagery in print. Remember: Even if a project, such as a book, fails financially it can be a success from the photographer's point of view if it leads to commissions, assignments, stock photography sales, or invitations to lecture or teach.

While all standard caveats apply (meaning that the responsibility for the text is mine alone) I should like to thank all those who have given so generously of their time and wisdom. This includes: Pierre Apraxine, Curator of the Gilman Paper Company collection; Miles Barth, of the International Center of Photography; Alan Batt; Lois Brown, of Rizzoli International Publications; Janet Swan Bush, of Little, Brown and Company; John Butsch of Creative Access; Cornell Capa, of the International Center of Photography; Eleanor Caponigro; May Castleberry, of the Whitney Museum and Umbra Editions, Inc.; Catherine Chermayeff of Magnum and Umbra Editions, Inc.; Ben Cohen, of Ben & Jerry's; Susan M. Coliton, of Aperture Foundation; Elizabeth W. Collins of Coast to Coast Publishing; Richard Dobbs, of the Museum of Modern Art Bookstore; Stephen Ettlinger; Ralph Gibson; David R. Godine; John Goodwin, of Printed Matter; Paul Gottlieb, Publisher, Harry N. Abrams; Peter L. Gould; Joanne and Stephen Gucciardo of Gucciardo Design; Charles Hagen, of Aperture Foundation; Maria Morris Hambourg, of the Metropolitan Museum; Marvin Heiferman; Carolyn A. Herter, of Simon & Schuster; Eric Himmel, of Harry N. Abrams, Inc.; Katy Homans; Marcia Keegan; Jane Kinne of Comstock; Benjamin Koo, of Book Arts, Inc.; Paul Liptak, of Bruce McGaw Graphics, Inc.; Michael J. Miller, of Yarrow Press; Lloyd Morgan, of Morgan Press; Robert S. Persky; Olivia Parker; Jim Pickerell; Ron Pramschufer of The John D. Lucas Printing Company; Lilo Raymond; Ira Rheingold; Harriet Rinehart; Eva Rubinstein; Robert Sheldon of Consortium Book Sales & Distribution; Robin L. Simmen, Senior Editor at Amphoto; Solomon M. Skolnick, Director of Book Publishing, The Image Bank; Jean M. Srnecz, of Baker & Taylor Books; Roger Straus III, of Farrar, Straus and Giroux; Joyce Tenneson; Eelco Wolf, of Agfa Corporation; Jacques Wolf, of Portfolio Lithography; Anne Yarowsky, of Yarrow Press; Floyd Yearout.

I have made every attempt to be accurate and complete, and to give the best advice I possibly can; however, my readers should be clear that the responsibility for their actions is their's alone. I can accept no liability for decisions made on the basis of material in this book and strongly suggest that legal or other expert advice be sought where appropriate.

On a personal note, I would like to thank my parents, Martin and Virginia Davis, and my friend, Eric Ryan, for their generous support far above and beyond the call of duty without which I would never have come this far, and my brother, Nathan Davis, for being there. I would also like to thank my many wonderful friends who have helped me over the rough periods and made my life a wondrous one filled with grace, joy and light.

Without Peter Gould's belief in me, I never would have had the opportunity to write this book: for this, I would like to thank him.

Finally, this book is dedicated to you, the reader, with the hope it will help you fully realize your publication potential with your photography. ❖

Table of Contents

Table of Interviews

List of Sample Forms, Letters, Documents

1

Introduction

The purpose of this book is to provide a detailed step-by-step guide to publishing your photographic imagery. Every aspect of the process will be covered, whatever your level of expertise and professionalism. This book is designed to help you:

- discover what you really want to do as a photographer;
- get started marketing your imagery as stock to publishers;
- promote yourself through the publication of printed pieces;
- shop a photography project to major book publishers;
- conceive, design, produce, market and distribute photography book publication projects;
- understand the philosophy and ideas behind successful publication of photography.

Throughout the book you will find samples of forms and documents that you will need. At the end of the book are more documents, a glossary, and a comprehensive resource section and bibliography which offer both a wealth of further information and provide references to the best books in the field.

I suggest you use this book by first skimming it to get an overview of the areas of photography publishing it covers. Read the profiles and interviews. Then focus on the specific application(s) you are interested in, and read the relevant chapters carefully. Make sure you are clear about the content and understand the actions you must take to achieve your goals.

You will get the most out of this book if you are clear about what your goals are. Put together a selection of your best and most publishable work. If you would like to start marketing your work as stock to publishers, start with 50 to 100 of your best images. If you are a professional photographer who would like to learn how to best promote yourself with printed material, put together a portfolio of your strongest commercial imagery of the sort you would like to market. If you are interested in creating a book, pull together as much of the material that would go into the book as you have readily available. Keeping these images and your intended project in mind as you read will make the text more relevant.

There are a number of different kinds of photographic books. These include: the **monograph** which presents the photographer's personal work as fine art; the **exhibition catalog**, which accompanies an exhibition; the **illustrated trade book**

which illustrates a subject and may appeal to a mass market; the **in-house book,** which can be one of a series and is sometimes sold via direct mail; the **how-to** book, which presents material on how to solve practical problems; and the **artist's book,** a limited production by the photographer which is often concerned with the form of the book itself rather than the imagery. Bear in mind that these categories are not hard and fast. There is overlapping. A more detailed discussion of the characteristics of these different kinds of books will be found in Chapter 5, "How the Photography Publishing Industry Works."

In John Szarkowski's notes accompanying the comprehensive exhibit "Photography Until Now" (which opened at The Museum of Modern Art in New York in the spring of 1990) he comments:

> *To the degree that photomechanical reproduction came to stand as a substitute for the chemical print, it caused the death of the photographer as a small independent publisher. At the beginning of this century most professional photographers made their living by selling photographs. A generation later the most advanced of them sold reproduction rights.*

Today, publication projects present the photographer once again with the opportunity to make a living selling objects rather than reproduction rights. Only this time around, the objects are made photomechanically, not chemically. The opportunity for substantial involvement in the design, creation and production of a publication project, as a self-publisher or in collaboration with an existing organization, gives the photographer a chance for artistic rebirth as a small independent publisher.

Reading this book should give you a sense of what sort of photographs lend themselves to publication and why. It is my goal to provide the tools and techniques that will enable you to achieve your objectives as a published photographer. In both the photography and publishing worlds it is necessary to be a business person and also to love what you do. Many of the people in the publishing business got there because they loved books just as photographers love photography. In addition, both kinds of professionals must understand marketing.

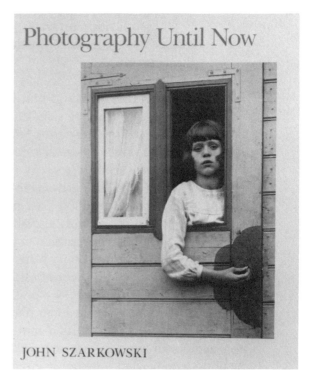

Courtesy Museum of Modern Art.

No two photographers' career paths are exactly alike, but certainly one thing that all successfully published photographers have in common is that their work is technically

solid and professional. Furthermore, at the upper end of the field, work needs to be distinguished, powerful, obsessional, highly creative and unusual or beautiful, in a word, extraordinary, in order to justify the expenses involved in the creation of a book. Work should also be capable of arousing powerful emotion in the viewer.

Although strong images are necessary, a good photography book is more than a collection of good photographs. Other concerns such as design, layout, and pacing all come into play.

To be successful, a book must be well-designed and well-manufactured. The photographs must be reproduced in a quality fashion. The book must have sequence and a flow. Layout of the photographs must be connected to the form of the book. Photographs must be related to one another in a pleasing, patterned way. Most importantly, the photographs must involve the viewer. They must speak to us, tell us a story, make us laugh with gladness to be alive or weep for the sorrows of the human race.

The good photography book makes us think twice about our preconceptions of the world. A book that works is not a naive creation. It can be looked at, viewed, and enjoyed many times, revealing something new each time. Like an old and dear friend, it feels familiar, but is still capable of surprising.

If you are not ready to tackle a book, you may want to consider publishing your work as promotional material. Effective promotional publication starts with an examination of who you are. Part of what photographers sell is themselves: their work that has already been created, their reliability, their ability as creative problem–solvers and their potential for creating future work. Adequate exploration of oneself requires a searching and fearless professional and personal inventory. Be as honest as possible. What is it exactly that you do? What percentage of your income is derived from photography? How large a library of images do you have? What subject matters are covered? What proportion of your library consists of truly publishable work? What makes your work special? What valuable non–photographic skills or traits do you have? (Examples might be skill as a writer, or with a computer, or sales ability, or being extremely reliable.) What are your hobbies or areas of special interest? Knowledge, enthusiasm and contacts in a particular area, for example, sailing, education, or biology, can help you carve out a niche as a photographer specializing in that area.

There are many kinds of photographers and photography. Some photographers might specialize in architectural, corporate, or still-life photography,while others limit themselves to location or wedding photography. There is a great deal of difference between selling a service, for example, creating an image to order for an advertising agency, and selling already completed images, as stock or decor. Certainly, not every photographer will also have the time, abilities and inclination to produce a photography book.

Once you are clear on what you have to offer as a photographer, the next question is, who are the people who will buy what you have done? This question applies at the consumer level. If you are creating a paper product or a book, will it sell? The best way to answer this question is to look at how work similar to yours has been published. This sort of research is probably best done in specialty stores that

carry photography books or products. It will tell you if there is a market for your work and how it must be packaged to sell.

If you are marketing reproduction rights to your stock library to trade clients, the same questions pertain. Specifically, who will buy your work? In marketing lingo, this is termed "qualifying your prospects". You won't make any sales, however, unless you have a marketable product. There is a great deal of difference between good photographs and marketable stock imagery. As Rohn Engh notes in his book *Sell & Re-Sell Your Photos*, "what editors need and what they like are different. Marketing is understanding that difference."

There are many ways to publish photographs. Start with what you find exciting. What are the potential markets for this work? The key is to figure out how what you want to do fits into the realities of the publishing world.

Interview: Ralph Gibson

Photographer, artist, self-publisher

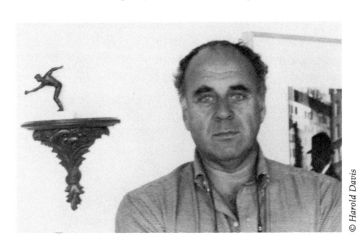

© Harold Davis

"Most photographers don't really have time to think," states Ralph Gibson, an intense curly-haired man who radiates energy. "I like thinking about my work and I don't want some nipplehead telling me what to photograph." Since 1970 Gibson has turned down all commercial assignments. In that year he self-published his book *The Somnambulist*. Its virtual overnight success enabled him to follow his own path, to market his prints, and to achieve international recognition as a photographic artist.

The Somnambulist was Gibson's third book and his decision to self-publish it partially resulted from his dissatisfaction with the design, production standards, and sales results of the trade publishers who had undertaken his first two. Gibson financed *The Somnambulist* by selling limited partnership shares in Lustrum Press (his publishing company) and by an advance sale to Light Impressions, a mail order vendor of photography books and products. The book sold out its print run of several thousand copies in a short amount of time, recouping the investment and making a small profit. More importantly, from Gibson's point of view, serial rights to pictures from the book were sold to numerous photography magazines. The recognition thus obtained allowed Gibson to pursue his career as an artist.

Lustrum Press went on to publish three other books by Gibson, monographs by leading photographers, and general photography books. Eventually, after receiving much recognition and financial success, Gibson closed Lustrum in order to concentrate on his own work. However, he hasn't given up on publishing.

"Publishing is like a drug," he says. In his studio currently he has three book dummies ready to go. Gibson feels that the dummy – a hand-made facsimile of what the book will look like – is the secret to publishing a book. "If you show a good dummy to a publisher, at least you know you are both talking about the same book."

Gibson notes that while his recognition is due in large part to his books, the total royalties he can expect on a book project is comparable to what he makes on the sale of one print. He exhibits around the world, is represented in New York by Leo Castelli, and has won Guggenheim and National Endowment Fellowships. He feels that his success in the art world stems from visibility generated by the books he has published.

Gibson keeps a journal and there is a strong relationship between his photography and his writing. The ideas for his book titles usually are connected to words. But, he feels, "a photograph is a definition of a feeling that [I] wouldn't otherwise be able to define. I cannot separate the act of photographing from the act of existence, thought or purpose."

Standing in his clean and well organized darkroom next to his old Leitz enlarger (a gift from Robert Frank who printed *The Americans* on it, and on which his friend Larry Clark printed *Tulsa*) Gibson muses: "I find that with age I judge things less and see them more clearly." ❖

2
Effective Self–Promotional Publishing

Basic Concepts of Marketing

Self–promotional publishing is the publication of an advertisement for oneself or one's work. A successful self-promotional project results in the sales of photographs or the services of the photographer. Books or products that are created to be sold to trade or the general public are not promotional.

Marketing and selling are two different things. Marketing involves strategy and the overall approach, while selling is tactical and has a specific goal: closing the sale. We will start with the broader picture and work our way down to discuss some specific sales methods.

Marketing involves three basic issues: the product (your photographs, use of your photographs, or your photographic services); the buyer; and the approach. Before any effective promotional publishing can be done, and, indeed, before a valid decision can be reached as to whether promotional publishing is warranted, each of these three points must be considered.

The first question involves who you are. Aside from selling photographs, photographers must also sell themselves: the work they have already created, their reputation, their reliability, their ability as creative problem solvers, their ability to work with people, and their potential for creating future work. Conduct a searching and fearless professional and personal inventory by considering the following questions as honestly as possible. What is it exactly that you do? What percentage of your income is derived from photography? How large a library of images do you have covering what subject matters? What proportion of your library truly consists of publishable work? What makes your work special? What valuable non–photographic skills or traits do you have? (Are you an airplane pilot, a writer, skilled with a computer, very persuasive, or extremely reliable?) What are your hobbies or areas of special interest? Knowledge, enthusiasm and contacts in a particular area such as sailing, education, or biology, can help you carve out a niche as a photographer specializing in that area. How are you with people? Can you take direction, or are you a lone wolf who, in Ralph Gibson's words, "doesn't want nippleheads" telling you what to do? The kinds of services you can offer as a photographer vary tremendously. If you are in a small town perhaps you can be a generalist and photograph everything from weddings to the little league to products. Otherwise you will need to specialize.

Once you are clear on what it is you have to offer, the next question is, who are the people who will buy what you have done or who will commission you to do what you would like to do. Start thinking about this is by finding work similar to yours which has been published commercially. Clients for this published work may be similar to purchasers for your work.

In the context of promotional publishing, the next questions are: Who controls your intended market? What is the most effective, and cost effective, way to reach this market? If direct mailing to a targeted list is the answer, what is the best kind of piece to mail?

Alternatives to mailing a promotional piece include purchasing space in a photographer's directory, telephoning, making appointments to show your portfolio, and relying on word of mouth. A combination of approaches is best.

Interview: Jacques Wolf

Printer of promotional cards for artists

Jacques Wolf and his wife Monica own and operate Portfolio Lithography, a small printing company in Manhattan which manufactures color postcards for artists, photographers, galleries and museums.

© Harold Davis

It is a sweltering hot day in July. Jacques has been tinkering with his printing press and his jeans and unbuttoned shirt are covered with sweat, process inks and stains from industrial lubricants. He wipes his hands on his shirt and starts talking.

"Printing is a business. A printer will try to make the most profit with the least effort like any other business person. The catch with printing is that any small mistake costs the printer the entire profit in any given job. Perhaps to compensate, printers are animals – they part you from your money as quickly as possible.

"On the other hand, artists are masochists. Mostly, they don't make a decent living. Professional artists who make a living work very hard indeed – perhaps twice as hard as normal people. They spend one working day making art and then spend another one selling it.

"I basically do one thing. I print standard size promotional and advertising cards for photographers, artists and galleries. Currently, the price is $285 per 1,000 without any extras. Color borders, larger sizes, or additional colors cost more.

"When photographers come to me with business, they tend to want larger then standard cards and bells and whistles such as a black border or purple type. All this, of course, adds to the cost. A person would be wise once things are no longer standard to get at least three competitive bids," he advises. "Printing is such a complicated business that you almost need an expert to explicate it."

"Many times artists are not aware of economic realities. They may not realize that a four–color match to a piece of original art that may have been done in many more colors, (including some that cannot be reproduced exactly in four–color) is, at best, an illusion and an approximation. Printing is not, repeat not, a science. I know my press, how to work with it, and how to adjust it. There are many variables including things like temperature and humidity and every time it is different."

Basically, Wolf is interested in producing a standardized product which is good for what it is and affordable to artists. Most of his business comes from referrals as well as small classified ads in *Gallery Guide* and *Photo District News*.

Wolf prefers customers to supply mechanicals, but he will do basic designs himself for a modest fee if requested. He advises against asking a printer to be a designer. "Get a friend who is a designer, or hire a free–lance designer, to do it," he counsels.

Wolf's general advice to anyone purchasing printing is "Buyer Beware. You are not making paintings, you are making little copies of paintings. However hard the printer tries, it will at best be a pleasing approximation of the original.

"Running a press is like playing a musical instrument," he explains. "Printing is Murphy's Law waiting to happen. It is an elastic thing, there are so many variables from the temperature and humidity to the state of the blanket. It's mostly in the preparation, once something is printing smoothly it takes no time at all." ❖

Promotional Pieces

There are many kinds of printed promotional pieces, which vary greatly in elaborateness, effectiveness and cost. Printed pieces that may be used for advertising and promotional purposes include: sales letters; flyers; newsletters; ad reprints; postcards; brochures; greeting cards; posters; calendars; and photography books. Obviously, you want your pieces to be as effective as possible. In order for a direct mail campaign to be successful, it must be planned as a campaign. Follow–up is essential.

The elaborateness of your piece depends considerably on the target audience and your budget. Visually sophisticated markets, such as top–flight graphic designers, require a more sophisticated design than a mailing for a local wedding shop. Of course, even with sophisticated markets, sometimes less is more. An appropriately designed simple and inexpensive piece can work very well – even in the top markets.

Cost may depend on how much you have to spend. The least expensive way to create four-color promotional pieces is to use a pre–formatted design. Created for postcards and brochures, they are offered by such printing houses as MWM Dexter

(see Resource Section for more names). While the designs are not going to win any prizes for elegance, you can expect a functional mailer.

Don't be discouraged if you do not receive a substantial response to your mailer. A 10 percent response rate to a direct-mail campaign is considered to be very good indeed. A direct-mail campaign should only be embarked on with long–term expectations. Before you start on a direct mail campaign, sit down with a calculator and make sure you can afford what could turn out to be a substantial investment. A rule of thumb is that between 5 percent and 10 percent of your gross sales should be put aside for advertising and promotion. If you will not be able to follow through with the project on budget, perhaps you are not ready for the campaign (or need to scale it down). Certainly, no direct-mail campaign should be undertaken on a do–or–die basis.

The more expensive your piece is to produce, the more closely you will want to target your market, and the less pieces you will want to send out. If you are mailing or handing out photography books, for example, the per unit cost of production will be staggering. Use your promotion money effectively – do not waste it.

Direct Mail

Once you have decided to publish a promotional piece, how will you get it to potential buyers of your work? Probably the best way to do this on any kind of scale is by direct mail. To whom will you mail your piece? It is possible to put together a list yourself using industry directories and telephone books, but it is far simpler to rent a list.

John Butsch, President of Creative Access Corporation, one of the leading companies that rents lists of photography buyers, states: "We help people in the creative industries identify, reach, nurture and keep future clients." Creative Access has a database of over 150,000 professionals who "buy or influence the purchase of creative services" such as photography and design.

According to Butsch, the first thing for a photographer who wants to sell work in a new area to do is to go out and talk to people in the industry to get feedback and see if the photographer's work is suitable. "You can't talk to an audience unless you understand the audience," notes Butsch.

After that understanding has been reached, there are many options open. In terms of direct mail, Creative Access will work with customers to decide how precisely to break down their database. For instance, editorial book buyers at publishers could be pulled. Creative Access will use their computer to compile a list based on user supplied criteria, such as job title and geographic location.

In his experience, Butsch finds 90 percent of all mailing pieces that photographers send out unattractive and unappealing. "They probably won't get opened," he says. Envelopes should be well designed and include color and copy. The piece must be designed to say why it was sent; otherwise it is a waste of time and money. A mailer must make it very clear that it is selling fashion photography

rather than the dress which appears in the photograph. Although Butsch is "cautious about games, gimmicks and giveaways," he does encourage the use of pre–paid response cards. He notes that in the theory of direct mail promotion there is a hierarchy. At the first level is the "targeted" audience, or "suspect". A member of the targeted audience who responds with interest to your mailer has become a "prospect". To be effective a direct mail campaign must plan the follow–up to prospects in advance. What will you send them next? Has a telephone response to inquiries been scripted? At the next level, if you have converted a prospect into a first-time customer, how will you convert the customer into a repeat client? "A new customer is like a first date. If it was good for them, they will want to return for more and hence become an ongoing client," says Butsch.

"A general rule of promotion is that as a target increases in importance you should become willing to spend more to reach them," he continues. "I find that many photographers worry too much about getting new clients and not enough about nurturing old ones."

Like other companies that market lists, Creative Access actually is licensing one–time usage of their information. The average cost to photographers for 1,000 names is about $130 with a $200 minimum. Information is provided on magnetic tape, floppy disk or on labels as required. Rolodex cards can also be obtained if a telephone follow–up is planned. For putting a mailing together, addressing envelopes and walking them to the post office, a mailing house will charge 25¢ to 50¢ per piece plus postage. Look under "Letter Shop" in the Yellow Pages for mailing services.

Design

There are many, many advertising pieces mailed in this society. Start a collection of those that appeal to you. Ask your friends in the graphic arts and design industries to save you mailers that they feel are effective (or particularly ineffective). Study them. What makes them work? Elements to consider include imagery, copy, type, color, paper stock, and finish.

The first thing the recipient sees when he or she gets your mailing piece is the envelope. Minimize the risk of having your piece go into the "circular file" unopened by using good quality stock for the envelope or mailing container. Use graphics that make it look distinguished. Try to figure out a way to arouse the recipient's curiosity about what is inside. If you have targeted your market correctly, the recipient should be interested in your work. Try to make this clear on the outside of your package by appealing, in a professional and intriguing way, to the special interests of your target market.

Make sure the design of the piece reflects the fact that you are selling your photographs, not the contents of the photographs. If you are an animal photographer, make sure that the piece could not be mistaken for that of a pet store.

If you are mailing a sales letter, testimonial quotes are very effective. Consider including a list of clients if you can legitimately do this and they are impressive.

Your printed promotional piece must communicate those things that set you apart from your competition and those benefits you have to offer besides your talent.

Unless you are producing a pre–formatted piece with pre–determined layout specifications, it is probably in your best interest to work with a designer. Talk to other photographers and contacts in related industries to find out who they recommend. Ask who designed pieces you like. See Chapter 8, "Design and Production", for an overview of what to expect from the design and production process.

I am in favor of simplicity and clarity of design. Design should not call attention to itself. Like children brought up the old fashioned way, design is to be seen and not heard. You are selling photography, not design.

If your campaign consists of a series of mailers, make sure they relate to each other visually and are connected by design.

Effective Selling

"Selling" is not a dirty word. Despite some degree of social hypocrisy on the topic (and the myth that artists shouldn't be good at selling) the fact is, that to be a successful photographer, sales skills are essential.

If you have a problem with the idea of sales, try looking at it in a different light. Once you have determined that the person or organization to whom you are trying to sell your work has a genuine need for it, you can re–conceptualize the process of selling as one of serving a needed function of providing information about what you do. Do not think of it as compelling or wheedling somebody into hiring you. Selling is about relationships. You are providing information about the benefits of working with you. This can be done, and, in fact, works much better with, integrity. In the long run, hard-sell pushy sales techniques do not work. Try to develop a relationship, based on your genuine understanding of the customer's needs, that will last.

Don't put down your competition. This lacks integrity.

Another important aspect of selling is planning and practicing. Almost every human endeavor is improved with practice, selling is no exception. Prepare a selling script. Plan out what you will do when you get a phone response to a direct mail campaign. Prepare another script when you have an in–person appointment with an art director, or are making a follow–up call.

Practice role playing with friends. Make sure you develop listening skills as well as talking skills. When you ask questions to find out the client's needs, listen carefully to the answers.

Do plan to follow up. The average sale is closed on the fifth contact with a prospect. Be polite, but be persistent. Very persistent. ❖

3

Selling Stock to Book Publishers

One way to publish your work without a major investment of time or money is through stock photography sales. Continuously expanding picture markets are coming to rely primarily on stock vendors for their imagery needs.

For more information on this ever changing market see the books suggested in the Resource Section.

In this chapter we will cover editorial sales for use in books, how to start a professional stock business of your own, organizing stock files, and briefly discuss working with agencies. A sample stock query letter and sample stock category list are included at the end of the chapter. Use them as a guide and modify them to suit the reality of your photograph library. A sample delivery memo and stock sales invoice can be found in the Appendix, "Sample Contracts and Forms".

The first topic, sales to the editorial book market, is highly relevant to the theme of this book because: (1) editorial stock sales provide a way to start publishing your work and learn about the business (before he became involved in the *Day in the Life* series photographer Rick Smolan was an editorial stock vendor); (2) many trade illustrated books use extensive photographic imagery that is essentially obtained as stock; and (3) a stock photography vendor may be in the position to produce or package books. As you get to know the publishing industry, and make contacts, you will be able to suggest projects of your own.

There is a very clear distinction between extraordinary imagery and marketable imagery. By definition, the market for the latter is far greater than for the former. Of course, sometimes extraordinary imagery is also marketable. But most published stock photography has a generic quality. That is why it can be effectively used as stock. The best way to get a feeling for what is marketable is to take a look at what's on the market.

An oft–cited proposition in the photographic community is that a stock file yields "a dollar a picture a year". While this figure may be on the low side, the order of magnitude is right. It follows that a profitable stock file must have a lot of pictures. But, as is discussed below, management of a stock file ("library") itself takes considerable professionalism and investment. I would call the buckshot approach – marketing large quantities of out-takes from other projects – highly questionable.

Another approach to stock sales comes from photographers who primarily regard themselves as "artists". These photographers have become known for the production of imagery in specific styles. They are able to gain substantial income

from the stock resale of their imagery, particularly in the editorial book market. For example, Lilo Raymond's well-known image of an unmade bed in Amagansett has been used in a computer science textbook to illustrate the proposition that "an uninitialized variable is like an unmade bed – you never know what you'll find in it." Olivia Parker's elegant compositions are widely used in science textbooks. And a landscape of mine was used as the cover of Peter Matthiessen's *Indian Country*.

How To Take Stock Photographs That Sell

Photography that sells successfully as stock tends to be either: (1) highly generic with human interest; or (2) technical in nature. By generic, I mean images that can be used to illustrate different concepts or sell varied products. A successful stock shot could be used on a textbook cover, in a promotional brochure for a bank, and in a point-of-purchase display. Typical stock shots include a couple on the beach, a multi–racial group having a picnic, and an executive working late at night.

Images that feature a symbolic element also tend to do well. For example, a reproduction of a tripod–mounted camera on a business card is a symbolic element which says that the card belongs to a photographer. Guns, uniforms, gas masks, tanks and airplanes can be used to symbolize wars and soldiers.

Pictures that sell illustrate something as simple as a situation or as complex as a mood. Backgrounds should tie into the main subject matter of the photograph.

People in photographs intended for stock sales should be attractive, interesting, and doing something related to the setting. Try to include as many different ethnic groups as possible. (If your models are recognizable, you will need a model release.) People should be the subject of the picture, interact with each other or something in the picture, or contemplate something in the picture. Stock photographs must either be up–to–date in terms of clothing styles and hairdos, or focus on timeless subject matter such as nature.

By definition, stock pictures are not novel. Pictures that sell well are the same ones that have been taken millions of times, couples holding hands romantically, office workers at their computers, cats in baskets.

Although it is imperative that you are aware of what pictures sell as stock, it is even more important to be true to your own sense of style and what you care about in photographs. As Michal Heron notes in her book *How To Shoot Stock Photos That Sell*:

> *This is where Polonius comes in. Know who you are as a photographer. Have a sense of your own style and be true to it.*
>
> *Trying to shoot in a style that isn't natural to you is a recipe for failure. However that doesn't rule out experimenting with new techniques or taking risks to stretch your photographic abilities. What is does mean is that you should avoid shooting what doesn't feel right or what doesn't excite or please you photographically – saleable or not. If it's contrary to the way you see the world, to what you care about visually, then it won't work – for you or for stock.*

Editorial Stock Sales

Although potential stock photography markets include magazines, newspapers, books and other media, this discussion is limited to stock sales for use in books. This kind of usage is generally considered "non–commercial". The photographs are not intended to advertise goods or services or to promote a business. Instead they communicate information. While fees for editorial book usage are not nearly as high as advertising or corporate usage fees, the competition is not nearly as fierce. The potential also exists for a high volume of sales.

Textbooks have come to rely primarily on photography for illustrations. Because the range of subject matter covered is extremely diverse, from anthropology through zoology, there is a vast need for variety.

Textbook publishers communicate their photography needs by sending out specific want lists for their books in progress. The lists range from the specific (a certain species of snail eating in the Olympic Rainforest, for example) to abstract requests for imaginative illustrations (the concept of infinity for a math textbook, for example). Publishers do not expect any one photographer to fill all of the requests on a given list. That is why they send them to many pictures sources. However, it is not a good idea to send in a submission unless you have good photographs that cover at least a number of the requests. Because textbook photo editors review a large volume of photographs, you can expect your imagery to go through more than one edit before it is accepted. Therefore, plan on relatively long holding periods. These editors, however, are professionals, and will do their best to return at least first cut rejections as quickly as possible.

Professionalism

Maintaining a professional approach to stock photograph sales is extremely important if you wish to succeed in this area. First and foremost, never send out submissions without an appropriate delivery memo. The delivery memo contains numerous important provisions that protect you in case of unauthorized usage or loss or damage of your material. Keep one copy of the memo for your files and send two copies to the client. The client should sign and return one copy, acknowledging the exact count of the material received.

The delivery memo serves as a contract. Like any contract, provisions can be negotiated to suit the mutual interests of the parties. At the request of a particular client or potential client, for example, you may wish to waive the holding fee provision. However, be extremely wary of anyone to whom you submit your material who will not agree in writing to the essentials: an acknowledgement of the count of material received in good condition, agreement not to use the material without express written permission, and responsibility in the event of loss or damage. Most organizations that are in the publishing and photography businesses

are quite ethical and have a routine arranged to deal with the concerns of their photograph vendors. With a few significant exceptions, problems arise mostly with first-time picture buyers who are not professionals, do not feel the need to maintain relationships in the field, and do not understand concerns of the stock vendor (such as the high replacement value of an original transparency). The only answer is to educate, be wary of such potential buyers, and insist on getting signed delivery memos. Better to lose a sale than lose a valuable selection of work.

Submissions should be well protected and carefully packed. Send them out by a method that either provides a return receipt or is traceable. Delivery services such as Federal Express and UPS or certified return receipt U.S. mail are acceptable; first class mail is not. If the client has requested rush delivery, it is appropriate to pass the costs along, either by using their delivery service account number or by billing for your costs. Make sure the client knows you will be doing this when they request rush delivery.

Honesty and professionalism are the keys to maintaining long-term relationships with stock picture buyers. If you can't help a buyer with a particular request, let them know as soon as possible. They will respect you for not wasting their time and may well call you for their next project. Handle requests efficiently. If you know a possible source for photographs you do not have, by all means make a referral.

Each time I research a picture request, I charge a research fee. My current policy is to charge a $50.00 fee, which is deductible from any actual usage fees. This means that if I go into the files and prepare a submission, at least I know I will be compensated for my research time. It also provides some insurance that the client is serious.

While you will have to formulate a research fee policy that you are comfortable with and that works for you, in the long run it's not economically feasible to do significant quantities of research without a guarantee of some type of compensation. It's a basic business decision. You could certainly decide to work with a specific customer without research fees because they are a steady client, or because the specific request represents a good opportunity. Or, you could formulate the research fee as a "kill" fee if no photographs are used. Whatever you decide, find a way that works for you.

It is important to clearly understand the basic concept of ownership of imagery. As "author" of a photograph, you own the copyright to all component rights to that image. (North American magazine rights, point-of-purchase display rights, and textbook rights are some of the component rights that make up the full bundle that is ownership of an image.) When you sell rights to stock usage of an image, you are actually leasing one specific component right. For example, "One time North American hardcover trade book reproduction rights, 1/2 page, grant limited to three years" licenses the user to reproduce your image in a hardcover book distributed in North America, 1/2 page size, for three years. Your invoice, which is the client's official license to reproduce the photograph, should clearly state what rights are granted and note, "All other rights reserved." For further discussion, see books suggested in the Resource Section.

If your photographs contain recognizable people, you will need a model release to sell them for "commercial" usage. This also holds true for property such as houses and cars. Although not strictly necessary, it is better to have a release for "non-commercial" editorial usage. By and large, people are happy to be photographed. They will usually co-operate and sign a release for themselves or their property. It is always and a good policy to get a release. If you don't have a release, let the client know and clearly indicate "No Model Release" on the photograph.

Remember a stock photography business is just that: a business. Treat it as such. Use clear paperwork, be courteous and helpful, calculate your real costs of doing business and charge accordingly, use well-designed letterhead and forms, and answer telephone calls in a professional fashion.

How to Organize a Stock File

One of the keys to a stock file's success is good organization. An ideal system guarantees that you know where every image is at all times. Store photographs safely, organize them so that you can find what you need quickly, and employ an easy to use and accurate system for tracking pictures and submissions.

It is worth it to implement a good system as early as possible. The longer you wait, the more work will be involved in switching to an effective system. A stock filing system consists of three parts: the physical housing for the photographs; the identification system used to mark the photographs (both on the photograph itself and in any separate written or computerized listing); and the record-keeping system that keeps track of such paperwork associated with images and submissions as delivery memos, model releases, and logs. A system that is doing the job should provide safe storage for photographs; easy ways to file photographs and retrieve them; a fast and convenient method of identifying and filing each photograph; comprehensibility, so that others can use the system; and flexibility, so that subjects can change and files can grow. If your system is not computerized, it should have the potential for easy conversion.

If your file is small, a simple system of establishing a place for everything and putting it back there may work best for you. Rohn Engh's discussion (on pages 227 – 237 of *Sell & Re-Sell Your Photos*) of his "lazy man's" record keeping system sounds like it would work well. If you have a larger file, you may wish to computerize it right away using a specially designed applications program or a database manager such as Dbase. Bar code technology seems to work very well for logging transparencies in and out.

My own system does not always work as well as I would like it to. I store my transparencies in acid-free slide pages in hanging files in cabinets. They are filed in a two-tiered system alphabetically by subject category. One tier contains what I consider my best work, the other serves as back up. Categories are cross-referenced. However, I do not always find it as easy to lay my hands on a specific photograph as

I would like. One problem is that the specific merit of an image may have nothing to do with what is in the photograph. A request for a "red" image may generate a search through a huge number of categories. This sometimes makes me feel like the dragon in *The Hobbit* who knows the precise location of every piece of his plundered hoard of treasure. I may know the file location of every photograph, and know when one is missing, but no one else working my files is likely to. All picture libraries have this problem. The only answer is time, skill, and intuition on the part of the researcher working the file.

A number of books listed in the Resource Section, particularly the *ASMP Stock Photography Handbook*, George Schaub's *Shooting for Stock*, and Michal Heron's *How to Shoot Stock Photos That Sell* have excellent discussions and suggestions on organizing a stock file.

How to Market Stock Photography

There is no fundamental difficulty in marketing stock to the editorial book markets, provided you have what these markets need. Photo editors and/or picture researchers do most of the stock photo buying for textbook publishers. There are probably no more than a few hundred textbook publishers nationally. You can find their names in *Literary Market Place (L.M.P.)*, or by looking at the textbooks themselves to see who they are published by. Another source is *Photographer's Market*. In any case, call before mailing material to make sure it is going to the right people. Picture editing is a transient profession by nature, and the buyers move around often. Some projects are put together by free–lance picture researchers. While it can be harder to locate free–lancers, many of them belong to the American Society of Picture Professionals (A.S.P.P.). The membership list is a good place to find them. (If you actually join this organization, you can meet these people and others involved in the stock photography business at A.S.P.P. events.)

Your goal is to get editorial picture buyers to automatically send you their want lists. It helps to appear professional and well–organized. Send a query letter listing your credits and a stock list outlining the subjects in your files. If you have the money you might want to consider sending a photographic promotional piece. In any case, be prepared to submit an appropriate sample of your work (a "Stock Portfolio") upon request. If you can arrange an in–person appointment with the photo buyer, so much the better. Follow up with everyone you contact in a regular, persistent, but courteous fashion – unless they have clearly stated they don't want to hear from you again. It helps to have a tracking system for your contacts and mailings. Send updated lists of new material and keep contacts posted about any new additions to your file that might fit their needs.

One great virtue of the stock photography business is that, with fax machines and overnight delivery services, you can operate with equal effectiveness from anywhere in the country.

Working With Agencies

If you don't have the time or energy to devote to stock sales, you might want to consider placing your work with an agency. While agencies do take a hefty commission of sales, usually 50 percent, they take care of all the work of filing, re–filing, marketing and preparing submissions, and paperwork. Agencies are also in the position of knowing what sells. Because they do a huge volume of sales they probably will have contacts that you could not possibly know about. If you don't wish to get involved in setting up and running a stock sales business, an agency relationship may be the answer. That way you can devote your time to making photographs.

However, the relationship with the agency should be treated with caution. Like some marriages, it may be easier to get your work into certain files than to get it out. A full discussion of the photographer – agency relationship and contractual issues is well beyond the scope of this book. Please refer to the *Photo Marketing Handbook* and the *ASMP Stock Photography Handbook* for more information on these topics. These books also contain excellent listings of agencies.

There are, in fact, many possible ways to work with stock agents. One possibility (which is what I have elected to do) is to handle your own stock domestically but work with agents in Europe and Japan who are supplied with duplicates. *The Photo Marketing Handbook* contains particularly valuable listings of foreign agents.

In general, most agencies will be happy to review your work. Contact them, to find out their procedures. Because agencies deal in volume, you probably will be expected to show a minimum of 200–300 photographs. Make sure they are high quality and marketable.

Interview: Jane Kinne

Vice President, Comstock

Jane Kinne is Director of Editorial Photography at Comstock, a leading stock agency based in New York City. As a stock agent, she has supplied the photography for numerous book projects. She is a recognized leader in the stock photography field, and in that capacity has appeared as an expert legal witness in more than 400 cases.

"The trick" to selling stock to the editorial market Kinne states, "is to get users to submit their lists." Young photographers, she advises, should study the area and not be unrealistic. Kinne suggests self–assignment as a way to generate appropriate work. "Keep abreast of what's going on in imagery, the world, and the news. The needs of textbooks tend to follow what's in the newspapers by 16 to 18 months," she explains.

How do you get users to submit their lists? 85 percent of photo buyers for textbooks are listed in *L.M.P.*, Kinne explains. "The best way to reach them is by direct

mail and by exhibiting your work. Photo buyers seem to follow exhibitions and exhibition reviews. Of course, you must have a very strong collection of imagery in the area of your specialty. It doesn't do to have just one or two individual strong topics. Stock is no longer, if it ever was, an area where you put out–takes from another project and expect to get results. Things have become very specific and targeted."

"Joining forces with other photographers to meaningfully handle more requests is one way to get more business," Kinne continues. "Obviously, having a targeted library of high quality photos and dealing with picture requests in a professional and thoughtful way works best of all. Look at the want lists to see if publishing houses are really putting on paper what is needed. Sometimes you'll see requests for photographs that just don't exist. If the buyer is not able to articulate what they need, you might familiarize yourself with the text the photography is intended to illustrate so you can decide if you really have the imagery that will work.

"If you handle stock yourself, don't waste a buyer's time. Be professional. Charge a research fee or arrange some other way to make sure you will be re–imbursed for the real costs of searching, retrieving, sending out and refiling selections.

"Picture buyers today are looking for imagery that is conceptual, generic, and extremely well executed," Kinne concludes. "The stock photographer must be his or her own art director, costume designer and creator of props. He or she has to be terribly aware of what is out there so he or she can go beyond it.

Despite its status as a top agency, Comstock works with only about fifty photographers. Kinne says the agency works to foster a spirit of community and non–competition between its photographers. The agency would like to add a handful of "heavy hitters in specific areas" to its roster and, in any case, is committed to looking at portfolios, critiquing, and giving practical advice to anyone serious. Contact Comstock for submission guidelines. ❖

SAMPLE STOCK LIST

Photographs by Harold Davis from the following categories are available for stock use:

ALASKA
 Aerial
 Bluegrass Music
 Bones
 Brooks Range
 Denali
 Flowers
 Gates of the Arctic N.P.
 Katmai N.P.
 Kenai Peninsula

Lumbering
Mining
Mt. Mckinley
People
Pipeline
Totem Poles
Towns and Villages
Valley of Ten Thousand Smokes
Winter
Yukon River

ANIMALS
 Cats
 Dogs
 Llamas
ANDORRA
ANTI–NUCLEAR DEMONSTRATIONS
ARCHITECTURAL, Details
AUSTRIA
AUTUMN
BASEBALL
BERKSHIRES
BIRDS
BRIDGES
 Brooklyn
 GeorgeWashington
 Golden Gate
BRITISH COLUMBIA
BUILDINGS, of the American West
CALIFORNIA
CACTUS
CANADIAN ROCKIES
CARS
 Antiques
CAVES
CEMETERIES
CHRISTMAS RELATED
COLORADO RIVER
COUNTRY IMAGES
DEAD ANIMALS
DEATH VALLEY
DESERTS
DESTRUCTION OF NATURE
DOUBLE EXPOSURE
ENGLAND
FARMS
 Farm Machinery
FIRE
FIREWORKS
FISH
FLOWERS
FRANCE
 Pere le Chaise Cemetery
FRUITS & VEGETABLES

GARDENS
GETTYSBURG MEMORIAL
GHOST TOWNS
GLACIERS
GRAND CANYON
GRASS
GREECE
GUITARS
GYPSY MOTHS
HAITI
HALLOWEEN
INSECTS
 Roaches
ITALY
INTERIORS
KAYAKERS
KELP
LAKES
LANDSCAPES
LEAVES
LICHEN
LIGHTS
LOVE CANAL
 Environmental Pollution
MAINE
 Fishing Boats
 Fishing Villages
 Lobster Boats
 Penobscot Bay
 Sailboats
 Rural Memories
MANIPULATED IMAGERY
MARATHONS
MASSACHUSETTS
MAZE, The
MINING
MIST
MOUNTAIN LANDSCAPES
NEW JERSEY
 Cape May
 High Point State Park
 Hoboken
 Hudson River

Jersey City
Newark
NEW YORK CITY
Extensive selection of all aspects.
Glamour cityscapes to aerials to
people at work and play. Call for
complete list.
NEW YORK STATE
 Adirondacks
 Catskills
NORTH AFRICA
OCEANS
OREGON
PEOPLE
 Backpackers
 Farmers
 Homeless
 Kayakers
 Musicians & Dancers
 Runners
PLANTS
RAINBOWS
RIVERS
ROCKS
SAN FRANCISCO
 Extensive file available.
SATURATED LIGHT
SHELLS
SHENANDOAH VALLEY
SHIPS
SIERRAS, California
 Backpackers
 High Mountain Scenes
 Hotsprings
 John Muir Trail
 Mt. Whitney
SICILY
SIGNS, Humorous
SNOW & ICE
SOUTHWEST
 Arches N.P.
 Bryce Canyon N.P.

Canyon de Chelly
Canyonlands
Capital Reef N.M.
Great Sand Dunes N.P.
Mesa Verde
Santa Fe
Zion N.P.
SPAIN
 Alhambra, Grenada
SPECTACULAR LANDSCAPES
SPRING
STILL LIFE
 Colors
 Flowers
 Insects
 Mirrors
 Painting and Photography
STORMS
SUGARCANE
SUNSETS
TEXTURES
 Nature
 Industrial
 Urban
TREES
UNDERWATER
UTAH
VERMONT
WASHINGTON
 North Cascade Mtns
 Olympic N.P.
WATER
WATERFALLS
WATER LILIES
WATTS TOWERS
WEST VIRGINIA
 Farms and farming
WINDOWS
WOOD
WYOMING
 Wind River Range

Wilderness Studio, Inc.
2673 Broadway, Ste. 107
New York, NY 10025
212-642-5123
FAX 212-663-6144

Date

Paula Picture-Researcher
Humongous Textbook Publishing Company
123 Main Street
Nowhere, NH 00000

Dear Ms. Picture-Researcher:

This letter is to ask that you add us to your Picture Request list. We would appreciate the chance to receive notification of your photograph needs and will do our best to meet your requests.

I am enclosing a list of some of the categories available from our library. Basically, our area of specialization is spectacular photographs of nature; our file is also strong in evocative rural imagery, environmental stories, New York City, and unique still lives. Most of our photographs, except the studio work, are 35mm Kodachrome.

My credits include *American Photographer, National Geographic* (many others); covers for The Maine Photographic Workshops (Summer, 1988), Scott, Foresman (**Intermediate Algebra**, 1987), Viking Press (Peter Matthiessen's **Indian Country**, 1984) (many others); fine art posters for Bruce McGaw Graphics, Modernart Editions, New York Graphic Society (many others).

I would be very happy to answer any questions you might have. I look forward to receiving your lists and working with you.

Sincerely,

Harold Davis

Enclosure

SAMPLE QUERY LETTER

4

The Paper Products Market

Introduction

Photographers who are interested in publishing their work should pay special attention to the paper products market because it presents excellent opportunities for showcasing imagery. Since most paper products require only one photograph, they are ideal for the photographer who is not yet ready to publish a book containing many sequenced and related images. Paper products are highly visible. They are often very well printed. As items which are meant to be bought on the basis of the image reproduced, they are designed to present that image as being of high quality. Paper products are very effective promotional tools for the photographer. They can also be very lucrative.

The paper products market can be divided into three different areas, and there are, in turn, two different approaches to each category.

The categories are: (1) cards; (2) posters; and (3) other products. Cards include greeting cards, notecards (uncaptioned greeting cards), and postcards. Posters are large-sized imagery intended for wall decoration with imagery and graphics. Subjects range from pop celebrity portraits to fine–art images such as the photographs of Ansel Adams. Other paper and related products include placemats, mugs, puzzles, key rings, bookmarks, calendars, etc. With a few exceptions, this category does not possess the same possibilities for showcasing fine photography as posters, cards and books do.

You can approach the paper products, stationery and related products markets two ways: (1) by licensing imagery to existing producers; or (2) by producing it yourself ("self–publishing"). While each category is distinct in terms of the type of imagery utilized and the marketing structure of the industry, they share an openness to new photographers and entrepreneurs. Small paper products producers are one of the last bastions of American ad hoc boot-strapping capitalism, and each product, company and deal must be considered on its own merits and in a flexible way. This is a market in which there are no rules.

Probably the best way to get a quick understanding of the paper products markets is to walk the major trade shows, particularly the National Stationery Show, which is held in New York City at the Jacob Javits Convention Center every May. At this show the visitor will observe everything from the latest pet rock variants to the most wonderfully designed and conceived products of an artistic nature. Many of

the products use photography. Companies that have created, and maintained, a market–niche as conceptualizers and producers of flawlessly elegant merchandise are next to novelty companies, toy companies and purveyors of sexually explicit greeting cards. This is free–hand market economy at its finest. However, while admiring the diversity, the observer should not forget just how tough it is for a new product or company to survive in this environment. The paper products market is an extremely volatile one, subject to internal and external fashion trends as superficial as a certain color being "in", or as consequential as a major world political event.

This chapter is organized in five sections. The first is this brief introduction to the paper products markets. The second covers the arena of greeting cards, with a practical emphasis on licensing imagery. The third contains a structural over view of the fine art poster industry. The fourth discusses other paper products. The fifth gives an over view of self–publishing in the paper products arena.

Cards

There are some key points when it comes to cards which shape how this market should be approached. The good news is that there are a vast number of companies eagerly looking for appropriate imagery. These companies range in size from small independents to big companies such as Hallmark. There is a market for almost every kind of image. While the big companies will offer more stability (a small card company may not be around next year), less well-known outfits are more likely to showcase your work, and, perhaps, offer you royalties.

The bad news is that because cards are an extremely-low-profit margin item, many cards must be sold before you'll see a profit. Usage fees or royalties also tend to be low. Typical fees for the use of a photograph on a greeting card range from $100 – $300. Card companies are reluctant to enter into royalty arrangements because of the bookkeeping costs involved. Royalties, when they are paid, average 2¢ to 5¢ per card.

If you produce the cards yourself, you will have to plan to print a minimum of 3,000 each of 12 different cards. (You cannot produce just one style of card because of the large size of sheets that go through printing presses). This will cost about $10,000. To break even, you must sell half of the cards. In theory, there is a potential gross profit (excluding overhead and cost of capital) of about $20,000 if you sell all the cards. The unit cost of production decreases as your print run goes up. A hugely successful card might sell 10,000 copies, netting a theoretical profit potential of about $30,000. But remember: you can neither publish nor distribute a single card. Although a best-selling card does come along occasionally, most card companies are satisfied to publish many cards which are only moderately successful.

Almost all cards sold, even blank notes, are related to an occasion of holiday or convey a specific message. Photographic imagery must be keyed into such

categories as Christmas, birthday, Valentine's Day, Father's Day, Mother's Day, friendship, apology, etc.

Photographers should approach greeting card companies as they would any other purchaser of imagery. Pick publishers who seem to be interested in your kind of work. Call or write for submission guidelines.

Focus: Avanti Press, Inc.

Avanti Press is a publisher of high quality photographic products. It specializes in greeting cards, but also publishes note cards, calendars, posters and invitations. The calendars and invitations are new product lines. Avanti has about 1,000 images in print and has won numerous awards for design and production excellence.

Rick Ruffner, President of Avanti, states: "We use photography to tell a story. We go through thousands and thousands of images and say 'yes' to those images that tell a story with simplicity, believability and integrity."

Avanti does not forget that consumers buy its product in order to communicate. Cards are designed with "timeless messages" in mind. Promotional material describes the product as "Bright. Bold. Romantic. Humorous. Friendly. Sensitive. Sophisticated. Warm. Playful. Fun."

The company puts considerable effort into picture research and building ongoing relationships with photographers. Avanti's picture professionals find outstanding imagery in a variety of ways. In some cases they work directly with the photographers with whom the company has a close, ongoing rapport. Or they approach picture agencies; research photography in books, galleries, trade and consumer magazines; and work with photographers individually to create original images specifically for Avanti. "Professionals working closely with professionals is key to Avanti's successful communication network," says Ruffner.

Avanti's current want list states: "...If you have seen our images in stores then you'll know that we are interested in the following image characteristics: Narrative – telling a story; Humorous – tasteful; Believable – natural; Timeless; Simple – to the point. The situations we are interested in cover a wide range but the subjects we're most interested in are:

> Babies
> Children (up to 4yrs old)
> Animals; domesticated – dogs, cats, etc., couples, groups, humorous
> Narrative scenics and still lifes – elements of life or "human presence"
> Florals
> Seasonal; Christmas, Halloween, Easter, Valentines, Mother's Day,
> Father's Day, Graduation

Some subjects we're not interested in:

> Travel
> Sunsets, general landscape
> Nudes
> High tech"

Submissions to Avanti should go to: AVANTI, Attn. Susan Carolonza, Picture Editor, 84 Wooster St., #5D, New York, NY 10012. Do not send original material to Avanti, which, in any case, will take no responsibility for loss or damage to material. Do include a self–addressed stamped envelope for the return of work. Avanti suggests using certified mail in both directions. ❖

The Fine Art Poster

A poster is an enlarged image that combines imagery with some form of graphics. It is generally intended for hanging on a wall and generally reproduced using a photo mechanical process. The fine art poster can be seen as a work of art in and of itself and is often designed and produced with great care. Retail prices for these pieces can be $30 and up unframed, and $120 and up framed. It is very common for the end consumer to purchase these posters framed.

Historically, fine art posters have three antecedents: art deco and art nouveau advertising posters, many of them excited by artists such as Tolouse–Lautrec; offset reproductions of paintings (or other art); and exhibition posters which typically promote an artist's show. As original art and limited edition graphics outpriced what much of the market could afford, in the late 1970s and early 1980s the fine art poster began to emerge as a medium in its own right. Standing out as innovators and founders of this new industry were David Lingwood of Modernart Editions and Bruce McGaw of Bruce McGaw Graphics, Inc.

Today, the industry is dominated by a dozen or so companies that function as some combination of publishing house and distributor. Their fundamental marketing tool is the elaborate trade catalog which reproduces the posters they carry. Unlike the card industry, where it is not only possible for the small publisher to sell directly to retailers, but, indeed, probably essential, in the poster industry it is virtually impossible for an independent to compete with the distributors. To succeed in this market arena it is necessary to either license imagery or sell the product to at least a few of the major distributors.

At the retail level, the fine art poster market has rightly been termed "very broad, but very shallow", i.e., there are a great many potential purchasers of posters, but nobody is going to buy more than one of any given piece, and probably no retailer will stock more than a few of any inventory item.

Retailers in the fine art poster industry include graphics galleries, frame shops,

This poster, **White Window With Forget-Me-Nots,** © *Harold Davis 1985, is published and distributed by the New York Graphic Society.*

interior decorators, and corporate art consultants. These retailers purchase their inventory from the publisher/distributors at wholesale, which is generally 50 percent of the retail price. For example, a poster which retails for $30 will generally be sold to the retailer for $15. If the publisher/distributor has published the piece, the photographer will receive a royalty based on sales. When the publisher/distributor has purchased the piece from a small self–publisher, they have generally paid 50 percent of wholesale, or, in our example $7.50 (termed in the industry "50 percent of 50").

What makes a successful poster? Moderately subtle work that is cheerful and graphically interesting seems to work best. Work that is escapist in nature and takes

the viewer away from reality to a better place suits the often intended use of these pieces as decoration for corporate back offices and hospitals. Generally, controversial subject matter including anything remotely negative, political, or sexual should be avoided. Within these very general parameters, a wide variety of high quality photography has been successfully used in fine art graphic posters.

The first thing to do is become knowledgeable about what's out there. This will help you to understand what works in this market and which publishers are likely to be receptive to your work. For example, Poster Originals, a very high quality poster publisher, will not consider publishing photography.

Information about the industry can be obtained by browsing in graphics galleries, looking through the poster publishers' trade catalogs (also generally available for inspection at the galleries), attending trade shows (particularly Artexpo in New York in April), and reading the trade publications (*Decor* and *Art Business News* are the two leading trade journals).

Once you have narrowed your search to a small list of appropriate publishers, follow standard submission procedures by calling or writing to determine how the company prefers to handle submissions. Generally, initial submission will involve either dropping off or sending a small selection of duplicate slides or prints; it will be your responsibility to arrange to pick the work up or to provide a self addressed stamped envelope (S.A.S.E.) for its return.

The more appropriate your work is for usage as a fine art poster, the greater your chance for acceptance. Try to keep your submission thematically linked, and remember that less is more. If you have succeeded in intriguing the publisher, they can always ask to see more of your work.

If your work is accepted for publication, you will be offered a contract. Remember that this is an offer of a contract and need not be accepted without negotiation. While there are no standard industry terms, a boilerplate contract will specify that the publisher is to bear all production costs and provide the artist with a nominal number of posters (perhaps 100) gratis. In addition, the artist may or may not receive royalties, an advance against royalties, or a flat fee per print run. Consider these arrangements carefully. It may be wise to get advice from industry experts, American Society of Magazine Photographers (A.S.M.P.) if you are a member, or other trade associations, and an attorney. The final decision rests with you: You are responsible for considering all the costs and benefits of any arrangement and must decide whether it is worth your while.

A poster that sells well may generate a very substantial amount of income year after year. My most successful poster, "Dance of Spring" has sold about 5,000 copies annually since 1984, at a retail price of $30.

Of course, there are also non-economic benefits to having a fine art photography poster of your work published. A better showcase is hard to imagine. Reproduction standards are extremely high. The context alone states, "This is significant work." And many art directors and graphic designers, as visually literate people, will be familiar with successful posters, and pay attention to the photographers who have had their work reproduced in this way.

Interview: Paul Liptak

Director of Acquisitions, Bruce McGaw Graphics, Inc.

Paul Liptak is the Director of Acquisitions for Bruce McGaw Graphics, Inc., the nation's largest publisher and distributor of quality fine art posters.

Liptak's job involves looking for art work for his company to publish and screening the 30 or 40 unsolicited submissions from artists that the company receives every week. If he is interested in work, he presents it to a Review Committee, and, if it is approved, coordinates with the artist, design department, and sales and marketing staffs.

A well–spoken elegantly dressed man, Liptak started in the sales department of Bruce McGaw Graphics eight years ago. He had no prior art background, and at that point the company was three years old. When the company decided to focus on publishing as opposed to distributing Liptak was asked to head the Acquisitions Department.

To make an initial submission, Liptak suggests dropping off a limited selection of work (no more than 10 to 20 pieces). Duplicates, rather than original work, should be left. Most of the submissions Liptak sees are slides, but he will look at other formats. If something catches his eye, Liptak will touch base with the artist and perhaps ask to see more work. The next step is presentation to the Review Committee for a collective point of view. Of the 30 to 40 submissions McGaw receives a week, perhaps three make it to the Review Committee. Of these, perhaps one every two weeks is accepted for publication.

Liptak comments that there is always a need for good work appropriate to the poster market. However, he admits that it is difficult to define what exactly is appropriate. Generally speaking, Liptak does not look for a specific style or technique. However, landscapes, whether they are photographed or painted, should be representational, not surreal. Liptak cannot use erotic work, nudes, work with a political connection, work that is topical or travel related, or anything having negative connotations. He looks for "pretty pictures, pleasant scenes that appeal to everybody and have generic qualities."

If the review committee's decision is affirmative, the in–house design department will then generate a variety of possible designs. After one has been selected, it will be shown to the artist for approval. Generally the text on the poster will consist of the artist's name, sometimes a title, and occasionally a gallery name if appropriate. The selection and design of the type is extremely important to the ultimate success of a piece and is handled with care.

Bruce McGaw Graphics' standard contractual arrangement with artists provides that the company pays all production expenses. After direct production expenses have been covered by sales, the artist receives a royalty equal to 10 percent of further sales. In addition, the artist receives 100 posters per print run. Copyright in the piece is registered in the artist's name. Advances are generally offered only to established

artists with whom the company has previously worked. The company purchases exclusive world–wide poster reproduction rights. Approximately 800 pieces have to sell before the production expenses are recouped and the artist starts to see royalties.

Liptak wants to find "another really strong selling abstract artist". He notes that only about 15 percent of the pieces Bruce McGaw has published over the past 12 months are photographic. Five years ago the figure was 75 percent. He expects the cycle to reverse and predicts more publication of photography in the future. Liptak notes that cleanly and consistently designed posters featuring imagery which demonstrate an awareness regarding the environment (such as those by Ansel Adams, Eliot Porter and the Talbot series of marine animals) continue to sell well. Posters are "still an exciting industry," he says. "There has been so much growth over the past ten years. Quality is far superior, and the public has become aware that fine art posters are not posters from the 1960s that you put on the walls with thumb tacks. On the other hand, everything has been done. It is difficult to find new artists whose work is appropriate. Right now there is some stagnation with no obvious break through artists. Posters are commercial, but we also take pride in the art. Posters make art accessible to everyone: they make it possible for everyone to be able to enjoy art of all kinds by an international roster of artists." ❖

Other Paper Products

There is a vast variety of miscellaneous products that use photography. They range from disposable celebrity posters to calenders, placemats, and key rings. With the exception of calenders, which can be a lucrative market and important display forum for photography, this category should not be relied on as a major source of steady income. It could be treated as possible avenues for stock sales.

Another marketing possibility the enterprising photographer might consider is promotional postcards and related items. Many local businesses have a need for such advertising products – motels, restaurants, tourist attractions. A photographer is in the position to offer these customers one stop shopping for both the photography and the printing. There are a number of printing companies (see Resource Section) that offer package printing of standard promotional items. The photographer makes a selection from a small number of possibilities and chooses a typeface that will be used. Often the finished printed pieces are mailed directly to the client, generally with a sales commission to the photographer built into the retail pricing structure. The sales materials that these companies provide to photographers contain full details including retail price lists and reproduction formats. They are suitable for presentation to clients.

Calendars can be very beautiful. They can also be very effective as promotional material for a photographer – everybody needs at least one calendar. They come in a number of varieties: the wall calendar, the desk calendar, and the engagement calendar.

The major problem with calendars is their ephemeral nature. A calender will get thrown away after the year's end, no matter how beautiful it is. There is also a very

narrow "window of opportunity" for marketing calendars. Stores are generally two seasons ahead. The trade buying period for 1992 calendars is the summer of 1991. If you fail to sell your stock during this period, you will be stuck with your inventory. Unlike cards, posters, or books, which can be timeless and thus sell in small quantities forever, there is no second chance for calendars.

The best bet is to produce a calendar design, based on a theme, and then license it to a company that handles a large line. Make sure your contract specifies that you receive enough copies to use for promotional purposes.

Research calendar publishers in stores, in the annual calendar wrap–up issue that *Publishers Weekly* puts out in June, in *L.M.P.*, and *Photographer's Market*.

Self–Publishing

As a self publisher not only will you create the artwork, you will also design the product, hire the printer, oversee production, and arrange for distribution.

The key to self–publishing is distribution; no matter how good your project is, unless you can get it to the product to the public, it won't sell. Each product has a different type of distribution. Fine art posters are generally marketed through distributors/publishers, but greeting cards must be sold directly to retailers using independent sales reps. Calendars are distributed by book publishers and also sold by independent reps to card stores. Novelty items are generally sold through a network of independent sales reps put together by each publisher.

A good way to learn about the distribution structure of an industry is to ask retailers how they buy, and from whom. (Retailers are also a source for product development ideas as they ultimately must purchase your product if it is to succeed.) The channels of distribution are centralized in the poster industry, but less so for other paper products. Card sales reps often work part time and change jobs frequently. One possible answer to this is to sell your own cards, particularly if the stores that will carry them are confined to one geographic area.

After you talk to retailers, approach distributors and sales reps. See if they would carry your product. If not, see if they have any suggestions about who would.

You stand to make more money with a self–published product than if you license the imagery. My "Dance of Spring" Poster, with sales of about 5,000 copies a year, generates a profit of about $20,000 per year, or $4 per unit. Had I licensed the design, I would probably be making 50¢ per unit, or $2,500 per year.

However, you can also can lose more when you self publish. It costs about $10,000 to produce an initial run of a poster or a minimum set of well–produced cards. Your entire investment is at risk.

Another point to consider is the business issues that do not involve photography. These include but are not limited to: financing and capitalization; product conceptualization; product design; image creation and/or selection; business systems; sales and marketing; distribution; and warehousing and

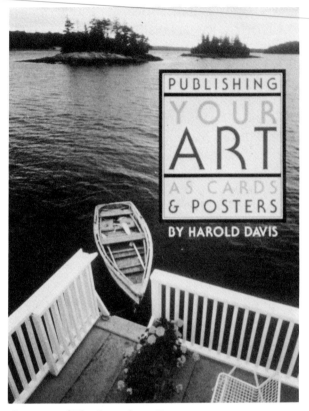

Courtesy of The Consultant Press.

fulfillment. Essentially, you are becoming a publisher. Once you are a publisher, you may regard photographers (including yourself?) as simply hired guns whose work product can be used on a stock basis.

Interested readers are referred to my book *Publishing Your Art as Cards & Posters* as well as the chapters in this book on "How to Self–Publish a Photography Book" and "Running a Publishing Business".

Interview: Alan Batt

Photographer, Owner, Piece of the Rainbow Cards

By using his sense of humor and salesmanship, and by becoming an accomplished photographer along the way, Alan Batt has created a card business that provides him with a nice living. His cards feature New York City imagery, and most of his market is in New York where he has about 100 active accounts. Using the trade names "Piece of the Rainbow" and "Battman", Batt has been successful with two kinds of cards that feature his work: generalized scenic tourist photography of New York and highly humorous idiosyncratic captioned cards that relate to New York. Examples of the latter that are among his best sellers include a view of the front window of the Yonah Schimmel Knishery (the inside caption reads "Best Knishes on Your Birthday"), a side view of an oil tank truck with the legend "Tanks A Lot" (inside, "For Every Ting!"), four well-dressed attractive women crossing Broadway (caption reads, "If You Looked At The Front Of This Card For More Than Five Seconds Before Opening It, It Proves One Thing 'You May Be Getting Older, But You Ain't Dead Yet!' HAPPY BIRTHDAY").

What goes into Alan Batt's work, and why has he been successful in creating a card line based on his photography when so many fail? First, Battman is his own primary and best salesperson. Prior to starting his card business, he was a star salesperson for Mattel Toys and Playboy Enterprises. His formula for success in sales is: "Be honest and pleasant. Nice guys don't have to finish last." Also involved is an enormous amount of service of his accounts, knowledge of their special needs, and plain hard work.

Another important point is that Alan works very hard to keep his costs and overhead down. In the beginning he scored 10,000 cards by hand. He still folds many of his cards himself. Much of his inventory is stored in a small storage space. Because he is both his own salesperson and artist, he pays neither sales commissions nor royalties. To a considerable degree his trade suppliers cooperate with him by extending him credit when necessary.

Batt has been commissioned to photograph a number of important New York tourist attractions, such as Lincoln Center and the United Nations, for posters and cards which the institutions then purchase from him. The minimum order is sufficient to cover his costs.

Finally, and perhaps most important, there is Batt's quirky sense of humor and willingness to learn and grow as a photographer. Many times he will have the basic idea for a caption or image far in advance of being able to produce it. Sometimes he will research a scene and return to it a number of times before finally photographing it.

What advice does Alan Batt have for someone who would like to follow in his footsteps? "This is not a glamorous business," he says. There is a lot of hard work. You must learn to sell your own product effectively. "Don't give up no matter what. Don't change because people tell you to. Listen to other people's input about things, but then follow your gut. The biggest problem is being able to eat while you `do' these `don'ts'!" ❖

5

How the Photography Book Publishing Industry Works

Kinds of Photographic Books

There are a number of different kinds of photographic books. While some books are easily identified as falling into one category, others are hybrid or not so readily pigeon-holed.

Despite these gray areas, it is helpful to be aware of the kinds of photography books and how they differ. (In the following discussion use of the generic term "book" implies "photographic book.")

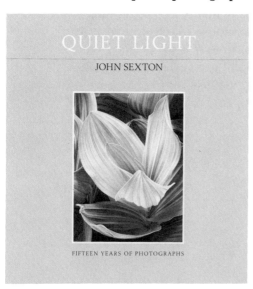

Courtesy of Bulfinch Press/Little Brown.

The "monograph" is a book of photographs presenting one photographer's personal work. It used to be the case that most monographs were reproductions of black and white work, but as color has become accepted as a fine art medium, this is no longer so. Generally, there is an implication that the photographer's work is of sufficient interest to justify this kind of presentation. Reproduction quality is usually excellent which makes these books expensive to produce. Because of the high costs involved, monographs are the most difficult kind of photography book to sell to a publisher, and also the most difficult to get the public to buy. From the photographer's point of view, a monograph may be the most desirable, although not the most lucrative, book to have published. It functions as a statement, a personal expression of vision, an institutional validation of the photographer, and a superbly impressive portfolio. Examples include *Ernst Haas Color Photography* published by Abrams, John Sexton's *Quiet Light* published by Little, Brown, and most of the illustrated books published by Aperture.

The "exhibition catalog" is published to accompany an exhibition or museum show. It may contain the work of more than one photographer, and it is often originated by the exhibiting institution rather than a publishing house.

The "illustrated trade book" deals with a specific topic. Subject matter includes travel, nature, sports, animals, or, as with a primarily word–oriented book, any topic of a general narrative interest. Recent examples include Rizzoli's *Brittany* and *Italian Splendor Palaces, Castles, and Villas*, Simon and Schuster's *Arnold Schwarzenegger*, and Little, Brown's *The Cat in Photography*. Some books in this wide–ranging category verge on the monographic, but the commercial appeal of the book hinges on its subject matter, not on the photographer. Most illustrated trade books are in color, and they are usually not considered art books. Production values vary tremendously. Illustrations may be done by one or many photographers. Ideas for a trade book may be proposed by a publisher, a photographer, or a third party such as a book producer. There is often considerable opportunity for the photographer to shape the editorial content of the book. Illustrated trade books, when properly conceived and marketed, can be tremendously successful and profitable.

The topic or theme for an "in–house book" is assigned by an editor or publisher, often on a flat fee basis. These books are often part of series. They are intended to be mass marketed and generally feature color illustrations. Examples include books published by National Geographic and Time–Life Books. Unlike monographs and illustrated trade books, in-house books are often compilations of the work of many photographers.

As the structure of the publishing industry changes, it is becoming increasingly common for in-house books to be put together by packagers and, in many instances, stock agencies. An example of the former is the *Day in the Life* series. An example of the latter are the "promotional books" put together by the book publishing division of the stock agency, The Image Bank. A promotional book is manufactured with the intent of either remaindering it from the start or selling it as part of a low priced series. Generally, this intent is apparent from the book design. Because customers for promotional books feel they need to get their money's worth, the books are designed with images crowded together and there is not much clean space around the photographs. While promotional books are at one end of the design spectrum, there are some very beautiful books in this category. They are exceptions, however, to the rule. These books also tend to present a pretty but sanitized view of a world without poverty, angst, or weltschmerz.

The "how–to book" is a book on photographic film, equipment, technique or marketing. There is tremendous range in the quality of text and reproductions in these books from useless and awful to quite good and beautiful. Amateur photographers are the biggest buyers of how-to books. If these

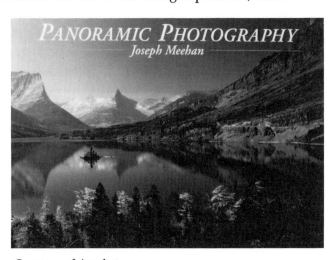

Courtesy of Amphoto.

books are properly conceived, published and marketed, they make money. Examples include Seth Joel's *Photographing Still Life* (Amphoto), and Morgan and Morgan's *Photo–Lab–Index* (PLI) (a reference work containing technical and how–to information on photographic chemistry).

The "artists' book" is one where the photographer has intense involvement in the book's conception, design, and publication. It may be a monograph but is not necessarily. The theme of an artists' book is often an attempt to manipulate the "reader" through play with the form of the book, not the presentation of one photographer's work as art. The artist's book is usually produced in small print runs. Because unconventional processes are often used, the finished product may not resemble a traditional book. The concerns of the creator may be political or related to conceptual bookmaking rather than primarily about the aesthetics of photography. Examples include Richard Long's *A Walk Past Standing Stones*, Robert Frank's *The Americans*, Ralph Gibson's *Deja Vu*, and Larry Clark's *Teenage Lust*. Distribution is usually limited and generally doesn't use the mainstream trade channels.

Structure of the Publishing Industry

The book publishing industry is vast, complex, volatile, and ever changing. The players in the publishing industry range from the most minuscule one–celled animal, the photographer self–publishing one book, to gigantic omnivorous corporate entities such as Gulf & Western's subsidiary Simon & Schuster. Even the method for getting books to stores is confusing; various systems of distribution co-exist.

Generally speaking, the publishing industry is far more geared to books which are word–based than photograph–based. One can speculate as to why this is (see interview with Roger Straus III, p 125–128) but it boils down to the bottom line: the average photography book does not generate as much income as books of prose. Photo books are more expensive to produce and for consumers to buy. Another factor is the lack of understanding within the publishing industry of how to produce and market good photography books. Nevertheless, there are some photography books which have made considerable amounts of money.

Because of the publishing industry's emphasis on prose, there are consequences the photographer who wishes to publish a book should consider. There are almost no agents who have experience in handling photography books. With some notable exceptions, publishers and their editorial staff are not good at giving photographers the guidance they need to create wonderful books.

Due both to commercial reality, and the word orientation of the publishing industry, photographers are highly unlikely to be given superstar status, large advances, and the promotional effort that is generally required to create best sellers.

It can be difficult (although the situation is changing) for a photographer to get recognition and credit as creative "author" of a project he or she brings in even in the situation where the book is mostly pictures with a few words.

There are numerous books for writers on how to get a book published. Or, if you are a writer who cannot get or does not want a contract from a major publisher, how to self–publish. Titles include Leonard S. Bernstein's *Getting Published The Writer in the Combat Zone* and Kathleen Krull's *12 Keys To Writing Books That Sell.* Because information contained in these and other related books is useful to anyone who wishes to be published, they are listed in the Resource Section. But they do not address many of the concerns and are not intended for the photographer as book creator. The only substantive in–print volume that attempts to deal with publishing books from the photographer's point of view is being read by you now. (An interesting, if somewhat grumpy, predecessor, is Bill Owens' now out of print *Publish Your Photo Book (A Guide to Self–Publishing)* (Bill Owens, 1979). Howard Gregory's *Self–Publish Your Own Picture Book in Glorious Black & White* (Howard Gregory Associates, 1989) is of curiosity value only.) This imbalance is well reflected in the attitude of mainstream publishing houses towards photographers.

What is the good news? First, our society is becoming increasingly image oriented. As photographers interested in publishing, part of our job is to bridge the chasm between word and images. We must learn ourselves and then educate our contacts in the publishing industry about what makes visual books viable. It is particularly important to communicate personally with people in the industry. Book producer Stephen Ettlinger's comment on how he finds out what's going on at a publisher is, "lunch." Because there are no "normal" industry schemes for dealing with photography books, as well as such buffers as agents, the photographer must be more knowledgeable, professional, imaginative and good with people than the average writer. For the photographer trying to break into the publishing world, attendance at the major trade shows – American Booksellers Association, and the Frankfurt bookfair – is an excellent idea. Trade shows provide a way to meet people in the industry as well as to learn about what is going on.

Nature abhors a vacuum. There is a need for superb photography books. Most of the obvious books – for example, monographs by the acknowledged masters – have already been published. There is room for a new generation to conceptualize excellent projects.

By far the largest category of photography books published are illustrated trade books. These are intended for the general public and sold primarily in retail bookstores, mass market outlets, specialty stores (garden centers, camera stores, etc.), book clubs, and to libraries. Stores order books directly from publishers or through wholesalers. Large trade publishers have an in–house sales staff that calls on stores and wholesalers. Small publishers rely on independent commissioned sales representatives or independent distribution companies.

Trade publishers generally publish two catalogs, or "lists", a year. The spring list is published from January through May and the fall list from September through November. Generally, book production from manuscript to final book takes from six months to a year.

The sale of subsidiary rights – excerpts or imagery from a book sold to other media such as magazines – can be very profitable and good for promotional

purposes. Trade publishers have rights specialists whose job it is to make these sales. The split of the proceeds between publisher and photographer is specified in the book contract. Similarly, sales of foreign reprint rights can make photography publication projects feasible. By sharing production costs, neither publisher carries as much risk as they would if operating alone. This works especially well with photography books, because there are not many words to translate. It is likely, however, that the photographer will have to set up this arrangement by selling the foreign publisher on the idea.

Returns are a tremendous problem in the book industry. No other industry handles returns in a similar way. Retail stores may return unsold books for full credit within a specified period of time. The reasoning behind this is that otherwise stores would not be able to stock inventory in books they have no assurance they will be able to sell. The practice presents difficulties for publishers in terms of extra record keeping and handling. Stores will often over order and then just ship back returns. Returns may not come back in pristine shape. It is particularly burdensome to self–publishers and small publishers. Because trade publishers routinely charge back an allowance for returns against royalty accounts, royalty payments can be delayed.

Another problematic issue that is causing much concern in the publishing industry is "best–seller–itis." Huge advances help create a situation where a publisher's resources and promotional ability are funneled towards the sure things in which they already have investment. Since photography books are rarely best–sellers, there is less money available to promote them. Publicity about these advances helps to create an atmosphere in which photographers have unrealistic expectations when they contact publishers.

Because of the huge number of amateur photographers interested in photography, specialty distribution to the markets is particularly important. There are several companies who distribute books through camera stores. There are also a few highly successful companies that market photography books via direct mail catalogs.

The publishing industry is filled with numerous small and specialty publishers.You may never have heard of many of them. Particularly worth the attention of photographers are university presses. While the books these academically oriented publishers producer tend not to get on the best seller lists, some houses, such as the University of New Mexico Press, publish wonderful photography books. It is worth your while to conduct some research. Sit down with *Photographer's Market* and *L.M.P.* Spend time in bookstores looking at current photography books. You may discover small publishers you never would have thought of otherwise.

At a traditional trade publisher, editors are responsible for finding publishable book projects. Editors also provide input on the contents of a book, and serve as a liaison with the publisher's production and marketing staff. As a photographer with a book proposal, you will be dealing with an editor.

Generally, books proposals come to editors over the transom or they actively solicit books or book creators. While an editor is the conduit through which proposals come in, the bottom line decision maker is the publisher. The publisher

also makes business and policy decisions for the company.

Publishing houses generally hold some form of regular editorial meeting during which proposed books are discussed. Editors present the books for which they are responsible and discuss marketing and cost analysis. Obviously, the clout, seniority and track record of the editor is important. ❖

PUBLISHERS

(Note: These are either publishers who specialize in photography books or large trade publishers who have published photography books. Since conditions change quickly in the publishing industry, *L.M.P.* should be consulted and the publisher contacted to find out if they are currently interested in photography books.)

Abbeville Press
488 Madison Avenue
New York, NY 10022
212–888–1969

Harry N. Abrams
100 Fifth Avenue
New York, NY 10011
212–206–7715
See pp 81–82

Amphoto
1515 Broadway
New York, NY 10036
212–764–7300
See pp 66–67

Aperture
20 East 23rd Street
New York, NY 10010
212–505–5555
See pp 78–79

Chronicle Books
275 Fifth Street
San Francisco, CA 94103
415–777–7240

Clarkson N. Potter Inc.
225 Park Avenue South
New York, NY 10003
212–254–1600

David R. Godine, Publisher, Inc.
300 Massachusetts Avenue
Boston, MA 02115
617-536-0761
See pp 139–141

E P Dutton
2 Park Avenue
New York, NY 10016
212–725–1818

HarperCollins
151 Union Street
San Francisco, CA 94111
415–477–4400

Images Press
7 East 17th St.
New York, NY 10003
212-675-3707
See pp 144–145

Alfred A Knopf Inc.
201 E. 50 Street
New York, NY 10022
212–751–2600

Little, Brown and Company
34 Beacon Street
Boston, MA 02108
617–227–0730
Bulfinch Press and New York Graphic

Society Books are imprints of Little, Brown; see pp 68–70

MacMillan
866 Third Avenue
New York, NY 10022
212–702–2000

Peregrine Smith Books
Box 667
Layton, UT 84041
801–544–9800

Rizzoli International Publications, Inc.
300 Park Avenue South
New York, NY 10010
212–223–0100
See p 64

Sierra Club Books
730 Polk Street
San Francisco, CA 94109
415–776–2211

Simon & Schuster
1230 Avenue of the Americas
New York, NY 10020
212–698–7000
See p 80

St. Martin's Press
175 Fifth Avenue
New York, NY 10010
212–674–5151

Thomasson–Grant
1212 Wisconsin Avenue, N.W.
Washington, DC 20007
202–342–9334

Thames & Hudson
500 Fifth Avenue
New York, NY 10110
212-354-5500

Twelvetrees Press
2400 North Lake Avenue
Altadena, CA 91001
818–798–3116

Viking
40 W 23 Street
New York, NY 10010
212–337–5200

W.W. Norton & Co
500 Fifth Avenue
New York, NY 10110
212–354–5500

Note: This list is not complete. It excludes university presses, specialty presses, regional presses, and numerous small and alternative publishers.

6

How to Create a Photography Book Proposal

The Dummy

A dummy is a handmade representation of what a finished book will look like. The dummy is to the photographic book creator what sample chapters are to the writer who is shopping a "written" book project. Its importance cannot be overstated.

The dummy serves four different purposes: (1) to help you conceptualize and understand your book; (2) to help sell a book project; (3) to communicate with your publisher; (4) to communicate with production vendors. As Ralph Gibson notes, if you have a thoroughly realized dummy, at least you know that you and your publisher are talking about the same book.

What your dummy should look like depends on how you intend to use it. You can use a series of rough dummies, with photographs indicated by pencil sketches, to help you plan your book. If you are using a dummy as a sales tool, then general issues of presentation apply. You may only need to do one or two complete layouts with a rougher indication of the rest of the book. These layouts should be fully realized. They are analogous to the sample chapter in a written book. Set the type, make the prints to size (in color if appropriate) and paste it all together carefully. This is the place to show the strongest work that will be in the book.

The more complete your dummy is, the less likely there will be communication problems with the publisher. You don't need to set all the type for a book: instead cut out the right amount of attractive type from another book or magazine and paste it up in blocks the way you would like to have the text placed in the book. Depending on your negotiations with the publisher, if they like what they see, they may give you design control over the project. If the publisher tells you, "We love your concept and photographs, but we think the design and sequencing need work," you will have the choice of accepting this or trying to find another publisher.

A dummy that is to be used by typographers, separators and printers needs to be precise. See Chapter 8, "Design and Production." While the dummy is not a substitute for mechanicals, it will be used to help make clear sequencing, backups, crossovers and image placement (see glossary for definitions of unfamiliar terms). A dummy used for this purpose needs to be clean and professional but it need not be elaborate. Black-and-white or color xeroxes are probably sufficient.

Start your dummy with a skeleton of a book that is physically similar to the book you want to create. There are a number of approaches. If paper wholesalers think you are a potential customer, they will generally make up a book for you (if you specify the paper and number of pages). Other options are buying a blank book, taking an existing book and pasting over the pages, or creating one from scratch.

If you are creating a few special layouts for sales purposes, present them as you would any other portfolio material. Do not try to insert them in the (otherwise rough) book dummy.

If you are working with a short layout, or are planning to self–publish the book and will need the type anyhow, order type from a typographer. Otherwise, use a personal computer to set type on a laser printer, or cut type out of existing books or magazines. If a rough layout is all you need, pencil in placement indications.

Indicate placement of photographs with prints, photostats, or photocopies. Every effort should be made to indicate correct cropping and scaling (size) of photographs. If you are making a rough dummy for your own purposes, again you might pencil in sketch representations of photographs.

Put your dummy together neatly, using rubber cement. If appropriate, mount the individual prints. Beware of spray adhesive: material pasted up with it tends to detach from its backing in short order.

Effort put into the creation of a superb dummy will pay dividends. It is the most important component of a photography book proposal.

Editing, Layout, and Sequencing

Bill Owens, author of *Publish Your Photo Book,* states: "There are no rules for designing a (photograph) book. Whatever works is what counts. You make your own rules as you go along."

However, sensitivity to editing, layout, and sequencing is vital to the success of a photograph book. The initial creation of the dummy is the time to start working with these concepts.

Look at well–designed photograph books with great attention. What makes Robert Frank's *The Americans* or Joel Meyerowitz's *Cape Light* successful? Is it the photographs themselves, or does the typeface and layout have anything to do with it? Imagine the books with six or seven images crammed on a spread; how would that affect the feel of the book? What would a lighter or heavier typeface do? How about the juxtaposition of photographs?

Before you even get to layout and design considerations, spend time editing your work. Narrow your book down to 80 to 100 images. Make prints of these images. Play with them. Sequence them. Edit them. Take your time. Become clear about the focus of the book. What is it about? What compositional elements do the photographs have in common. Are the colors or tones all the same, or are they different? How will placement make the images contextually more exciting?

As you create your dummy, you may wish to involve a designer. The designer can help with the mechanical aspects of dummy or layout creation. Designers essentially perform the function of specification, transforming your wishes into technically precise layouts. They can also help you to conceptualize, format and edit an entire project. In either case, make sure you are comfortable with the aesthetic of the designer. Get an idea of his or her style by looking at previous projects. Get referrals for designers from photographers, self–publishers, publishers of quality photography books, and graphic arts professionals. Design fees will vary tremendously depending on what the designer will actually be doing and their reputation.

Photographs depend on context. Without context, they have no meaning. Photographs have no objective truth. Instead they have with a great capacity to appear to represent the "real" world. This creation in the viewer of "willing suspension of disbelief" is an illusion. Sequencing and context of photographs are crucial to an understanding of their meaning, and crucial to the creation of the photograph book. Give it a great deal of thought.

Layout should not call attention to itself. It should enhance and not detract from the photographs. There should be some system of margins, placements and enlargements so that chaos is avoided. At the same time the layout should not be boring. Page size, gutters, and sequencing should be considered design elements of the book and used in an imaginative and intelligent fashion.

Elements of the Photography Book Proposal

A photography book proposal consists of a cover letter, visual material, and a written statement. Sample text and a table of contents are also sometimes appropriate. The cover letter (not a query letter, which is discussed below) mentions the title of the book and contains a brief summary of what the proposal contains, a reminder of previous interaction between editor and photographer (or, if none, how the photographer chose this editor as a recipient for the proposal), and information about where the photographer can be contacted.

The written statement should open with the title of the book and a one sentence description of the book ("handle"). Note the number of pages, the size, and number of color and black-and-white reproductions. Be sure to include the name(s) of photographer(s), author(s), and any other relevant creator(s), as well as a brief description of the background of the creator(s). Pay particular attention to previous books (noting if they sold well, were well-received, or otherwise important). Continue with a detailed discussion of the contents of the book, it's market, and the existing competition.

The proposal is a selling tool. There is no commandment written on a stone tablet telling you what must go into it. Include what is appropriate and will work best for your project. For example, a proposal for an illustrated how–to book should certainly contain a table of contents and a few sample chapters, in addition to photographs.

Remember that, like most industries, publishing is people oriented. It is much easier to sell a proposal if the recipient already knows and likes you. Trade shows such as the one given by the American Booksellers Association (A.B.A.) (see discussion of trade shows in Chapter 10, "Running a Publishing Business") are a good way to start making contacts.

Harold Davis

Wilderness Studio, Inc.

2673 Broadway, Ste. 107
New York, NY 10025
212–642–5123
FAX 212-663-6144

Date

Edwina Editor
Humongous Publishing Conglomerate, Inc.
Main Street
Nowhere, NH 00000

Dear Edwina,

When we met at the Humongous Publishing party at A.B.A. in Las Vegas you were kind enough to express an interest in my next book project after I finished the *Photographer's Publishing Handbook.*

I have started work on a book on electronic imaging and the future of books and photography. My provisional title is *Photography, Publishing and the Computer.* It is to be illustrated, in color, with electronically produced and manipulated imagery, by myself, and other artists interested in relevant fields.

Topics covered will include: electronic imaging as an artistic medium; digital replacement of silver process; social impact of widespread use of digital imagery; the nature of photographic "truth"; the impact of the computer on publishing; and computer storage media as the "books" of the future.

If Humongous Publishing would be interested, I would be happy to get you a complete proposal including a Table of Contents, Sample Chapters and Imagery.

Please let me know. In any case, I enjoyed talking with you.

Sincerely,

Harold Davis

SAMPLE BOOK PROJECT QUERY LETTER

PROPOSAL:

Fallen Angels: New York City's Halloween Parade

Photography by:

Mariette Pathy Allen
Elijah Cobb
Harold Davis
Lauren Piperno
Marilyn Stern

Text by:

Jack Kugelmass

Book Specifications

Fallen Angels is a trade book, 9X12", with approximately 70 color photographs and 20 pages of text.

Parade

Since its creation in 1974 by theater director and mask–maker Ralph Lee, the Greenwich Village Halloween Parade has grown into one of New York City's most exuberant and well–attended cultural events, drawing thousands of participants, hundreds and thousands of spectators, and worldwide media coverage. *The New York Times* called the parade "the best entertainment that the people of this city ever gave to the people of this city." It is an explosion of creative energy that fills the streets with 40–foot airborne snakes, flocks of pink flamingos, human condoms dancing to Samba bands, closets full of Imelda Marcos' shoes, transvestite fairy godmothers on roller skates, bathroom fixtures, Korean salad bars, victims of the Texas chainsaw massacre, and ghosts and ghouls of every description.

Photography

A group of five prominent New York photographers – Mariette Pathy Allen, Elijah Cobb, Harold Davis, Lauren Piperno and Marilyn Stern – have collaborated in documenting the Halloween Parade. They have been designated as the parade's official photographers for the past four years. Their varied interpretive styles – from Cobb's abstract Widelux images to Davis' close–up portraits – come together in a body of work that is vibrant and cohesive, echoing the rhythms of the parade itself. The photographs also show personal preparations, transformations and behind-the-scenes activity that precedes the parade.

SAMPLE PHOTOGRAPHY BOOK PROPOSAL
(This page and following page).

Text

The book's text is by urban anthropologist/folklorist Jack Kugelmass, who has worked in close collaboration with the photographers. The text, in a narrative anecdotal style, examines the experiences and motivations of a half–dozen extraordinary parade participants (who overlap as the photographers' subjects). It traces the evolution of the Parade from a street theater piece conceived and directed by Ralph Lee to its present state as a mass participatory New York carnival.

Market

The exciting, colorful and technically imaginative photographs should appeal to the photograph and art book market. The insightful text and empathetic imagery will create a market beyond this in those interested in anthropology, folklore, urban studies, theater, performance art, and the gay community. Additionally, New York City is a subject with continuing appeal nationally and internationally. Finally, Halloween itself is increasingly becoming a gift giving occasion. This book would be the perfect sophisticated Halloween gift. There are no other books on New York's Halloween Parade.

Availability

All of the photographs for the book are assembled. The text is in its final editing stage. A sample condensed dummy has been prepared to indicate basic book organization, sequencing, and design.

All rights are available.

What Editors Look For in a Proposal

Editors are looking for a book that will both make money for their publisher and enhance their own reputations. They are also looking for book creators who won't make their life miserable. Editors prefer to work with photographers who do what they have agreed to do in a clean, professional, quality way, on time! Your proposal will be examined as to whether your book will make money and be of recognizable quality. It should also reflect your ability to keep agreements, produce good work, and keep deadlines.

Editors look for books which exhibit good photography, good writing, humor, emotional engagement of the reader, originality, universality, knowledge of the market on the part of the creator, intelligent discussion of issues, relevance, topicality, clarity, sincerity, longevity and professionalism.

Editors are turned off by books which are inappropriate for their company, books which are similar to books which have flopped, boring, long–winded writing,

mediocre photography, book proposals that are put together in a sloppy or unprofessional way.

Your proposal should help the editor make the case for your book. Suppose an editor falls in love with your project and wants to become your editor. Your editor will have to sell the editorial committee and publisher on your book. Your proposal, dummy, samples, and market research should be designed to make that process easier.

Advances

An advance is money paid to a photographer, author, or creator of a book against future sales. It is to be repaid out of the creator's royalties.

The size of the advance depends on many variables, including the author's reputation and track record, what kind of book is involved, and who the publisher is. For many creators, it is the single most important part of the contractual publishing arrangement and subject to the most negotiation. Perhaps the best answer to the question "How much advance do you get?" is "As much as you can." Books which are expected to sell well get the biggest advances. A creator whose current book is a best–seller can expect a large advance for the next one.

If your book is expected to make money, you should receive an advance against royalties. Not only does this guarantee you some money for your work, it also helps to insure commitment to the book on the part of the publisher.

A rule of thumb is that the advance should equal your royalties based on projected sales for the first year. For example, if the publisher feels that 8,000 copies of a $30 book will sell in the first year, and your contract calls for royalties of 10 percent of the suggested retail price, the advance will be $24,000. However, a publisher may have a standard policy that differs.

Royalty percentages do not tend to be as negotiable as advances. 10 percent of retail for sales of under 10,000 is standard. The percentage may rise for greater sales, sometimes reaching 15 percent for sales over 30,000 copies.

As in all negotiation, the best approach is to define the parameters of the other side's position. What advance will they offer you? What is the range of advances they typically offer for similar books?

Provisions for expenses should be discussed and responsibility allocated in the contract. Common examples include the cost of leasing rights to use other photographers' imagery in the book, hiring a writer, and financing a photographic shoot. If the photographer is to be responsible, these expenses will come out of the advance. Another option is a separate grant for expenses, which is not chargeable against royalties but is treated as part of the cost of book production. In a third scenario, the publisher may pay the expenses directly.

As discussed elsewhere, the superbly produced monographic book has tremendous benefits for the photographer. However, it is also the case that monographs often make no money for the publisher. They are often produced with

no advance granted to the photographer. While I am not enthusiastic about this, benefits to the photographer are so enormous that an offer to publish without an advance should not be rejected out of hand if the publisher is well respected and intends to do a good job. You will have to use your own business judgement. If the publisher is not giving you an advance, perhaps you can get more free author's copies to use for promotional purposes or sell at workshops.

Negotiating a Book Contract

A book contract covers many issues. Some of them are extremely technical, such as return allowance allocations. Others may have a big financial impact (for instance, stepped up royalty percentages as sales rise). While you can negotiate a contract yourself, consider consulting an attorney who is knowledgeable about book contracts or an agent who knows about photography books. Consultation costs will either be based on an hourly rate or a percentage of the advance and royalties. These costs will probably be recouped through the improved contractual provisions achieved by a skilled intermediary.

At the minimum, a book contract should contain a description of the book, allocation of responsibility for costs, delivery date, advance, royalty percentage, accounting provisions, subsidiary rights provisions, and a method for resolving disputes.

For more information see Leonard Duboff's *The Photographer's Business and Legal Handbook* and the chapter on "How to Understand and Negotiate a Book Contract" in Richard Balkin's excellent *A Writer's Guide to Book Publishing*. In general, do not sign anything you do not understand, and do not feel you have to accept the publisher's standard form contract. Get any commitments that are important to you in writing, either in the contract itself or in a letter from your editor. While oral promises are often made with the best of intentions, when time passes, they may be forgotten or your editor may leave for another publishing house.

Publishing used to be considered a "gentleman's business". Today, there is more of a sense among book creators that they must contractually protect their rights with publishers. (See "For Authors, the Key Words Are in the Book Contracts", *The New York Times*, 8/27/90, p. D1, col 1.) Although most publishers will act in good faith, it never hurts to get the details in writing.

Book contracts can be highly technical. Boilerplate clauses often favor publishers. If in doubt, get qualified legal and business advice.

Book Producers

Book Producers, also known as book packagers, are very important to photographers who are interested in book publishing. The American Book Producers Association, a trade association of independent book producers, states:

A book producer creates the concepts for books and develops these ideas for publishers, undertaking any or all of the services necessary for publication. The book producer may deliver any one of the following:

 1) a fully edited manuscript with or without layouts
 2) camera–ready mechanicals
 3) final films
 4) finished books

Working with authors, agents, editors, designers, photographers, illustrators, typesetters, and printers, producers develop books on a wide variety of subjects.

Because photography books are complicated to produce, publishers are using packagers with greater frequency. Producers are an important potential market, both for stock photography and book projects. Also, it is possible, and a help in selling photography book projects, for the photographer to function as his own producer (see Chapter 10, "Running a Publishing Business").

As a photographer working with a packager, your contractual arrangement is with the packager and not the publisher. While royalties are sometimes arranged, it is more common for the packager to pay photographers and writers on a flat fee basis.

The Resource Section contains names of some producers who work with photograph books.

Interview: Stephen Ettlinger
Book Producer

An intense bearded man in his early forties, one's first impression on meeting Stephen Ettlinger is of a thorough, concerned intelligence. He, in fact, notes a strong personal interest in what is going on in the world, along with a fascination with photography and design.

Stephen is third generation entrepreneur, born and bred in the Midwest. His parents, his father an inventor and his mother an artist, are deeply involved in art and design. Stephen remembers spending a lot of his time as a child reading books; he was particularly impressed by *The Family of Man*, his "first book", which permanently shaped his conception of photography.

In college, he designed his own major combining urban studies and visual communications. However, perhaps the most formative experience of his college days was his work as a staff photographer on Adlai Stevenson III's successful Illinois campaign for the U.S. Senate. He rubbed elbows with *Life*, *Look* and *Fortune* staffers and learned about photojournalism. He noted with interest that photojournalism allows access to an endless variety of different worlds.

Following a three year stint in the international business world, Ettlinger answered a blind ad in the International Herald Tribune and in the summer of 1974 went to work in the Paris office of Magnum as Assistant Bureau Chief and Desk Editor. The history of modern photojournalism was in the contact sheets filed in the Magnum archives, and Stephen spent many evenings browsing through this work – especially that of Henri Cartier–Bresson. He also developed strong personal relationships with many of the Magnum photographers (which he has maintained to this day) and exercised his ability as a writer by packaging stories, writing short text and captions, for syndication. Often, when a photographer with whom he worked had a book published, the photographer would give him a copy. Each of these books was a treasured possession. Stephen feels that the pleasure he found in these gifts is part of why he likes photography books so much today.

An injury to his father brought Stephen back to the United States to help run the family business, in particular to set up a production line of industrial dishwashing machines. Stephen functioned as Production Manager, a position he feels is not so different from what he does with books, managing a creative team.

After the family business was running smoothly, Stephen moved to New York where he took a job as Associate Picture Editor with the newly formed Geo Magazine. He remained in this position until its last issue appeared in January of 1985. Stephen feels that he learned an important lesson at Geo: throwing money at a problem often doesn't solve it, and, in fact, can cause new problems. In publishing, having less money to waste can often be a plus rather than a minus. Stephen's job often involved teaching the executive levels of the organization at Geo about the professional realities of publishing photography. His ability and experience in dealing with corporate types has been very helpful in his book packaging business. He has also learned that it is a mistake to expect to be treated as "special" by publishing industry executives who have many projects on their minds. If you are trying to shop a project to a publisher who can only give you a small part of his attention and you react by being offended, this will only be counter–productive. While working at Geo, Stephen also clearly realized the folly of not understanding the different personalities and viewpoints that make-up a creative team.

Tired of working for a corporation and feeling the genetic pull of his entrepreneurial parents and grandparents, Ettlinger noted that several text editors at Geo were doing book projects on a free–lance basis. One day, while trying to buy a thingamagig at a hardware store, he had an idea for a book that simply listed, illustrated, and explained everything found in a hardware store. After talking with a number of Geo colleagues and contacts, he was encouraged to proceed with the book. Ettlinger not only co–authored The Complete, Illustrated Guide to Everything Sold in Hardware Stores (Macmillan), he also served as packager, thanks to his knowledge of contracts and negotiation.

A book packager (or producer) organizes a creative team to produce books. He delivers to the publisher a manuscript (usually edited) and often illustrations. A publisher might also contract for camera–ready mechanicals, film, or bound books. Packagers also produce bound books for corporations, for example, a cookbook that is given away with an oven.

When Stephen functions solely as an agent, as was the case with Jill Freedman's fifth book, *A Time That Was: Irish Moments* (Friendly Press) he receives from 12.5 to 15 percent of the advance and royalties as his fee. As producer, his fee ranges from 15 to 50 percent depending on how much work is required. If mechanicals or film are required by the publisher, an additional fee (or grant) applies.

The problem, Stephen feels, with a lot of photography books is that they are strictly personal. Being personal can be a good motivation, particularly because there is seldom enough money involved to justify the photographer's participation on a strictly economic basis. However, there must be an appropriate balance between motivation and obsession. For example, the major publishers that Stephen currently works with generally do a good job but things fall through the cracks. "Perhaps the most important part of my job as a packager", says Ettlinger, "is following up on all those details. Major publishers have many different projects going at once. It is of the utmost importance to follow up politely. Being nasty is counter–productive. As an agent, I am supposed to be the intermediary between an angry author and an unfeeling bureaucrat. As a producer, however, I am the author and the agent. That is the challenge."

In 1989, Stephen produced *Vietnam: The Land We Never Knew*. Published by Chronicle Books, *Vietnam* features photography by Geoffrey Clifford, text by John Balaban, and art direction by B. Martin Pedersen. As with the Freedman book, Stephen felt an emotional affinity with the subject matter and admired the photography. The book, which presents Vietnam veteran Clifford's photographs of post–war Vietnam, had an interesting story to tell to a wide audience.

Vietnam is Stephen's most positive example of how to produce and "make books happen." The photographer, Geoffrey Clifford, and his agent, Paul Wheeler, had been spinning their gears on the project, unable to interest a publisher. Finally, they paid Stephen in the neighborhood of $1,000 to write the book proposal. He then shopped it around to all the major publishers and negotiated a deal with Chronicle Books in San Francisco for an advance and a grant for the mechanicals. The writer and designer were paid out of the advance. But the photographer had to pay for three more trips to Vietnam out of his own pocket. What did Clifford get out of the project other than a small portion of the advance which was more than used up in travel expenses? Essentially, this was a labor of love: he got to see his work reproduced in a well-designed book.

Photographers need to be realistic about the economics of book publication. Stephen points out that the average advance for all books is between $7,500 and $10,000. Since this figure includes the well–publicized million–dollar advances, a realistic figure for the average book is substantially less than the average. A rule of thumb is that the advance should equal the royalties on sales of 80 percent of the first print run. Assuming a 7,500 print run on a $30 book with a 10 percent royalty, the advance would be $18,000. Out of that $18,000, the agent or producer, photographer, writer and maybe the designer need to be paid. The photographer should forget netting an advance of anything over $10,000, out of which the expenses of producing the photography must be paid.

Stephen notes that while his Vietnam book has sold "respectably" well, there is a probable tie–in down the road with a major cultural institution which will be sponsoring a series of exhibits based on the imagery in the book. Ultimately, this could make the project more profitable. ❖

Interview with Lois Brown

Lois Brown, Managing Editor, Rizzoli International Publications

Lois Brown is Managing Editor of Rizzoli International Publications. Rizzoli is one of the leading publishers of photographic books. They have 14 photography books scheduled for release in the Fall of 1990 and the Spring of 1991.

Brown feels that Rizzoli is "successful because we present the photography well, on decent paper, in a large format. Essentially we publish subject books that happen to be photographic. We are very selective and our publisher, Gianfranco Monacelli, personally looks at the photography before we go ahead on a project.

"An example of a book that has sold well for us because of its subject is our book on Alaska, with imagery by a group of photographers. A current release that we are excited about is Jake Rajs' *America*. Of course, Rajs is a very well known photographer. James Michener wrote the foreword simply on the basis of his enthusiasm for the beauty of Rajs' work for this book."

Rizzoli almost never gives large advances. Although a photographer might eventually make substantial money from royalties, if they don't have the imagery already created as stock they would have to be well capitalized in order to work with this publishing house.

"The best way for a photographer to get a book published," says Brown, " is to have an important exhibition coming up or to have work on a commercially strong subject. My advice is to go out and take pictures of subjects you love. Eventually you will have a strong body of work available as stock and a publisher may be able to afford you."

Contact Rizzoli by mail, with a S.A.S.E. for any material you wish returned. "Please," Ms. Brown requests with a firm smile, "no phone calls." ❖

Interview: Olivia Parker

Photographer

Three monographs of Olivia Parker's work have been published to date. The first, *Signs of Life*, consisting of work in black and white, was published by David R. Godine in 1978. Next, *Under the Looking Glass*, a collection of reproductions of large

format Polaroids, was published by New York Graphic imprint by Little, Brown and Company with support from Polaroid. Most recently, *Weighing the Planets*, was published in 1987 in hardcover as a New York Graphic Society/ Little, Brown and Company and in softcover by The Friends of Photography. Parker says, "When it became clear that *Weighing the Planets* was going to be difficult to publish conventionally, I went to book packager Floyd Yearout (see pages 70–71) for advice

© Harold Davis

and to see if perhaps he would produce it for me. Floyd said there was no margin for him in the project but he very generously sat down with me and spent considerable time advising me and encouraging me to package it myself with the help of Katy Homans who designed my first two books.

"First we made a dummy, then Katy got estimates for all production costs. After that we sold the project to two publishers, New York Graphic Society (Little, Brown and Company) for the hardcover and Friends of Photography for the softcover editions. My contracts with the publishers provided for an advance to start production, the balance to be paid as soon as we delivered the books. As a result I had money tied up in the project only from the time the printing was done until after the binding was finished and the books delivered. I broke even on the project, but I was able to keep 500 hardcovers. *Weighing The Planets* is now out of print, but I have my extras to sell at lectures and workshops. They are my royalty. Most importantly, I maintained control of the book throughout production which meant that the only compromises were due to costs."

Parker first became interested in photography as a child. In college she majored in the History of Art and was interested in writing and painting. Her writing grew more visual, she began painting more, but didn't start photographing seriously until about 20 years ago. She moved away from painting because photography was a more appropriate medium for her to explore a group of themes in depth. Parker became aware of the potential of sequencing

Under the Looking Glass

COLOR PHOTOGRAPHS BY
OLIVIA PARKER
INTRODUCTION BY MARK STRAND

Courtesy of New York Graphic/Little Brown.

through Minor White, and from there books were a natural direction for her.

Describing herself as professionally isolated in the early 1970's, Parker views David R. Godine's publication of *Signs of Life* in 1978 as a turning point in her career. "At best," Parker says, "a book is not a profitable exercise. My first book did not give me an advance. I was extremely happy just to have Godine publish it my way. It opened so many doors for me in terms of things like invitations to teach at workshops and print sales."

When Parker's students ask her about publishing their work as books, she explains to them that "publishing photography books is a very expensive proposition. The work needs either a subject-matter appeal beyond the audience for art photography or subsidization. While self–publishing of visual work does not carry the stigma of vanity publication of non–visual work, it is very difficult to find effective distribution. Photographs should have a reason to be a book. The book must become a whole new work, not simply a retrospective collection. Even when an artist has worked many years, chances are a retrospective collection would not be as interesting as a selectively sequenced group of pictures from a small segment of a career. If students are really fascinated with the idea of books, they should experiment with the creation of hand-made books."

When Parker looks at advanced student work, she likes to see photographers evolving toward what they will do best. "At least after a while, I would expect to see ideas rather than empty technical experimentation," she explains. "An artist's work, like language, an essay, poem or novel, should have its own syntax and ongoing self–justification. It is really wonderful to see work where the artist cares and has the kind of obsession it takes." ❖

Interview: Robin Simmen

Senior Editor, Amphoto

© John Hart

Robin L. Simmen is Senior Editor at Amphoto. Amphoto, an imprint of Watson Guptill Publications, specializes in photographic technique books that are also attractive showcases for photographic imagery. Ms. Simmen, an articulate, charming woman with an academic background in anthropology, notes that Amphoto publishes a wide range of books amateur and professional photographers at all levels. While the typical Amphoto publication contains technical information, "it also approaches the coffee table format," she says.

Simmen points to John Shaw's *The Nature Photographer's Complete Guide to Professional Field Techniques* with over 40,000 copies in print, as one of Amphoto's most

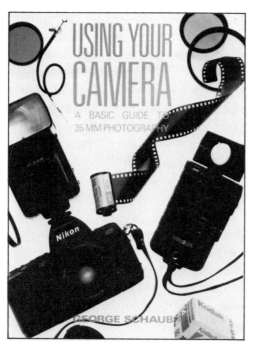

Courtesy of Amphoto.

successful books. Upcoming releases for which she has high expectations include *Understanding Exposure* by Bryan Peterson and Gary Braasch's *Photographing the Patterns of Nature*. Simmen notes that these books contain not only technical information about photography and stunning imagery but also discuss how to see and design pictures that sell.

"Amphoto," states Simmen,"expects to make money on every book it publishes. Unlike some presses, we won't knowingly publish a book if we don't think both we and the author can make a profit on it. Between our general trade distribution and our distribution into retail camera stores, our sales distribution is absolutely unbeatable." In addition to more sophisticated books that combine techniques and imagery, Amphoto also publishes basic instruction manuals such as George Schaub's *Using Your Camera: A Basic Guide to 35mm Photography*, and works on marketing photography, such as Kathryn Marx's *Photography for the Art Market*. Production values are generally very high. A great deal of attention is given to design; the foremost concern of the in–house design department is that the design not detract from the photography.

According to Simmen, the most important market for Amphoto books are "buyers who think that they can learn to take beautiful pictures like the ones in our books. Also, amateurs are voyeuristically interested in what it takes to be a professional photographer. Photographers who have backgrounds as teachers tend to make our best authors because they have experience addressing the kind of questions that interest the average amateur. The inclusion of technical data is essential; it sells the book. For example, our readers love diagrams that show how the pictures are taken."

Simmen is committed to publishing beautiful books. Her goal is to incorporate

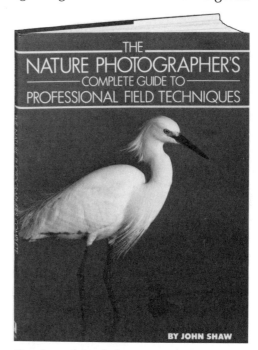

Courtesy of Amphoto.

the required instructional material and still come away with an attractive product. Photographers working with Amphoto are sometimes not quite clear about Amphoto's focus and want their book to be more of a monograph than the company is able to sell. Simmen is very open to book proposals that fall within these parameters. She suggests that would-be authors write a letter that briefly and clearly summarizes their idea. A table of contents, sample chapter, and tear sheets may be enclosed, but absolutely no original or valuable art work should be sent.

Amphoto tends to work directly with photographers rather than through agents. Simmen finds that because book agents are not very familiar with heavily illustrated books, there is usually not enough money involved to be worth involving a third party. In fact, many of her books really come together in the design stage when an agent is only in the way.

The typical Amphoto advance against royalties is computed against a two–year sales projection for the book and covers both text and imagery. It is generally the author's responsibility to obtain releases and pay any usage fees for photography not created by the author. Royalties conform to industry standards and are calculated using the book's retail price as a base. They start at 7.5 percent of the retail price for paperback sales and 10 percent for hardcover sales under 10,000 and rise to 15 percent for sales greater than 20,000. The typical first run of an Amphoto book is about 10,000.

Simmen is actively looking to develop books on hand–colored photography, electronic-flash techniques, food photography, interior photography, auto-focus photography and electronic imaging. She notes that there is also a need for quality video instructional books and basic technique books in Spanish.

The good news for photographers who are willing to study Amphoto's list and to create books that work in the context of what the company publishes is that Amphoto has found a broad niche market for beautiful books that approach monographs in their visual content. And they actually make money for their photographer authors. ❖

Interview: Janet Swan Bush

Little, Brown and Company

Nestled in the cobbled streets of old Boston's Beacon Hill are the editorial offices of Little, Brown and Company, one of the foremost publishers of "serious" and successful photographic books in this country, including, for example, the books of Ansel Adams and Robert Mapplethorpe. Bulfinch Press is a new imprint of Little, Brown, which until recently published its photography and art books under the New York Graphic Society imprint.

Janet Swan Bush is Executive Editor of Bulfinch Press. She greets me warmly as she ushers me into her office. "Today," she states, "most photography publishing has

to involve more than one partner. Also, even a serious fine art photographer's personal work needs a theme and cohesiveness to be published." She cites Eliot Porter's *Maine*, William Albert Allard's *Vanishing Breed: Photographs of the Cowboy and the West*, and Joel Meyerowitz's *Cape Light*, as examples of successful Little, Brown books that combine content and serious work.

Bush admits that there is a sort of Catch–22 involved in the very act of producing a book with the kind of quality it needs to find an audience. A beautiful book printed in duotone with a 5,000 copy press run will be priced at $60 retail, well beyond the point where it can find a large audience. "Some sort of support such as a major exhibit accompanying the publication of the book is needed," says Bush. "Although it should be noted that to make a real difference the exhibit must be of the blockbuster variety."

Courtesy of New York Graphic/Little Brown.

"Another approach that works is to work with foreign co–publishers," continues Bush, "They invest in the project and help spread the immense costs of publishing a quality book of fine photography. Here, the photographer's contacts might help. If the work is really strong and cohesive as a body, and of the sort that people will want to buy, then there will be a way to get it published. Finally, subject matter broad enough so that there is wide interest in it may sell a book. For example, Sally Euclaire's *The Cat in Photography*, a collection of classic photography of cats, will probably sell to cat lovers who do not care that the imagery is by such masters as Cartier–Bresson, Weegee and Weston. Put another way, if we are dealing with a book of portraits, whose portraits are they? Will people buy the book based on interest in the people photographed?

"I respect personal vision in photography and would like to be able to publish new work, but it is increasingly difficult. Much of the publication we do is related to an important exhibit, possibly with editorial and production work done by the institution involved. Obviously, considering financial and marketing realities and the limited size of our list, we are not always able to publish what we want. But what we do publish is top notch."

Bush stresses that photographers presenting proposals should not be vague. "Don't just send in a tray of slides along with the statement `Here's a Book'," she explains. "What precisely is the book? Do a formal written proposal. Is there text? Include information on yourself. Have you been exhibited? Published? Do you have useful contacts, particularly with institutions who might be interested in mounting an exhibit along with the publication, or with foreign publishers who might co–publish?

"One of the biggest changes in the business of publishing art books is the emergence of the packager," she continues. "The packager, often an ex–publisher, will take over the editorial, design, and, often, production functions of the publisher,

thereby saving the publisher's staff time. Sometimes a photographer will act as packager of his own book as John Sexton did for his *Quiet Light*.

"Photography publishing is here to stay," Janet Bush concludes. "A book is a great way to reach people and it is permanent, while an exhibit is not. The only question is finding ways to make it work." ❖

Interview: Floyd Yearout

Book Packager

© *Harold Davis*

Floyd Yearout and I are sitting in an elegant restaurant in Boston. Yearout is a handsome man who wears colorful neckties and whose apparent youth belies years of experience and accomplishment in publishing photography books. He is perhaps best known for his work as editor at Little, Brown and Company during the time that such blockbuster books as Ansel Adams' *Yosemite and the Range of Light* and Joel Meyerowitz's *Cape Light* were published.

Prior to coming to Little, Brown, Yearout was Director of Foreign Rights for McGraw–Hill, a position that involved some negotiation of stock photography usage but little other active involvement in the production of photography books. At Little, Brown he was assigned immediately to edit *Yosemite and the Range of Light* which sold massively—over 100,000 copies at $75 retail in its first year—and, by so doing, ushered in a new era in the publication of photography books. Publishers for the first time could realistically consider the possibility of huge sales from a photography book. Ansel Adams' success translated into a substantially increased ability for photographers' to sell books to publishers.

For Yearout, who grew up on a ranch near Fresno, California and whose family summered in Yosemite, Adams was a "godlike" figure. Becoming his editor was a dream fulfilled. Yearout says that he was "interested in photography but did not know too much about it. Basically, I now feel that this was an advantage because I was able to spend a lot of time asking questions. My only agenda was to publish photography books that needed to be published. I compiled lists of subjects and artists. I also learned a lot from some of those I worked with. Bob Delpiere, the designer of Robert Frank's *The Americans* comes to mind. We worked together on the retrospective Cartier–Bresson book.

"Joel Meyerowitz' *Cape Light* was a project I inherited when I came to Little, Brown. The book has done tremendously well, largely through word of mouth, basically I think because it combines what is clearly "art" with transcendental beauty. It is very special photography, novel, yet accessible. Joel doesn't deal only in pretty subjects, yet the work has a very precise sense of place."

Yearout has represented Meyerowitz as a packager on his last several book projects and is currently working with him on a book of portraits of red heads. "A book packager," Yearout states, "is a photo editor and publisher, or photo editor and agent."

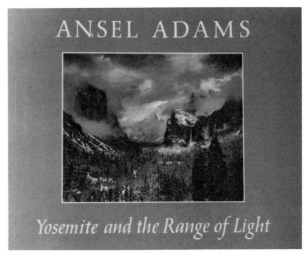

Courtesy of New York Graphic/Little Brown.

I ask Yearout the question he posed at the start of our conversation. How do projects get published? He ponders for a moment, while taking a bite of his smoked duck. "The least likely book to get published is a naked collection of one photographer's random imagery. The chances are a little better if the imagery is tied to a major museum exhibit. But, the best bet is to present work on a specific subject with commercial appeal.

"There are many stages between taking a picture and putting a book together," Yearout continues. "Perhaps your first question should be, `Why should people spend a lot of money on my book?' Probably, a first book should be subject oriented. In terms of selling projects I am working on, I like to do a complete dummy in book form. This means setting type, printing to size and using the actual paper planned for the published book.

"Corporate support of exhibit catalogs is perhaps the major route for publication of monographic photography books. In such a case, a grant will fund the publication of a catalog that accompanies a museum show. A trade publisher such as Little, Brown will then distribute and/or produce the catalog. Sometimes a dealer who has an interest in a photographer will help to line up financial support for an exhibit, catalog and trade distribution." ❖

---- 7 ----

Interviews and Profiles

There is a tremendous amount of information contained in the interviews in this book, ranging from the practical to philosophic and inspirational. In some of the interviews with photography publishers or buyers, they indicate what they are looking for and how you should submit work.

Interview: Eva Rubinstein

Photographer

Eva Rubinstein is a photographer who makes her living from the sale of her original prints. She is able to do so because her imagery has a high degree of recognition thanks to its publication in monographs and on cards and posters.

An elegant, gracious and intelligent woman with a slight foreign accent and searching eyes, Eva Rubinstein's loft studio and home are located in an industrial neighborhood of Manhattan. Imagery is everywhere. The couch is covered with stacks of prints ready to be examined by a European publisher. On the walls are Eva's prints, views of interiors and of people, black and white details of life which are as romantic, revealing and compelling as the photographer herself. Alongside her work hang prints and reproductions of work she has collected over the years. Everything the visitor sees is exquisite: ceramics, glass bottles, lace curtains and pillows. The objects are arranged as carefully as a still life that is about to be painted or photographed, but there is not an ounce of preciousness or clutter. The overwhelming impression is of clear, clean, bright, white light saturating everything. Eva's innate love of beautiful imagery and objects is abundantly clear.

Born in Argentina, Eva, the daughter of pianist Arthur Rubinstein, was raised in California. Her first career was in ballet, and then in the theater. She performed on Broadway in *The Diary of Anne Frank*. Giving up her acting career, she married the Reverend William Sloane Coffin Jr., then chaplain at Yale University, and raised a family. Rubinstein's years in New Haven were those of the civil rights movement and the antiwar movement.

Eva was first introduced to photography in 1967. As part of her job in the public relations department of the Long Wharf Theater, she assisted the photographer,

helping him spot prints and watching him in the darkroom. The experience gave her "shivers," she recalls. "It was magic, a spiritual fix. There was no limit to what one could do with photography. One could say anything. One could express beauty, ugliness, love, hate, war, serenity." Photography was immediate. "There was no need for a translator, sets, script or toe shoes."

Photography gave Eva "an option in life, a dose of reality, a chance to turn my pain into understanding and express it." In addition, it seemed a possible viable option as a way of making a living. A year after she "discovered" photography, Eva enrolled in a commercial course at the New York Institute of Photography, where one of her instructors encouraged her to pursue her personal work. She put together a body of portraiture and went to *Vogue* where she got her first commercial assignment.

Eva found, however, that she was really interested in photography that was an expression of herself. She found it difficult to work for other people; the compromise involved in looking through another's eyes that is often part of an assignment did not appeal to her or her sense that "every photograph you take is a self–portrait." Her preference for "real photography" was nurtured by publication in *Camera 35*, *Popular Photography*, and other photography magazines as well as numerous exhibits in America and Europe.

In 1974, Morgan & Morgan published a monograph titled simply *Eva Rubinstein*. The cover image, perhaps her most famous photograph, shows an unmade bed reflected in a mirror. It is at once simple and complex, evocative and haunting, stark yet romantic. Inside, there are 69 well reproduced photographs. The book sold out its initial print run of approximately 3,000 copies, but is not currently in print.

Eva comments about monographic photography books: "Once you have the title, you really can fit any kind of imagery in it. If the photographs are very personal and the title fits your point of view, the book amounts to a sort of cumulative self–portrait. While the content of a photograph is what is important to me, there must be form to serve the content. It is the same with a sonnet or with a book, where there is a formal structure but what we care about most is the content. While the wine is what is important, there must be a glass to hold the wine."

Today, Eva continues to exhibit and sell prints to collectors. Two books of her work are being published in Europe. Her cards and posters sell in the thousands. What kind of imagery does she find works as a card or poster? Although Rubinstein claims not to think about marketing when she shoots, she cites "vaguely romantic imagery, such as interiors or foggy landscapes," as the most successful.

Rubinstein's work — original photographic prints, books, cards and posters — is a rich reflection of this vibrant, warm and subtle human being.

❖

Interview: Joyce Tenneson

Photographer

"Doing something you really like is a privilege," states photographer Joyce Tenneson. "Of course, there are bad days. But it's such a great life compared to having a boring office job. When I am working and have a good day it is the most exciting thing imaginable, filled with magic and grace."

Tenneson's first publishing project was *INSIGHTS: Self–Portraits by Women* (David R. Godine, 1978). Tenneson dealt with the photographers, edited the imagery and wrote the introduction. In 1983 Godine published her monograph *Joyce Tenneson, Photographs*, and in 1989 Contrejour, a French publisher, brought out a monograph of her color work. Her books have all been modestly successful, but Tenneson does not feel that the book publication projects have had much impact on her career. Instead she credits her exposure in magazines with the widespread recognition of her imagery. However, she feels that a publication project is important because it "makes you confront what you've done so far and helps you move on to another level." She would like to do a new book which would be a sort of retrospective "containing a summary of my life."

A strikingly beautiful woman with unflinchingly clear eyes, Tenneson maintains a studio in the garment district of Manhattan. She has worked as a photographer for over twenty years. Initially, she supported her personal work by teaching at the college level in Washington, D.C. She has always been interested in people and loved to teach. "Intimacy is a natural way of life for me," she says. "People open up to me and I frequently have an ability to open new worlds to them."

However, she found teaching emotionally exhausting (today she turns down many workshop teaching positions) and in 1984 moved her studio to New York. Her intent was to generate enough commissioned assignments for magazines and advertising to support her personal work. She states, "I didn't go into commercial work to makes lots of money. Like teaching, it is another way to pay the rent. There is a great deal of gratification in feeling you can problem solve and keep your integrity at the same time. If you can find a niche that doesn't consume you and leaves you free to do your own work, it's great."Tenneson has been lucky. She has been successful obtaining work in the fields of fashion, beauty and portraiture. As we talked, she was interrupted by a call from her French agent discussing an assignment to do celebrity portraits at the Cannes film festival.

Tenneson's personal work, in color and black and white, centers on the human figure. Her work, she states, evolves as she evolves as a person. She is always pushing herself and asking: "Am I continuing to grow?" Despite her "full time job" as a commercial photographer, her massive lecture circuit schedule and her numerous exhibits, Tenneson is committed to taking the time she needs to develop as an artist. In fact, she spends about 80 percent of her time on her own work.

Tenneson's formula for success "is so simple as to be self–evident. Work from the deepest part of yourself," she urges. "Be self–critical. Push forward. Accept the responsibility to grow. Sooner or later it adds up." ❖

Interview: Marvin Heiferman

Book Creator

Marvin Heiferman has worked in the photography world as a curator and editor for over eighteen years. He edited Nan Goldin's *The Ballad of Sexual Dependency* (1989), co-authored with Diane Keaton *Still Life* (1983), a collection of early Hollywood color photographs, co-curated *Image World*, a 1989 exhibition at the Whitney Museum which traced the history of media influence on contemporary art; and curated *The Indomitable Spirit* (1990) an exhibition about aids which was accompanied by a fund–raising project and book. Heiferman is now collaborating with Carole Kismaric to create unconventional books. They then shop the books to trade publishers.

Heiferman's interest lies in the book form itself as a kind of populist art media and in how visual imagery relates to the "preoccupations that people have". His most recent project *I'm So Happy* (Vintage Books, 1990) is an inexpensive ($10.95 retail) paper bound visual narrative about the pursuit of happiness in the United States. The photography was found in stock agency files. As Lynda Barry said in her review of *I'm So Happy* in *The New York Times*," through photos culled from four decades of advertising and pop culture, Marvin Heiferman and Carole Kismaric put together a sort of goofy retroactive instruction manual documenting an impossibly cute American dream." In large part, the book is about how this imagery diverges from reality. Since this is a book of existing photography which has been edited from files, it becomes very clear the extent to which the act of editing is central to the creative act of photography.

Currently, Heiferman and Kismaric are planning to do more "unusual books which reach a visually literate, not art, audience. We didn't want *I'm So Happy* marketed as a photography or art book but rather as humor, an impulse buy, something one can hold in one's hand. In order to achieve this at a reasonable retail price, we were willing to compromise on certain production values."

Heiferman enjoys playing with the form of the book itself. He points to comic books and 1920s and 1930s graphics as important design influences. He feels that it is unfortunate that most photography books don't use photography to communicate, instead they isolate imagery as something apart from the huge stream of visual media in which our society is immersed. Heiferman suggests that anyone thinking of doing a photography book consider who is the book is for, what's the best way to get to these people, and are there enough of them around or are you willing to have only a few people "read" your book? ❖

Interview: Richard Dobbs

Book Buyer, The Museum of Modern Art Store

Richard Dobbs is the Book Buyer for the Museum of Modern Art store. A smiling man who wears glasses, he exudes an air of efficiency and a desire to be helpful. "Generally," he states,"book purchasing goes through me. I see the publisher's sales rep. I make decisions after consulting with the photo book librarian and appropriate curators. One factor is whether the artist is in our collection. If a book is put out by a reputable publisher, the artist is in our collection, and the reproductions are good, 99 percent of the time we will buy it, placing a fairly substantial initial order.

"We are not a normal trade bookstore. People come here specifically because of their interest in art and photography. The curatorial staff is encouraged to make suggestions – if they see a book they feel we should stock they call it to my attention. Many of our customers are just leaving the museum and have seen, for example, a Diane Arbus print and would like a Diane Arbus book. Others are very knowledgeable and scholarly.

"In addition to books that are current, we maintain a backlist," continues Dobbs. Robert Frank's *The Americans* consistently sells as a classic as does the Aperture Diane Arbus monograph and monographs of work by Walker Evans, Edward Muybridge, Edward Weston, Weegee, Joel Meyerowitz's *Cape Light*, Man Ray, Andre Kertesz, the Pantheon photo library, and Dover reprints. We are also doing well with Eggleston's *The Democratic Forest*, Aperture's "Writers on Artists" series, Nan Goldin's *Ballad of Sexual Dependency* and Ken Schles' *Invisible City*."

Dobbs notes that the average trade store faces some special problems carrying photography books. For example, people often want to browse through a copy. This means that if the store orders three copies they will have to write one off for display. Photography books tend to be the most browsed through and least purchased. The photography section, and, indeed, the entire art section is just not that important to a general bookstore as a whole. This results in limited shelf space for both classic and new-release photography books. Display presents another problem; to have the most impact, elegant books should be presented face–out. Most people will not buy art books when they are on the shelves spine–out unless they have come to the store with a particular book already in mind.

Dobbs concludes: "In general I am supportive of people publishing their own books or trying to get their photography published. I try not to be negative. But photographers should be aware that it is not an easy road to take, that there is serious competition, and that these books are so expensive to produce that you can't really expect to make money."

Interview: Benjamin Koo
Printing Broker

A printing broker serves as an intermediary between printers and customers. They often oversee complex productions, or supervise when the printer is geographically remote from the client.

Benjamin Koo, President of Book Art, Inc., was born in Shanghai, China. In 1974 he immigrated to Canada, and using his contacts with color separators and printers back in Hong Kong, started Book Art to broker printing services. All of his clients are book publishers, ranging in size from giants like Oxford University Press to small outfits such as Marcia Keegan's Clear Light Publishers. Koo currently operates out of Toronto but is planning to open a New York office soon.

Koo notes that the basic reason a book publisher goes overseas for printing is cost. A complete photography book — color separations, page making, proofing, printing and binding — will probably run about 25 percent less in Hong Kong than in the United States. Most of Koo's clients do not, in fact, go to Hong Kong to oversee production. Instead they rely on press proofs, second proofs (if necessary), Koo's supervision, and the printer's eye.

Finished books are shipped on export container ships. It takes about four weeks for them to reach the West Coast; advance copies are airmailed. There are no customs duties in the United States for books; however, a publisher will need to retain a customs broker to facilitate clearance. This will probably cost about $500.

Roughly, on a 5,000 run of a lavishly illustrated 96 page hardcover photography book the cost of printing will be about $6 per unit. Until a working relationship has been established, Koo expects advance payment to the Hong Kong suppliers by letter of credit.

Because advances in computer driven page making, desktop publishing and separating are rapidly driving down pre–press costs in the United States, the technically sophisticated publisher may take care of pre–production here rather than abroad. Koo's response is to concentrate on parts of the book production process which are very labor intensive such as binding and case making.

Benjamin Koo genuinely cares about his projects and clients. He wants to see his clients get their investment back, and feels that unless they have channels for marketing and distribution, photographers should probably re–think self–publishing. Artists may have their own ideas which are not actually marketable. Koo tries to save money for clients by changing specifications to match machine sizes. "Why waste?" he asks. "I like to see projects done properly and economically. Designers should be very careful: will the fancy (and expensive) flourishes actually help the project sell?"

❖

Focus: Aperture Foundation

In 1952 Dorothea Lange, Barbara Morgan, Beaumont and Nancy Newhall, and Minor White met at the San Francisco home of Ansel Adams to found an organization to "communicate with serious photographers and creative people everywhere." The result was the Aperture Foundation.

Today, Aperture Foundation sponsors a number of different kinds of photographic activities including publication of the Aperture periodical, books, and portfolios. The foundation also tours exhibitions, presents exhibitions at its own Burden Gallery in New York City, and maintains the Paul Strand Archive and Library.

Aperture is well known for its commitment to excellence in its publications both in terms of reproduction quality and in the importance of work it presents. Public relations material states:

> *Aperture has published more than 250 books on a broad range of subjects including monographs on individual photographers and publications on the history and nature of photography....From classic black and white masters to color avant–gardists, Aperture has presented the most significant photographers in unsurpassed publications over the last three decades. ...*
>
> *Very few of these books could have been produced by a commercial publisher because there was little financial gain. But, the profit motive is only one difference between Aperture and commercial printers. The other, more profound, is quality. Aperture uses the best inks, the finest papers and the truest printing techniques. When possible, in an effort to remain faithful to the original work, Aperture invites the artists themselves to supervise the actual printing. And the texts of Aperture publications are as carefully prepared as the images....[I]t is the only publisher that specializes in the field.*

Trade distribution of both the Aperture periodical and Aperture books is through Farrar, Straus and Giroux.

Charles Hagen, Editor of the Aperture periodical, notes that "photography is a bit paradoxical as a medium because it is both informational and aesthetic. It extends from the museum to the stock agency. Our mandate to serve our constituency – the community of serious photographers – allows us to present a variety of material from art to journalism. Our concern with quality production allows us to exploit the possibilities inherent in the marriage between photography and half–tone reproduction.

"A photographic book is different than a book of photographs. It is a wonderfully flexible, versatile form, a gathered sequence of pages. It can be a moving, informative sequence of well–made images. Many photographers don't fully understand the potential of the photographic book.

"Our books fall somewhere between artists' books, with their highly individual structure and conceptualization, and mass market books, which are done to formula."

The Foundation publishes about 20 new book titles a year covering a broad range of categories, including fine art monographs, books on social or environmental issues, historical works, books of criticism, and the Writers and Artists on Photography Series. Aperture staff is open to looking at all kinds of material but suggest studying their publications to understand what would fit into the Aperture list. Preparation of a quality dummy prior to presenting a project is probably a good idea.

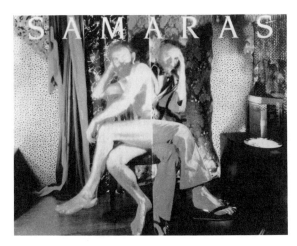

Courtesy of Aperture.

Susan Coliton, Development Director at Aperture, notes: "We produce photographic books of significance at the highest possible level. In general, with perhaps the exception of a few books like the Diane Arbus monograph, these books need subsidization. For example, the Paul Strand book we are doing in association with the National Gallery of Art has been underwritten by Southwestern Bell."

Classic monographs on the backlist – books by Edward Weston and Minor White, for example – continue to have an audience. Young, contemporary photographer's books generally don't make money for Aperture, but they are published thanks to Aperture's commitment to the importance of the medium. Royalties follow industry standards and advances are negotiable but not huge.

How does Aperture find the sponsors it needs to subsidize its lavish publishing projects? Coliton responds: "We re–invent the wheel each time. Sometimes a project comes in with a sponsor already committed, for example, the Strand project. Sometimes there is a natural and obvious sponsor as was the case with the National Park Service and our Ellis Island book. Sometimes the sponsor is an individual who is a supporter of the photographer involved. We also receive grants from State and Federal agencies and private foundations for specific projects and for operating costs."

Hagen notes that "we are here because we love photography and think we are publishing good books. I wish there were more Apertures because we can only do so much, and there are a lot of great books out there. This business is not a science, rather one we are trying to pursue with creativity and commitment down the line."

❖

Interview: Caroline Herter

Vice President, Simon & Schuster

Caroline A. Herter, Vice President and Director of Illustrated Projects at Simon & Schuster notes that almost all the projects she is involved with at Simon & Schuster are designed by outside producers. They are "a necessary and valuable source for houses that do not concentrate specifically on illustrated books, " she explains. "We simply do not have the time or resources to handle design, picture research and editorial services for heavily illustrated or complexly designed books."

Book projects come to Herter in three ways. Most often an outside producer or packager will submit a proposal, generally consisting of a dummy with sample layouts. This producer could be a foreign publisher who is proposing a buy–in arrangement. Most of the proposals Herter sees are not for purely photographic books.

Secondly, an agent may present a project. However, many agents are not particularly familiar with the special concerns of illustrated books. "Unless they know exactly how many images are involved, an approximate page count, whether it is in black and white, duotone, or color, and various other production specifics, and have considered scheduling issues, we may not be making the same design assumptions," says Herter. "This could have tremendous impact on production costs and our ability to do the book at all."

Finally, sometimes Simon & Schuster will commission projects. Herter notes a personal interest and commitment to photography. However, it is the subject matter, not the photography, that makes a project sell. Simon & Schuster's *Rolling Stone The Photographs*, a compilation of the best celebrity photographs from *Rolling Stone*, was a tremendous success with a first printing of over 100,000 copies.

Generally, before a decision is made to go ahead with an illustrated book, a thorough analysis of the production costs involved is made. Herter notes that on average Simon & Schuster publishes only about three straight photography books a year; however, the company publishes a huge number of illustrated trade books that make extensive use of photography. For example, in the *Encyclopedia of Interior Architectural Detail* one third of the illustrations are photographic; Kevin McCloud's *Decorative Style* contains 915 photographs.

Herter's advice: "Try to develop a saleable concept out of a body of work and be aware of scheduling, design, and production concerns before you submit."

❖

Interview: Paul Gottlieb

Publisher, Harry N. Abrams, Inc.

Paul Gottlieb is the President, Publisher and Editor–in–Chief of Harry N. Abrams, Inc. Abrams publishes approximately 125 books a year, roughly half of which are about visual arts. These include artist's monographs, museum catalogs and books about permanent museum collections.

According to Gottlieb, it is virtually impossible for an unknown photographer to get a monograph published. In the 1990 Abrams listings there is only one true monograph, *Ernst Haas Color Photography.* While the Haas book has sold extremely well (about 25,000 copies to date) it is an exception to the rule that monographs are not profitable.

Eventually, Gottlieb feels, "anything decent surfaces". If you are good, sooner or later you'll be discovered. In publishing, however, good photographs are not enough. "Books come out of obsessive interest" on the creator's part, and are supported with commitment and encouragement by the editor and publisher.

Courtesy of Harry N. Abrams, Inc.

Successful Abrams books that use a great deal of photography and are thematically linked to other topics of interest include: *Carnival in Venice,* by Shirley and David Bowen; *Stopping Time: The Photographs of Harold Edgerton; France From the Air* by Daniel Philippe and Colette Gouvion (and other books in this aerial photography series); *Honey Hunters of Nepal,* by Eric Valli and Diane Summers (anthropology by a National Geographic photographer); *The Indelible Image,* edited by Jane Livingston (co–published with the Corcoran Museum, it includes war imagery chosen for aesthetic rather than political reasons); and *The Indomitable Spirit.*

The single most successful photography book that Abrams has published is Richard Avedon's *In the American West.* When Avedon was recuperating from an illness on his Western ranch, he became interested in photographing hard–working ordinary people of the area — a radical departure from his celebrated fashion work. The book was coordinated with a series of museum exhibits. The museums ordered a total of 1,200 copies. Gottlieb was convinced that the "wonderful portraits were brilliant work" and ignored the miniscule quantity of advance orders. He took a substantial financial risk, opted for high production values and "said to hell with it, and printed 40,000." The book has sold over 100,000 copies to date.

Gottlieb suggests that anyone interested in submitting a book proposal should look at a lot of books and see who is doing what. When you're ready to actually approach a publisher, look up the names of editors in *Literary Market Place* and send a query letter offering to show samples. In terms of the actual presentation, remember that less is more. "If you are really good, and know how good you are, six pictures should be enough," says Gottlieb.

When asked about the future, Gottlieb notes that the technology of printing is improving week–to–week. He feels that photographers should realize that new computer media, such as CD–ROM[1], is on the verge of creating a huge need for imagery that will have to be supplied from somewhere; however, CD–ROM players or other gadgetry will never replace the "tactile thing that books have." ❖

[1] CD-ROM is an acronym for Compact Disk – Read Only Memory. It is a form of storage for digitized information that can be read by a PC and is suitable for reference works that contain illustrations or photographs such as encyclopedias. As the price of CD-ROM continues to decline, more and more "books" will be marketed in this media.

8

Design and Production:
How to put a Book Together from Conception through Printing

Good Design and What Actually Goes Into a Book

Good design is extremely important to any product, especially one as visual as a photography book. Do not neglect it. Study photography books that are well designed. Find out who designed them. Unless you have an extensive design background consider hiring someone to turn your ideas into layouts. Choose a designer who has experience with and is willing to oversee the actual printing production process. Do not, however, expect this service to be free. If you cannot afford to pay an expert to oversee production, learn all you can about the process. Study this chapter and note the suggestions in the Resource Section. Never be afraid to ask your printer questions. Do not accept results which appear inadequate to you at any step along the way unless you are presented with a very good reason.

As well-known book designer Eleanor Caponigro observes, the "effort of design" should stay in the background. Attention should not be directed to the design at the expense of the photography. "Keep it simple" is good advice. It is certainly more difficult to make serious and costly mistakes within a simple design framework. Almost anything that calls too much attention to the design without good reason should be avoided.

The elements of the photographic book are paper, ink, photographs, text, typography, some form of binding and a plan for putting it all together via the printing and production process. Printing is a complex blend of art, craft and business. Although it uses technology, it is not a science.

Katy Homans, a distinguished contemporary designer of photography books, observes that when book projects come to her the design is in varied states of completion. For example, Lee Friedlander presented her with what amounted to a very complete book dummy for *Like a One-Eyed Cat* (Abrams, 1989). Other projects have come to her as a box of loose prints without a unifying scheme.

Working with the publisher and/or artist, Homans establishes a format for each book. She sizes the pictures, and using sized photocopies of the photographs, indicates the placement of photos and type to the printer.

"Good design," Homans states, "does not in itself make a good book. For that you need good photography. Production standards, however, do make a big difference. Printing is getting better, although not cheaper. Typography, on the other hand, is getting cheaper, but not better."

There is a vast range in the quality of printing available and a wide variety of businesses that provide printing services. These businesses range from the neighborhood quick–print shop to large high–technology operations. It is important to find printer who is experienced with production at the level of quality you desire.

In addition to the elements of the photographic book listed above, there are some formalities that must be observed. For instance, information such as the copyright notice must appear on the copyright page (see page 118-119). If you wish to market the book, you will need an ISBN number which should appear on the back cover as well on the copyright page. See Chapter 10, "How to Self–Publish a Photography Book" for further detailed information.

The production process begins with planning. Make sure the printer or other producers are involved from the start. Next, we will consider how to work with photographs, from a design and reproduction perspective. Typography will be considered. Placement of imagery and type as well as methods for specifying placement and cropping will be discussed. Pre–press and proofing are the next topic. Moving towards the main event, paper, ink and coatings will be examined. Offset printing comes next. Finally, we need to look at different ways to bind a book. We conclude with the fulfillment process.

Planning

Someone must plan and coordinate the production process. The goal is to get the job done well, in time and on budget. Categories of professionals who handle print job coordination include: printers (there is a great deal of variation in how much design and pre–press work printers can effectively handle); printing brokers (a printing broker coordinates printing jobs and makes his profit by adding a markup to the cost of printing); and graphic designers. No matter who you hire, it is to your advantage to know as much about the production process as possible.

Some printers specialize in producing books. A sales rep will be serving as your liaison and coordinator with the production department at the printer. Try to make sure of this person's knowledge, integrity and willingness to do the necessary work.

Not only do printing brokers have a specialized knowledge of the printing industry, but also they may be buying printing services wholesale. It is possible that even with their commission you will pay less for the printing than you would on your own.

Design studios generally charge a flat fee. Variables include the complexity of the project, the reputation of the designer, and the schedule involved. The prices range for the design of a photography book, exclusive of expenses, is $1,000 to

$5,000. Expenses, including photostats and type, should be between $500 to $2,000 unless there is alot of text. Unless you have agreed otherwise, the designer's responsibility ends when you have accepted mechanicals. Therefore it will be up to you to make financial arrangements with a printer. However, it is important that the designer be in communication with the printer in case there are any equipment-specific requirements. You might want pay your designer an additional fee to oversee the entire production process.

As always, buyer beware. When working with graphic arts professionals, a personal referral from a satisfied customer is probably the best recommendation. Review work they have done before you make any decisions. Try to get agreements in writing (or at least to confirm any oral understandings in a letter). However, remember that you are contracting for a creative service. You are hiring a designer on the basis of their previous work and perhaps a distinctive style. If you do not like the style, perhaps you should not be working with that particular designer. Your input is valid. But do not attempt to change the designer's "look".

In any case, as publisher, the buck stops with you. It is your money that is being spent. You will need to pin point the production stages of the job and establish a schedule and responsibility for each stage. The Printing Job Organizer, adapted from *Getting It Printed* shows the production stages of a book printing job.

How many copies of the book should you have printed? The minimum practical offset run is about 2,000 copies. However, the longer the printing run, the lower the unit cost. Printing in larger quantities will save you money, but only if you use all of the copies. A book with a first run of 2,000 copies and a second run of 5,000 copies might have an average unit cost of $5.00. However, had it been printed in a 7,000 run the average unit cost might have been $4.20. Both paper and printing costs will continue to rise. It is less expensive to print today than tomorrow. On the other hand, if you print too many copies, you will end up having to "eat" your surplus. Also, there is a "cost of capital" involved in money tied up in inventory.

❖

Printing Job Organizer

Job Name _____ Coordinator _____ Date _____

Function	Person Responsible	Supplier
Write copy		
Edit copy		
Proofread copy		
Approve copy		
Make rough layout		
Approve rough layout		
Make comp and dummy		
Approve comp and dummy		
Choose typesetter		
Specify type and mark up copy		
Set type		
Proofread type		
Create illustrations		
Create charts, graphs, maps		
Create/select photographs		
Approve visual elements		
Miscellaneous camera work		

BOOK PRINTING JOB ORGANIZER – *page 1*
Courtesy Coast to Coast Books (adapted, with permission, from *Getting it Printed*)

Function	Person Responsible	Supplier
Choose production artist		
Paste up mechanicals		
Proofread mechanicals		
Approve mechanicals		
Choose/specify trade services		
Make halftones/separations		
Approve proofs of photographs		
Select paper		
Write printing specifications		
Select possible printers		
Obtain bids from printers		
Choose printer		
Contract with printer		
Approve proofs from printer		
Do printing		
Approve press sheets		
Do bindery work		
Verify job done per specifications		
Verify charges for alterations		
Verify mechanicals and art returned		
Pay printer and trade services		

BOOK PRINTING JOB ORGANIZER – *page 2*
Courtesy Coast to Coast Books (adapted, with permission, from *Getting it Printed*)

Probably the best advice, at least on an initial print run, is to be conservative. You can always go back to press if you need more. Even major trade publishers of photography books have difficulty in estimating optimum press run size and tend to limit their gamble by keeping quantities small.

It is important to determine your budget. For more discussion, see Chapter 9, "How to Self–Publish a Photography Book".

Look at how much money you have available. Note what comparable books are retailing for. While there is an element of circularity here (the concept of "comparable" itself implies production value decisions with impact on budget), the basic analysis, following the rule of thumb that unit production costs should be less than one sixth of retail, is that if you are publishing a $30.00 photography book, then you had better be able to bring it in for less than $5.00. If you are printing 2,000, this implies a budget of $10,000 total. This may not be possible, while if you run 5,000 copies, for a budget of $25,000, it might.

It is important to distinguish between fixed and variable costs when determining your budget. Fixed costs stay the same no matter how many copies are printed. They include writing, editing, photography, typography, design and pre–press work. Costs that vary with the number of copies printed include paper, press time, binding, finishing and fulfilling.

Printing quality varies tremendously. Some shops turn out superb books and others produce merely adequate work. In the middle are the shops that can do excellent work if they are motivated and compensated. Expect to pay more for superb quality. If you are not patronizing one of the handful of printing houses that specialize in world-class book making, be sure to communicate your expectations to the printer. As with any major project, get bids from at least three printing vendors.

When it comes to quality, the most important decision is your choice of printer. Word of mouth from knowledgeable people who work with printers – photographers, publishers and designers – is one good way to get referrals. The Resource Section lists a few domestic printers who are known for their quality photographic book printing. John Kremer's *Directory of Book, Catalog, And Magazine Printers* (see Resource Section) is also an excellent source of information.

Take a close look at any printing samples a prospective vendor shows you. The printer is trying to get your business; if they present you with work that is sloppy or less than first rate, watch out. It is appropriate to ask for names of previous customers for recommendations.

Consider the background of your printing broker or sales representative. Have they only worked in sales, or do they also have strong production experience? It is a plus to be working with someone who knows many aspects of the printing business. If your printing coordinator has worked for a publisher or owned a small business it's a good indication that he or she will understand your situation. You are looking for a long term relationship with this person. How much clout do they have with the printer? Will they be able to rush your job through the plant at some time in the future if you need it fast?

Be as professional a purchaser of printing as possible. Learn about the production

process. Do not hesitate to ask questions. Present formal Requests for Quotation and Purchase Orders. Get quotations for a range of quantities. Be business–like. Above all, provide clean and clear dummies, mechanicals and art for reproduction.

If you are a new customer, do not expect a printer to extend you credit. They will probably only do this if you have a substantial ongoing business with a verifiable trade credit history of purchases comparable in size to the printing job. Otherwise, standard terms for a first time printing job might be 1/3 down, 1/3 when going on press, and the balance on delivery.

Involve the printer as soon as you possibly can in the project. Part of the printer's job is to discuss possible projects with customers. As experts in the technology of printing, they may have good ideas on better or cheaper ways to produce your book. They might suggest changing the size slightly, for example, so you can get on a smaller press and thus save a great deal of money. Do not, however, alter your project substantially simply to fit the equipment characteristics of a particular printing shop. The fact that the shop happens to have a large quantity of some particular paper stock lying around is not a good basis for fundamental design decisions.

As with publishers, it is a good idea to show the printer a dummy. That way you'll be sure that you and the printer are talking about the same project. Feedback from the printer about your dummy can help clarify production specification issues, such as what stock to use.

On the next page you will find a Request for Quotation form, which is reproduced from *Getting it Printed*. It is a good idea to request and receive quotations in writing. (You will find definitions of terms used in the glossary).

Provide your printer with as much information as possible so he or she can give you an accurate quote. The Request for Quotation form will probably not be specific enough without an accompanying dummy and comments.

❖

Request for Quotation

Job name _____ Date _____

Contact person _____ Date quote needed _____

Business name _____ Date job to printer _____

Address _____ Date job needed _____

Phone _____ **Please give** ☐ firm quote ☐ rough estimate ☐ verbally ☐ in writing

This is a ☐ new job ☐ exact reprint ☐ reprint with changes _____

Quantity 1) _____ 2) _____ 3) _____ ☐ additional _____ s

Quality ☐ basic ☐ good ☐ premium ☐ showcase comments _____

Format product description _____

 flat trim size _____ x _____ folded/bound size _____ x _____

 # of pages _____ ☐ self cover ☐ plus cover

Design features ☐ bleeds ☐ screen tints # _____ ☐ reverses # _____ ☐ comp enclosed

Art ☐ camera-ready ☐ printer to typeset and paste up (manuscript and rough layout attached)

 ☐ plate-ready negatives with proofs to printer's specifications

 trade shop name and contact person _____

Mechanicals color breaks ☐ on acetate overlays ☐ shown on tissues # pieces separate line art _____

Halftones ☐ halftones # _____ ☐ duotones # _____

Separations ☐ from transparencies # _____ ☐ from reflective copy # _____ ☐ provided # _____

 finished sizes of separations _____

Proofs ☐ galley ☐ page ☐ blueline ☐ loose color ☐ composite color ☐ progressive

Paper weight name color finish grade

 cover _____

 inside _____

 _____ _____

 _____ _____

 ☐ send samples of paper ☐ make dummy buy paper from _____

REQUEST FOR QUOTATION – *page 1*
Courtesy Coast to Coast Books (adapted, with permission, from *Getting it Printed*).

Printing ink color(s)/varnish ink color(s)/varnish

cover side 1 _____ side 2 _____

inside side 1 _____ side 2 _____

_____ side 1 _____ side 2 _____

_____ side 1 _____ side 2 _____

Ink ☐ special color match ☐ special ink _____ ☐ need draw down

coverage is ☐ light ☐ moderate ☐ heavy ☐ see comp attached ☐ need press check

Other printing (die cut, emboss, foil stamp, engrave, thermograph, number, etc.) _____

Bindery

☐ deliver flat press sheets ☐ round corner ☐ pad ☐ Wire-O

☐ trim ☐ punch ☐ paste bind ☐ spiral bind

☐ collate or gather ☐ drill ☐ saddle stitch ☐ perfect bind

☐ plastic coat with _____ ☐ score/perforate ☐ side stitch ☐ case bind

☐ fold _____ ☐ plastic comb ☐ tip in _____

comments _____

Packing ☐ rubber band in # ____ s ☐ paper band in # ____ s ☐ shrink/paper wrap in # ____ s

☐ bulk in cartons/maximum weight ____ lbs ☐ skid pack ☐ other _____

Shipping ☐ customer pick up ☐ deliver to _____

☐ quote shipping costs separately ☐ send cheapest way ☐ other _____

Miscellaneous instructions _____

REQUEST FOR QUOTATION – *page 2*
Courtesy Coast to Coast Books (adapted, with permission, from *Getting it Printed*).

Working With Photographs

To achieve the best quality reproduction of photographs, you will want to work with a high quality "original".

There are three kinds of originals:

1. Black–and–white prints. Look for medium contrast semigloss prints with good shadow detail. Avoid textured paper (the texture may cause uneven reproduction). Make sure prints are clean and in focus. Unless otherwise specified, provide the printer with 8X10" prints along with cropping and scaling instructions as discussed below. On some occasions you'll want to create prints to exact size.

Handle prints with respect. Do not write on them, front or back. Use an overlay sheet for instructions.

2. Color transparencies. These are also known as chromes, color positives, and, most commonly, slides. Original transparencies will reproduce the best, although sometimes making a "reproduction duplicate" is justified. It makes sense to work from a dupe if the original is too valuable to be risked in the reproduction process, or if you have to color correct or re-touch the original. When you dupe an original, you run the risk of losing sharpness and encountering a slight color shift. However, if you invest in a high quality dupe, the loss of sharpness can be so minimal as to not be a problem. Ask for a 4X5" or 8X10" duplicate. That way corrections or improvements such as burning or dodging certain areas can be done in the duping process and the original will be safe from harm since only a duplicate will be in the hands of the separators and printers. A large format duplicate is also easier to look at and probably will get more attention than a 35mm slide. If you are working with repro dupes, be sure to use them for any precise layouts and cropping and scaling as they will differ slightly in size from the originals.

There are major disadvantages to using a dupe: a good-quality reproduction duplicate adds a step to the production process, takes time to make, and costs $50 to $100. Depending on the number of reproductions in your book, duping fees could add up to a substantial expense that is better off avoided.

When you are checking transparencies or "reflected copy" (non–transparent art such as prints, proofs, and actual press work) for color correction, look at them under standardized light conditions so you can accurately compare results. When you are using a light table, make sure that it is equipped with bulbs rated at 5000 degrees Kelvin.

Beware of judging slides by how they appear projected, as they will always seem much brighter when light is passing through them. This is also true of transparent art viewed on a light table. Resulting reflected reproductions will never appear as bright as transparencies.

In general, slower color films have a denser grain structure and therefore lead to sharper reproductions. Kodachrome probably gives the sharpest results of any of the available 35mm transparency film stocks. For color imagery that will reproduce

well, look for sharp images with no visible grain patterns, strong saturated life–like colors, and details in shadow areas. Make sure the transparency is free of scratches, blemishes or dirt.

Color transparencies should be treated with a great deal of care and respect. Do not leave them for too long on a light table. Pack them well and place them in clear protective sleeves when delivering them to printers or other vendors. Identification numbers for correlation with mechanicals and scaling and cropping information should not be written directly on the slide – either put it on the slide mount or include a keyed–in chart. However, put your name or project title on every transparency mount in case one gets separated from the rest.

3. Color prints. Color prints are made from color negative films, such as Kodacolor and Fujicolor. Since prints are one generation removed from the original, they are inherently less desirable for reproduction. However, sometimes it is desirable to reproduce from a color print for aesthetic reasons or to create a special effect. In this case, the print must be unmounted (so that it will wrap around a scanner cylinder) and smaller than 11X14".

Black-and-white Reproduction Process

Quality offset reproduction of black-and-white photography is accomplished in three basic ways. In the first two, a process camera together with a "line screen" is used to create a halftone negative from the continuous tone photographic print. (A halftone is a black-and-white photograph converted into a dot pattern. Plates are made from the halftone negatives.) When the resulting halftones are magnified, the dot pattern becomes visible. The fineness of the line screen (which is expressed in lines per inch) has a big impact on the quality of printing. The range for a quality photographic project is 150 to 300 lines per inch. Consult with your graphic arts professional to determine the appropriate line screen, taking into consideration equipment, paper stock, and other factors.

Halftone reproduction entails making a plate from one line–screened halftone. A duotone entails making plates from two line–screened halftones and printing them in register. The two plates could both be black ("double dot printing"), black and another color such as sepia, or two distinct colors. Fake duotone involves printing a sold tint of color beneath a halftone. True duotone appears much richer and more satisfying than single halftone printing. It is more costly because it requires precise stripping and press work (and, possibly, an extra printing pass).

Another option is to scan a back-and-white print as though it were color and create separation film (color halftone separations are referred to simply as separations). The resulting halftones can then be used to create plates which then can be printed in duotone or tritone. This is a superb process which can produce excellent results.

Color Reproduction Process

The primary method for reproducing color photographs is with four–color process halftone separations, which are referred to simply as separations. These are created with a laser scanner.

In theory, the color waves are broken down into their component parts. Think of a choir performing a musical score. The audience "hears" the blend, not the soprano or bass line. Chromogenic color film (i.e., slide film) consists of dye layers of primary colors. These layers of dyes are transposed into screened halftones. However, not all perceived colors actually reproduce in four–color process. It is sometimes necessary to add additional color passes on the printing press to achieve the illusion of verisimilitude, or some other color effect that is desired.

Today, almost all four–color separations are created on scanners. Prior to 1980, a process camera was used to create four halftone line screens. Each of the four exposures was then filtered to remove all but the desired color. For example, to create the yellow plate, cyan, magenta and black were filtered out. The resulting four separation negatives were used to make plates. By combining the plates and printing in register using the appropriate process ink color, four–color process was achieved.

Today's methods still involve the creation of four separation negatives. The best contemporary technique involves placing the color transparency on the drum of a laser scanner. Imagery must be cropped and scaled before it is placed on the scanner so the separator knows what percentage blow–up to make.

The scanner projects pinpoints of light through the transparency and creates a digital version of four–color process halftones for each of the three primary colors, designated yellow (Y), cyan (C) and magenta (M), and a black (B) halftone. The scanned information is stored as a digital computer file. This computer file can then be electronically manipulated, enhanced, or re–touched. The file can be output as screened halftone separation films from which plates are produced for each of the halftone screen films. The combination of the colors in register will produce four-color process color. The film is used to generate color proofs. These "loose proofs" (they have not yet been assembled with type and other design elements) appear on a plastic stock and are usually referred to as "Cromalins" or "Matchprints".

When viewing proofs, remember that color is subjective. It is affected by cultural relativism and above all is a matter of individual taste. Some colors that Americans like tend to be regarded as garish by the Japanese. Make sure to view proofs under standard light conditions as discussed above. When you compare proofs to original art, do so under the same standard lighting conditions. That way you won't be comparing apples to oranges. You will probably have to correct first proofs. Your printer or separation house expects this. Don't worry if you don't know the technical terms for what you want. Just tell the separator or printer, "This looks too red" and let them worry about what the correction should be. Look for small problems in the separations such as hairs, dirt and dots. While these may just be on the surface of the proof, alert the separator or printer to the possible problem.

Whether your printer is making the separations (and he may have contracted them out), or you are working directly with a separation house and plan to deliver the finished film to your printer, there is an issue as to who owns the separation films.

The general trade practice seems to be that when you contract for the separations with a trade house and provide them to the printer, you own them. However, I would get this in writing from your printer. Personally I would take this a step further and avoid a printer who claimed ownership over separations created at my expense, even though the printer was the creator. However, I wouldn't hesitate to store my separation film at my printer's, provided the printer appears stable and reliable and has good storage conditions.

Color separation houses can be found via word of mouth from your graphic arts contacts, in the yellow pages, at trade shows and in trade publications.

Unfortunately, the possibility of damage to your materials always exists. Unlike stock photography customers, who will generally sign Delivery Memo outlining damage and valuation provisions, most printers will not. Furthermore, printers' standard contracts usually strictly limit their liability for customer's materials. Regardless of the etiology of the problem, what steps can you take? When possible, protect yourself by using reproduction duplicates. This may not be feasible. But never give your only copy of a valuable original to a separator or printer without being aware of the possibility of uncompensated loss or damage.

Let the printer know about your concerns. If possible, negotiate a written agreement in which makes your vendor financially responsible in the event of loss or damage of original artwork. Package your material in a way that protects it and demonstrates that you value it. Examine originals immediately upon their return for any indications of damage. You might want to consider taking out special insurance to protect yourself financially.

❖

Request for Quotation

Job name __Beyond Reality__ Date __2/1/91__

Contact person __Joe Photographer__ Date quote needed __ASAP__

Business name __Wonderful Self Publishing, Inc.__ Date job to printer __2/15__

Address __Main Street Nowhere, NH 00000__ Date job needed __3/15__

Phone __212-976-6969__ **Please give** ☒ firm quote ☐ rough estimate ☐ verbally ☐ in writing

This is a ☒ new job ☐ exact reprint ☐ reprint with changes _____

Quantity 1) __1,000__ 2) __2,000__ 3) __5,000__ ☐ additional _____ s

Quality ☐ basic ☐ good ☒ premium ☐ showcase comments _____

Format product description __Photography Book_____

 flat trim size _____ x _____ folded/bound size __8-1/2__ x __11__

 # of pages __160__ ☐ self cover ☒ plus cover

Design features ☐ bleeds ☐ screen tints # ____ ☐ reverses # ____ ☒ comp enclosed

Art ☒ camera-ready ☐ printer to typeset and paste up (manuscript and rough layout attached)

 ☐ plate-ready negatives with proofs to printer's specifications

 trade shop name and contact person _____

Mechanicals color breaks ☒ on acetate overlays ☐ shown on tissues # pieces separate line art ____

Halftones ☐ halftones # __80__ ☐ duotones # ____

Separations ☒ from transparencies # __1__ ☐ from reflective copy # ____ ☐ provided # ____

 finished sizes of separations __8-1/2 x 11_____

Proofs ☐ galley ☐ page ☒ blueline ☒ loose color ☐ composite color ☐ progressive

Paper	weight	name	color	finish	grade
cover	10pt	Carolina C1S	White		
inside	80#	LOE Dull	White		

 ☒ send samples of paper ☐ make dummy buy paper from _____

COMPLETED REQUEST FOR QUOTATION FOR PHOTOGRAPHY BOOK
Page 1 – Courtesy The John D. Lucas Printing Company

Printing ink color(s)/varnish ink color(s)/varnish

cover side 1 <u>4C Process + film lamination</u> side 2 _____

inside side 1 <u>Black ink throughout</u> side 2 _____

_____ side 1 _____ side 2 _____

_____ side 1 _____ side 2 _____

Ink ☐ special color match ☐ special ink _____ ☐ need draw down

coverage is ☐ light ☒ moderate ☐ heavy ☐ see comp attached ☒ need press check

Other printing (die cut, emboss, foil stamp, engrave, thermograph, number, etc.) _____

Bindery

☐ deliver flat press sheets ☐ round corner ☐ pad ☐ Wire-O

☐ trim ☐ punch ☐ paste bind ☐ spiral bind

☐ collate or gather ☐ drill ☐ saddle stitch ☒ perfect bind

☐ plastic coat with _____ ☐ score/perforate ☐ side stitch ☐ case bind

☐ fold _____ ☐ plastic comb ☐ tip in _____

comments <u>Add'l to Smyth Sew with glue on cover</u> _____

Packing ☐ rubber band in # ____ s ☐ paper band in # ____ s ☐ shrink/paper wrap in # ____ s

☒ bulk in cartons/maximum weight <u>45</u> lbs ☐ skid pack ☐ other _____

Shipping ☒ customer pick up ☐ deliver to _____

☐ quote shipping costs separately ☒ send cheapest way ☐ other _____

Miscellaneous instructions _____

COMPLETED REQUEST FOR QUOTATION FOR PHOTOGRAPHY BOOK
Page 2 – Courtesy The John D. Lucas Printing Company

The John D. Lucas Printing Company

Joe Photographer
Wonderful Self Publishing Co.
Main Street
Now Here, NH 00000

We are pleased to offer the following specifications and price:

DESCRIPTION: Beyond Reality

QUANTITY: 1000

SIZE: 8-1/2" x 11"

PAGES: 160 pages + cover

STOCK:
Inside 80# Loe Dull
 Cover 10Pt Carolina C1S

 INK:
Inside Black ink throughout
 Cover 4 Color process + film lamination (4-0-0-4)

BINDING: Notch perfect

COMPOSITION: None

PROOFS: Book blues

ARTWORK: Line mechanicals

ILLUSTRATIONS: 80 - 175 line screen halftones

PACKAGING: Bulk cartons

F.O.B. BALTIMORE:
 PRICE:

 1000 @ $7879.00 Add'l Smyth sew w/glue on
 2000 @ $9812.00 cover 1000 @ $563,
 5000 @ $15,611.00 2000 @ $853, 5000 @ $1724

Acceptance of order is based on availability of paper and price prevailing at time of delivery.
Please see reverse side for Printing Trade Customs.

Very truly yours,

Ron Pramschufer

1820 Portal Street / Baltimore, Maryland 21224 / Phones: Baltimore: (301) 633-4200 / Maryland: 800-492-2158 / Outside Maryland: 800-638-2850

New York Sales Office: 421 Seventh Avenue / New York, N.Y. 10001 / (212) 947-6006

1. QUOTATION, PHOTOGRAPHY BOOK, ONE COLOR – B&W
Courtesy of The John D. Lucas Printing Company

The John D. Lucas Printing Company

QUOTATION

Date <u>February 1, 1991</u>
RON45

Joe Photographer
Wonderful Self Publishing Co.
Main Street
Now Here, NH 00000

We are pleased to offer the following specifications and price:

DESCRIPTION:	Beyond Reality
QUANTITY:	1000
SIZE:	8-1/2" x 11"
PAGES:	160 pages + cover
STOCK:	
Inside	80# Loe Dull
Cover	10Pt Carolina C1S
INK:	
Inside	Black +1 PMS (throughout)
Cover	4 Color process + film lamination (4-0-0-4)
BINDING:	Notch perfect
COMPOSITION:	None
PROOFS:	Book blues
ARTWORK:	Line mechanicals
ILLUSTRATIONS:	80 - 175 line screen duo-tones
PACKAGING:	Bulk cartons

F.O.B. BALTIMORE:

```
              PRICE:
              1000  @  $11,933.00    Add'l Smyth sew w/glue on
              2000  @  $13,896.00    cover 1000 @ $563,
              5000  @  $19,788.00    2000 @ $853, 5000 @ $1724
```

Acceptance of order is based on availability of paper and price prevailing at time of delivery.
Please see reverse side for Printing Trade Customs.

Very truly yours,

Ron Pramschufer

1820 Portal Street / Baltimore, Maryland 21224 / Phones: Baltimore: (301) 633-4200 / Maryland: 800-492-2158 / Outside Maryland: 800-638-2850

New York Sales Office: 421 Seventh Avenue / New York, N.Y. 10001 / (212) 947-6006

2. QUOTATION, PHOTOGRAPHY BOOK, TWO COLOR – DUOTONE
Courtesy of The John D. Lucas Printing Company

The John D. Lucas Printing Company

Joe Photographer
Wonderful Self Publishing Co.
Main Street
Now Here, NH 00000

We are pleased to offer the following specifications and price:

DESCRIPTION: Beyond Reality

QUANTITY: 1000

SIZE: 8-1/2" x 11"

PAGES: 160 pages + cover

STOCK:
Inside 80# Loe Dull
 Cover 10Pt Carolina C1S

INK:
Inside Four color process (throughout)
 Cover 4 Color process + film lamination (4-0-0-4)

BINDING: Notch perfect

COMPOSITION: None

PROOFS: Book blues, Cromalins proofs of color

ARTWORK: Line mechanicals

ILLUSTRATIONS: 80 - 175 line screen color seps. (6x9 average size)

PACKAGING: Bulk cartons

F.O.B. BALTIMORE:
 PRICE:

 1000 @ $32,162.00 Add'l Smyth sew w/glue on
 2000 @ $34,158.00 cover 1000 @ $563,
 5000 @ $40,149.00 2000 @ $853, 5000 @ $1724

Acceptance of order is based on availability of paper and price prevailing at time of delivery.
Please see reverse side for Printing Trade Customs.

Very truly yours,

Ron Pramschufer

1820 Portal Street / Baltimore, Maryland 21224 / Phones: Baltimore: (301) 633-4200 / Maryland: 800-492-2158 / Outside Maryland: 800-638-2850

New York Sales Office: 421 Seventh Avenue / New York, N.Y. 10001 / (212) 947-6006

3. QUOTATION, PHOTOGRAPHY BOOK, FOUR-COLOR PROCESS
Courtesy of The John D. Lucas Printing Company

These estimates are for a standard photograph book job in either one color black and white, duotone black and white, or four color.

Typography

The wonderful world of type is a subject that could fill many books (some are referenced in the Resource Section). There are aesthetic, technical and financial issues involved. Basically, as a producer of photography books, you need to know how to specify type size and styles and how to get the type from manuscript to printer. There are an infinite number of type faces. Each conveys a different tone. When you combine a typeface with the different sizes available, you can get almost any effect you desire.

Type that is meant for the text of a book, or "body" type, should be set in a face that is pleasant to read, in an appropriate size for reading, and have plenty of white space between lines (leading). For example, the body text of this book is set in 11 point Palatino with 13.4 point leading. Headers are set in 14 point Palatino Bold.

Typefaces are either serif or san serif (without serifs). Serifs are the short cross–lines at the end of the long strokes of letters. In general, a type face with serifs works best for books. The serifs make type easier to read by leading the eye from one character to another. A font is a complete assortment of type of one size and face, containing all the letters, numbers, and characters needed for ordinary composition. Examples are ITC Garamond Light Italic 12 point, Helvetica Bold Extended 14 point, and Times Roman 8 point. Many type families include a great number a variants, far more than would be appropriate for use in a single project. For example, the ITC Garamond type family includes 16 faces.

ITC GARAMOND LIGHT

ITC GARAMOND LIGHT ITALIC

ITC GARAMOND BOOK

ITC GARAMOND BOOK ITALIC

ITC GARAMOND BOLD

ITC GARAMOND BOLD ITALIC

ITC GARAMOND ULTRA

ITC GARAMOND ULTRA ITALIC

ITC GARAMOND BOOK CONDENSED

ITC GARAMOND BOOK CONDENSED ITALIC

ITC GARAMOND BOLD CONDENSED

ITC GARAMOND BOLD CONDENSED ITALIC

ITC Garamond font family set at 14 points.

The typographer's standards of measurement are the point and the pica. There are about 72 points to the inch and 12 points to a pica. Point size for a given font is measured from the bottom of the deepest descender, for example the foot of the letter "p", to the top of the highest ascender, e.g, "h". Point size does not always give an accurate impression of the size of most lower case letters used. X height, or the ratio of size of lower case letters, to point size varies significantly from one type face to another.

The white space between lines is termed leading. It, too, is specified in points. The leading is generally two points greater than the font size and is indicated with a slash following the font size. For example, 10/12 means 10 point type with 12 point leading.

One of the best ways to learn about type faces is from typesetters' catalogs (generally available free of charge). These show the type faces the vendor carries. (You will probably want to contact a number of vendors in any case to get competitive bids and see who is best to work with.)

An important distinction is made between "display" type and "body" type. "Body" type is used in the text of a work and is generally 14 point or less. "Display" type is defined as type larger than 14 points. It is generally used on the cover and for headers. Some creators of photography books place such a high value on display faces that they will go to great lengths to obtain special fonts. For example, Maria Morris Hambourg, when working on the *New Vision* project described later in this chapter, sought and obtained the original Futura display font from Barcelona to match the feeling of the era of the photography in the book.

Your book will be coherent visually if you keep the body type, headers, and display type in the same family.

Typographers can set type on a laser printer or on a linotronic machine. Resolution of type on a laser printer ranges from 200 to 1200 dots per inch (dpi) while higher quality linotronic type resolves at about 2400 dpi. The cost difference is substantial for a book. A page set on a laser printer costs from $1 to $2; a page set on a linotronic machine costs from $5 to $10. It takes careful scrutiny to tell the difference between 1200 dpi laser and linotronic typesetting.

The way to go depends on your project and your budget. Laser type is certainly sufficient for newsletters. An art photography book, which has few pages of text, should be set linotronically. A book that has a substantial amount of text could be set either way depending on aesthetics and your budget.

If you decide to use laser type, you can produce type that appears sharper by having it set 20 percent oversize. Then ask the printer to reduce the page.

LASER TYPE	LINO TYPE
Laser versus Lino	Laser versus Lino
LASER VERSUS LINO	LASER VERSUS LINO

Comparison of laser and linotronic type.

Typography

Words express meaning in which to get a point across. To convey this meaning with feeling, typography comes in to play. Each font can express a different mood or feeling to adapt to that particular expression. The designer can enhance your concepts by usage of fonts. To give insight on the basic tools, below is a list of typographical terms.

Ascender — The part of a lowercase letter above the x-height.
Baseline — The line on which the characters appear to stand.
Characters — Individual letters, figures and punctuation marks.
Counter — The enclosed or hollow part of a letter.
Descender — The part of a lowercase letter that falls below the baseline.
Font — A complete alphabet: one typeface in one size.
Italic — A type in which the forms slant to the right.
Justify — To set a line to a desired measure.
Kerning — The manipulation of inter-character spacing to achieve more asthetically pleasing visual spacing.
Leading — The spacing between lines (measured in points).
Letterspacing — The space between the letters in a word.
Lowercase letters (l.c.) — The small letters.
Picas — A unit used to measure the length of a line of type. One pica (0.166″) consists of 12 points and six picas (72pt.) equal approx. one inch.

Point — Used to measure the typesize–from the top of the ascender to the bottom of the descender plus space above and below to prevent the lines of type from touching. The point (0.1383″) is the basic unit of printer's measurement.
Ragged right, ragged left — Unjustified type that is allowed to run to various line lengths.
Roman — A type in which all the letters are upright.
Sans serif — A typeface without serifs.
Serif — The short strokes that project from the ends of the main body strokes of a typeface.
Typeface — A specific design for a type alphabet.
Type family — All the styles and sizes of a given type.
Word spacing — The spacing between words in a line.
Uppercase letters (U.C. or C.) — The Capital Letters or CAPS.
x-height — The height of the lowercase x in a given typeface.

Three commonly used faces shown in various point and lead sizes.

ITC Garamond Book

9/10
> If I am not for myself, who is for me?
> If I am only for myself, what am I
> If not now when?
> -Hillel

10/11
> If I am not for myself, who is for me?
> If I am only for myself, what am I
> If not now when?
> -Hillel

11/12
> If I am not for myself, who is for me?
> If I am only for myself, what am I
> If not now when?
> -Hillel

Helvetica Regular

9/10
> If I am not for myself, who is for me?
> If I am only for myself, what am I
> If not now when?
> -Hillel

10/11
> If I am not for myself, who is for me?
> If I am only for myself, what am I
> If not now when?
> -Hillel

11/12
> If I am not for myself, who is for me?
> If I am only for myself, what am I
> If not now when?
> -Hillel

Times Roman

9/10
> If I am not for myself, who is for me?
> If I am only for myself, what am I
> If not now when?
> -Hillel

10/11
> If I am not for myself, who is for me?
> If I am only for myself, what am I
> If not now when?
> -Hillel

11/12
> If I am not for myself, who is for me?
> If I am only for myself, what am I
> If not now when?
> -Hillel

VARIOUS TYPEFACES:

Americana	**ITC Bauhaus Heavy**	ITC New Baskerville	Bodoni Book	Caledonia
ITC Century Book	**Cooper Black**	**Futura Bold Condensed**	Garamond #3	Gills Sans
Helvetica Regular	ITC Korinna	Melior	Optima	Palatino
ITC Serif Gothic	ITC Tiffany Medium	Times Roman	Trade Gothic	**Walbaum Bold**

There are three ways to have type set.

1. Give the typesetter hard copy, e.g., a typed double–spaced manuscript with penciled type specs (instructions). Refer to style and other reference works listed in the Resource Section for information on symbols used to indicate typesetting instructions and how to mark–up a manuscript. (You can also ask your typesetter for instructions.)

The advantage to giving the typesetter hard copy is that it affords the least chance of technology–related errors. Typesetters effect their typographic decisions by inputting computer codes and formatting instructions. When they work with hard copy, they can input the codes as they enter the text. There is a financial disadvantage however. Costs are greatly increased because the typesetter has to physically input the manuscript. There is also a greater possibility of errors being input along with the text.

2. Probably the best option is to give the typesetter a word processing file on a disk (electronic transfer by modem is also possible) along with hard copy indicating type instructions. (Typesetters should have no problem converting standard word processing files such as Wordperfect, but if you are using obscure software you may have to convert your file to ASCII.) Not only will you save the cost of re–keyboarding the material, you'll also make the typesetter's job easier. If you wish, display, caption and header copy can be submitted separately on paper. Most type shops can also make borders, lines, graphs, and charts to your specifications.

3. If you are equipped with a heavy duty desktop publishing program such as Pagemaker, Ventura, or Quark, you can set the entire manuscript, output a laser copy for corrections, and send a disk to a service bureau for final setting on their linotronic or high dpi laser equipment. This is the least expensive option but it requires considerable expertise and equipment. In most cases it would probably be wiser to limit yourself to visual and editorial concerns.

Expect to make text corrections on a photocopy of the galley proofs. But do examine the actual type output for clarity and density of type. Make sure corrections have actually been made. Check that lines of text are straight, that bodies of text have been evenly justified, and that characters are unbroken and without flaws.

The earlier in the production process that an error is spotted, the less expensive corrections will be. Stopping the press to fix something is much more expensive than changing a mechanical.

Preparing Camera–Ready Material

Along with the black–and–white and color photographic material you will have to give the printer a camera–ready mechanical or "mechanical". A mechanical is a

flat sheet, often mounted on cardboard, that serves as a map for the printer. It lets the the printer know the precise placement and cropping of the photographs. It indicates the percentage blow–up or reduction of the original material ("scaling"). Percentage enlargement or reduction is determined proportionally by drawing the diagonal of the rectangles involved. Positioning of body type, captions, headers, and lines are indicated.

The usual system is to paste–up this material on mechanical boards positioning the actual type and line art for the camera. These boards include registration and crop marks. Scaling, positioning and cropping of photography is indicated by placing a substitute for the photograph and keying it by a number or letter to the original art. Keylines, prepared by your typesetter or mechanical artist, can be used, but it is a better idea to use sized and cropped photostats or xeroxes. This gives you a chance to view the project with the photograph in position. Each position copy should have a piece of white tape across it with the number of the original art that goes with it and the notation "for position only" or "fpo". The corresponding art should be marked (on a tissue overlay for black & white prints and on the protective sleeves for color transparencies) with its identifying number, percentage enlargement, and cropping indications.

The actual preparation of mechanical boards is a craft that requires experience, dexterity and skill. It generally pays to hire a production artist (if you are working with a designer, this will be the designer's responsibility). Make sure that you understand everything on the resulting mechanicals and that they appear clean and professional.

A process camera (a camera with very flat depth of field) is used to shoot line art and typography. The negatives will then be stripped together with halftones or separations to create the flats from which printing plates are made. The high contrast graphic arts film used in the camera records only black or white: light gray becomes white and dark gray becomes black. Since the process camera has so little depth of field, mechanicals need to be absolutely flat to insure sharpness. Generally, printers will have their own process camera, but they might send material out to a trade shop.

An alternative to creating mechanicals by hand is computer page assembly. You design the pages, and the computer generates the mechanicals. This works only when you have a limited number of choices for the position of photographs and blocks of text. Basically, you will establish a grid pattern as a reference and then enter co–ordinates into the computer. The computer then outputs on paper a kind of a mechanical. Another option is to electronically generate standardized text blocks and the like and manually add such items as display type and for-position-only copies of photographs. Finally, if you are setting your type from a computer file, investigate the possibility of having your typesetter do the mechanicals for standardized body text based on your specifications. If the typesetter is set up to do this kind of thing, they can also generate lines to size to indicate the positioning of photographs.

The bottom line is that the mechanical is a communication tool, a map, used to show how you want your job done. There is no one right way to create the mechanical, but it must communicate with clarity and precision.

Pre–Press and Proofing

Negatives from the process camera and scanners must be assembled prior to printing. This process is called "stripping" and the resulting assembly, from which a single printing plate is made, is called a "flat".

In addition to checking negatives for flaws such as pinholes and scratches (which once found will be opaqued out), strippers are responsible for imposition – arranging the negatives in flats. Accuracy of imposition is complex and makes clear the need for mechanicals and dummies that communicate well. Check flats against a "blueline" proof which is a monochromatic photographic contact print of a flat. Bluelines can be folded and bound together in book form so that page sequencing and referencing can be checked.

In most cases color reproductions will have been proofed and corrected at an earlier stage as loose Color Keys, Cromalins or Matchprints. Another kind of proof is the "press proof", which will probably have been provided by the vendor who is handling separation services. Press proofs are actual inked sheets of paper run through a press that is used for proofing only. Of all the kinds of proofs, they will give you the best idea of what the final reproduction will look like. Press proofs are expensive and time–consuming and, considering the increasingly high quality of other proofing systems, generally not necessary. When you are printing abroad, however, often press proofs are provided at little additional cost to help ensure a satisfactory job.

Proofs should be checked very carefully at every step of the production process. As observed above, the earlier a mistake or change is noted, the less expensive it will be to fix. Do not hesitate to ask questions or simply say, "This looks wrong."

Although proofs will give you an idea of the finished product, you will not know exactly what the job will look like until actual sheets start to come off the press.

Negatives and flats are valuable property. You'll want to store them safely in case sales justify reprinting your book. Make sure that the printer puts it is writing that you own the materials. Provided that your ownership is accepted, storing the flats at the printer is probably a good idea (if the printer has a clean, dry, and organized storage area for them). Most printers that specialize in books have a storage space set up and will be able to reprint editions quickly.

Paper, Ink and Coatings

Paper, also known as stock, represents a very substantial portion of variable publication costs. (Over time, the price of paper only seems to rise as the world's forests disappear.) Specify and purchase paper stock with knowledge and care. It is important to be familiar with paper and the size sheets it comes in to create an effective and economical design.

While stock does represent a large percentage of production expenses, it may be the one area where a small incremental increase in your investment produces the

largest noticeable improvement in the quality of your project. Don't be penny wise and pound foolish. If at all possible, use good paper. A few of the quality sheets suitable for photographic offset reproduction are Warren Lustro (LOE) and Mohawk Superfine. Both are premium sheets. LOE comes in a gloss or dull version. Mohawk Superfine is an uncoated stock.

Printing papers come in a number of different grades ranking from #5, which is used primarily as magazine stock, to Super Premium, which is used in the best quality books, annual reports, as well as for prestige projects. For practical purposes, most readers of this book will want to use a middle-grade sheet. The appropriate ones for a quality photography book are most likely "coated book" and "cover", or high quality non–coated such as Mohawk Superfine. Each sheet will give a different effect. Printed samples are available from your paper broker or your printer. Paper thickness, or "bulk", is expressed in pages per inch. You'll need to know the width and length of your book to specify type size for the book spine.

Paper is uncoated, or treated with a coating. Coated paper is either matte or gloss in finish. Because coated paper does not absorb ink the way uncoated paper does, photographs printed on coated paper appear sharp as the dot edges from the halftones remain crisp. Photographs printed on uncoated paper tend to seem softer. Paper also comes in different shades of white. View samples carefully. You will probably want to use a coated book paper for your book's inside pages and, if it's a trade paperback, a coated cover stock for the outside. The cover may be further treated with lamination, as discussed below.

Paper prices are quoted by weight, generally per a 100 pounds ("CWT"), or per 1000 sheets. Paper mills sell exclusively to distributors, which can provide you with samples, swatch books, and blank assembled dummies bound in book form from a given stock.

You probably will have the choice of buying paper directly from a paper distributor or buying it through your printer. Once you know the quantity and kind of paper you want to specify, it is a good idea to do some comparison shopping. Although the printer will mark up the cost, they will take responsibility if there is anything wrong with the paper. This is a form of insurance. If you purchase the paper yourself, make sure you buy enough to cover spoilage (sheets used during makeready, setting up the press, and in binding). If you buy paper with flaws, or do not buy enough, your printer is not responsible. You may also be responsible for the cost of down press time if the printer cannot work due to flawed paper. On the whole, if the printer's markup is reasonable, you are wise to let go of the responsibility.

In addition to the process inks (cyan, yellow, and magenta, and black) you may need to mix ink to match a specific color. For instance, large colored display type that is against a white background will generally not appear sharp if reproduced in four–color process. (This frequently comes up in the production of art posters.) The solution is to mix a special ink to the value and hue that you require (having created a plate just for the imprint of this color). If your job were four-color, and you added a mixed ink in this fashion, it would be referred to as "a five color" job. Each color you add represents a substantial additional expense.

Specification and communication about mixed ink is done via a color matching system. The most common one was developed by Pantone, Inc. and is referred to as the Pantone Matching System ("PMS"). Colors are specified by number from a swatch book, which is available at bookstores, art supply stores, and from printers. The Pantone system is based on eight basic colors plus black and white; the swatch book shows 500 specifiable colors on coated or uncoated stock. Any printer who has the eight basic colors (and a scale for proportional weighing) can match any of the colors in the swatch book. The PMS system is designed to help communication between graphic arts professionals, it is not intended to replace the human eye. You can modify PMS inks when you're on press and actually printing by special mixing.

Specialized inks are also available, although they may add to the cost and complexity of a project. They include: gold, silver and bronze metallic ink; fluorescent ink; and scented ink.

Once the sheet has been printed, it may be protected and enhanced with a coating that goes over the printing. Varnish is one common coating. Coatings have a big impact on the appearance of the finished product. Varnish goes on like ink and is either glossy or dull (matte). Each pass of varnish requires a plate and is referred to as another "color". Sheets can be either spot or flood varnished. Flood means to varnish the entire sheet; spot varnishing hits only certain areas of the sheet, such as the photographs. Spot varnishing requires an additional negative to control the area of application. It is common to spot varnish photographs. Spot hits of dull and gloss varnish may go on the same sheet.

It is also possible to coat sheets with plastic, lacquer, film laminate, or UV Coating. Like varnishes, these coatings are available in either matte or gloss finish. Film laminate is an appropriate treatment for the cover of a quality trade paper book

Offset Printing and Production

The discussion in this chapter on printing has so far been limited to offset lithography. Two other processes are worth a brief mention: letterpress and gravure.

Letterpress is the oldest form of printing. It involves pressing raised letters directly against paper. Photochemical etching creates raised plates from halftone art for letterpress work. While letter presses are suitable for certain routine work, they are also used for very limited runs of elegant books printed on beautiful paper. Fine letterpress printing is associated with the tradition of artisan as artist that goes back to Gutenberg in the fifteenth century.

Today, gravure is primarily used for print runs of over 1,000,000 copies. It is a precision process involving cylindrical plates that translate line art and halftones into dots. The plate cylinder is pressed against a paper web. Historically, gravure has been used as a significant fine art reproduction process for photography. Most of the illustrations in Alfred Steiglitz' *Camera Work*, published between 1903 and 1917, were printed by photogravure. Another famous example of photogravure is Edward

Curtis' *The North American Indian,* which contains over two thousand photogravure plates made between 1895 and 1930. Fine photogravure printing is kept alive by a few ateliers, such as the one supported by Aperture Foundation, and is an extremely expensive process.

Offset lithography involves the transfer of images from an inked plate to a rubber blanket. The blanket, not the plate, is then placed in contact with the paper and actually prints the image. The term "offset" is used because the image is offset from plate to blanket and blanket to paper. Offset printing produces a sharper image than direct plate to paper printing would because the blanket conforms to surface variations in the paper. Offset plates are less confusing to work with because they are "right reading" - the plate looks the same as the printed page. (If the image went directly from plate to paper, the plate would have to be backwards; it could be read with a mirror.) Web offset presses, are fed with paper coming off a roll (termed a "web"). The paper is then cut and delivered as folded signatures ready for binding. The paper which runs through a sheetfed press has already been cut. Sheetfed presses are generally used for offset runs of less than 100,000.

A sheetfed press can print between one and eight colors in one pass. A six–color press is standard. Sheets pass under different blanket cylinders, each one adding a different ink or varnish. Ink flow is controlled by computer or by the press operator. Sheets must be in precise register. While four-color process may be achieved on one or two color presses by re–inserting sheets the appropriate number of times, with a four or more color press only one pass is necessary and you will see what you are going to get as sheets roll off the press.

Offset lithography is an extremely versatile process. It is efficient and inexpensive and suitable for runs that produce between 500 and 500,000 copies. Quality ranges from mediocre to extraordinary. An example of superb and unusual photographic book production is *The New Vision: Photography Between the World Wars, Ford Motor Company Collection at the Metropolitan Museum of Art* which is the catalog to the exhibition of the same title. It won a Wittenborn Award in 1989 for outstanding achievement in art book publishing. Organized by Metropolitan curator Maria Morris Hambourg, the intent of the book was to reproduce the vintage prints in facsimile, and when possible in life size.

Hambourg states "Since the 1930s the original has been the starting place for the reproduction of photography with designers and printers ending up with some sort of acceptable compromise. What we wanted to do was concentrate not on the images as reproducible matrices but rather on the prints as individuated objects. We used additional "color" passes and variable varnishes to simulate the tones and surfaces of prints that varied widely." The production process was masterminded by Richard Benson, a photographer, MacArthur Fellow, and unparalleled technician in offset reproduction.

Hambourg researched the location of the original Futura font which was eventually found in Barcelona. It was then used for display type in the book. She feels that very few people who casually pick the book up really notice the subtlety of reproduction involved and the virtual facsimiles of the prints. "What we are doing,"

she says, "is probably perceived just below the conscious level"; visually aware viewers know quickly that this book is something special indeed.

The New Vision was subsidized by a grant from the Ford Motor Company and retails for $60. It is distributed by Harry N. Abrams, Inc.

Another, even more extravagant project, along similar lines, is the stupendous *Photographs from the Collection of the Gilman Paper Company*. Published by Gilman under the imprint of White Oak Press in 1985, it reproduces works from their important collection in virtual facsimile. Plates are again by Richard Benson. According to John Szarkowski's introduction to the exhibition "From the Gilman Collection: Photographs Preserved in Ink" (The Museum of Modern Art, New York, 1984), this limited edition book, which sells for $2,500, presents the photographs in the Gilman collection "with a degree of fidelity not formerly attained in reproduction". As you may have surmised, expense was not an object. About this project Benson writes:

> *Today the requirements of commerce ... force the setting of arbitrary standards at various stages of production to permit the use of many specialized hands. ... This way of thinking has disrupted the ancient pattern of the artisans, those who have always been among our true artists, and forced a reduction in the quality of the objects with which we live. ... There has been no densitometer, light meter, film processor, laser scanner and above all, no computer allowed here. The decision to ignore these modern tools was, of course, intentional, and was made in the belief that they only interfere with the real tools – the eye, mind, and hand functioning through their extensions, the camera and press, to make an object with that sort of complexity that defies external, particulate description.*

The press check, or press okay, is your final opportunity to approve a job or make changes. It should be taken very seriously. It will be the first time you see the printing job on your chosen paper. Often, a press check takes place in an atmosphere of tension and excitement. Take your time - within reason. This is your last chance to see that your book is printed in a way that is acceptable to you. It is your job to make sure that it is right, but remember that idle press time does cost money. Do not feel pressured to okay something that is not okay. But, be gracious and appreciative if the work looks good. Check for appearance from a lay person's point of view: do not attempt to offer technical suggestions. Be flexible.

Be sure to check registration on press sheets. Extremely tight registration is vitally important to the appearance of a quality printing job. Check multi–color registration by looking through a loupe at the edges of any printing. If you can see dots other than those forming the top color, there may be a problem.

Backups and crossovers also warrant some attention. Backup printing, on the verso of the sheet, should start and stop at the same height as the printing on the front. Crossover, or printing running across the gutter, should line up. (This can never be considered a sure thing until after the binding.)

Ink should appear to be consistent in density across the sheet. If printed areas are washed out or flooded, there may be a problem with inking. Printers do place color bars across the top of a sheet to analyze for ink density using a densitometer. As a customer your responsibility is to note printing appearance, not to make technical suggestions.

Ghosting, the undesired appearance of phantom imagery, generally beneath an area of heavily inked solid colors or black, is another potential problem. This problem is best avoided at the layout stage. Consult early with your printer if you have large areas in a solid tint.

In general, large solid black borders seem to cause difficulties and make apparent flaws that would not be as noticeable otherwise. Be prepared for difficulty and higher than average spoilage. Only work with the very best printers if your design requires substantial black borders.

Press sheets should also be checked for dirt, smudges and hickies. Hickies look like tiny white holes in the printing surface. They may have a dot of color within the hole. Resulting from dirt and paper fibers sticking in the printing press, they will shift in location in the course of a press run. Hickies should be circled on press sheets prior to a press okay.

You will be asked to sign a press sheet once you have agreed that the job is acceptable. If the press sheet that you sign has any hickies or minor flaws that the printer has agreed to correct, make sure you circle them. If you don't understand something, ask questions.

Bindery Work

Everything that happens to the sheet following printing falls under the rubric of bindery work. Almost all jobs will, in fact, require work after printing. In the case of a book, this involves cutting sheets, folding, binding and packing them.

Cutting sheets, or trimming, is not always necessary with a book. But in some jobs, unused parts of the sheet need to be trimmed away, and items must be cut apart from one another.

Folding is done on machinery. It is generally not as precise as one would like it to be. For most projects this is not a problem but with some designs, imperfect cross–overs may be noticeable.

Press sheets are folded into "signatures" of eight, 12, 16, or 32 pages. Books are made by binding signatures together, generally using either "inserted" or "gathered" signatures. Inserted signatures have one signature inside another like a stapled magazine or catalog; gathered signatures have one on top of the other like most books. Note that the order of pages is determined by which method is used. You must choose a signature style before mechanicals are made and stripping has occurred.

Although there are alternatives, such as spiral or Wire–O binding, most photograph books are "perfect" bound, "case" bound, or "notch" bound.

Perfect binding involves gathering signatures together and cutting off the folded end. The exposed ends of the paper are then hot glued to the back of the spine. Many paperback and soft cover books are perfect bound.

Case binding is used for hardcover books. It is durable, looks good, and is expensive. Signatures are sewn together along the spine, often with a "Smythe" machine. (Smythe is a pattern used for sewing bindings.) They are then put inside a case made of board covered with paper, cloth, plastic, or leather. The case is glued to the signature along the spine and between endsheets.

There are a tremendous number of elements in case binding that must be specified including shape of the back, imprinting along the spine, boards, endpapers, cover material and dust jackets.

Notch binding is similar to perfect binding in that the signatures are not sewn together. However, instead of trimming off the backbone, the individual signatures are cut perpendicular to the fold and gathered. Glue is applied into the cut, giving the glue more surface area to hold onto, and strengthening the binding .

Due to the fact that most photograph books are printed on heavier coated papers, notch binding or Smythe sewing are generally preferred for paperbacks.

To achieve the strongest type of binding, Smythe sew individual signatures and then glue on the cover. This case binding is expensive, but the financial impact on small runs may not be great.

Beautiful bookmaking is an art unto itself. If you wish to get involved in slip covers, leather, and handmade endsheets, find a specialty bindery that specializes in book restoration and elegant books made by hand. Expect to pay for it.

Once your books are finished, they must be packed for shipment. Books that are not shrink–wrapped should have slip sheets (protective sheets of paper) between each book. Material should be tightly packed in units that are not too heavy to manage. ❖

── 9 ──
How to Self–Publish
a Photography Book

This chapter is the second of three on how to self–publish a photography book. Chapter 8, *Design and Production: How to Put a Book Together from Conception Through Printing*, details the design process, production options, working with printers and other vendors, and the actual production process. This chapter provides a guide to distributing and marketing your photographic book. Chapter 10, *Running a Publishing Business*, discusses what comes next.

Should you decide to self–publish your work, in addition to the usual concerns of the author, you will have to consider the following topics: creating a business organization; product or book design; marketing; financing; production; fulfillment; distribution; and managing cash flow.

The great virtue of self–publishing is that it offers you almost complete control. When a large company publishes your work, generally you will have to surrender some control over how the product will look, what it will contain, and how it will be marketed. The chance to make these decisions yourself gives you a tremendous opportunity to have an immediate, direct and powerful impact on the world. However, it can also be a good prescription for losing your investment if your decision making process turns out to be wrong.

Let's step back for a minute and ask the following question: if your first choice was to sell your book to an existing publisher, why weren't you able to?

Perhaps you didn't try hard enough, in which case you should re–read Chapter 6, "How to Create and Sell a Book Proposal", check out some of the books suggested in the Resource Section for that chapter, and try again.

Maybe the project is not really marketable. If this is the case, you'll save alot of time and money by realizing it now. It is, of course, possible that the publishers to whom you submitted your project were mistaken. But if you made a concerted submission effort targeted at appropriate publishers, their reaction should be carefully considered. Do you know something that the acquiring editors at publishing houses do not? Are you willing, and can you afford, to publish at a loss, perhaps a substantial one?

Do you really want to be a publisher? Your responsibilities will include photography, text, editing, design, production, fulfillment, financing, distribution, sales, and marketing.

Before a Book is Produced

Well before your book is in production, obtain an International Standard Book Number (ISBN). Use the ISBN to obtain a Bookland European Article Number (EAN) bar code. If you wish for mass market purposes, register with the Uniform Product Code Council (UPC) and obtain a EAN and UPC combined bar code. Obtain an Library of Congress Catalog (LCC) Number. If possible, participate in the Cataloging in Publication program. Register as a vendor with Baker & Taylor, the largest book wholesaler. Send Baker & Taylor advance information on your book. Register your book in advance with *Forthcoming Books in Print*.

ISBN

ISBN stands for International Standard Book Number. It is a 10 digit code which uniquely identifies a book. It is essential to obtain an ISBN because books are ordered using this number. Without it, no one in the book trade will acknowledge the existence of your book.

The ISBN must go on the outside of the book as well as on the copyright page. The first digit in the code indicates in what group of nations the publisher belongs. The second group, from two to seven digits, is the publisher's prefix. The third group, from one to seven digits, is the title identifier. Publisher prefixes are assigned in groups of ten, one hundred, or one thousand, depending on how many books you intend to publish. Once you have a publisher prefix, assign the unique title identifier using the registry log provided. There is a $100 registration fee per publisher. For registration forms contact:

> International Standard Book Numbering – U.S. Agency
> R.R. Bowker Company
> 245 West 17th Street
> New York, NY 10011
> 212–645–9700

The agency requests that publishers contact them directly (not through lawyers, printers, or agents). Expect to wait twenty working days for your application to be processed.

Bar Codes

In order for your book to be distributed to chain bookstores and to certain large independent book vendors, it must have a bar code. The bar code version used by the book trade is known as Bookland EAN (technically, the bar code language used

is the OCR-B font). Once you have your ISBN it is easy to obtain camera-ready copy of the Bookland EAN bar code from one of various service companies (see Resource Section). Cost is about $20 and turn around time about 24 hours.

Complicating matters somewhat is the fact that products which are mass-marketed through drugstores, supermarkets, chain stores, etc., require the Universal Product Code (UPC) rather than the Bookland EAN in bar code version. UPC product designations are available from:

Uniform Product Code Council
8163 Old Yankee Road #5
Dayton, OH 45459
513-435-3870

Cost of registration in the UPC program for a small business is about $300. Presumably, there is no reason for a publisher to have only the UPC code (although you might certainly decide to do without the UPC code). If you wish to have both the UPC and Bookland EAN bar codes, advise the service company which is preparing your bar code as camera-ready art once you have the ISBN and the UPC product designations. They will prepare camera-ready copy with a bar code for the back cover that combines the two designations and a Bookland EAN bar code for the inside front cover. Cost of the conversion is about $35.

Unless you are planning to sell your books to drugstores and supermarkets, you will only need the Bookland EAN bar code.

Library of Congress Number

If you wish to sell your book to libraries you will need a Library of Congress Catalog Number (LCC). This identifying number, which goes on the copyright page, is assigned to the work itself: each edition that appears will carry the same LCC Number. The LCC Number is available without charge; it takes about 10 working days to get one. For registration forms and information, contact:

Cataloging and Publication Division
Library of Congress
Washington, DC 20540
202-707-6372.

Cataloging in Publication Program (CIP)

CIP provides publishers with standardized classifying information that is printed on the copyright page. This makes it much easier for libraries to catalog the book, in turn increasing the probability that they will purchase it. Books in the

program are also included in the Library of Congress database, which is distributed to many libraries.

Note, however, that participation in the CIP program is limited to established publishers. You may have to have already published a few books to qualify for the program. Due to funding shortages, the future of the program is in jeopardy. Currently, enrollment in CIP is not available to any publisher not already involved. For further information, contact:

Cataloging in Publication Office
Library of Congress
Washington, DC 20540
202–707–6372.

Forthcoming Books in Print (ABI)

R.R. Bowker publishes a directory, *Forthcoming Books in Print*, twice a year. Inclusion in this registry is free and leads to automatic listing in *Books in Print (BIP)*. (Following publication, double check that this has actually happened and that stores can find your books. If a customer comes into a store and asks for your book by title, photographer's name, or ISBN and the salesperson can't locate it in their computer, ABI or BIP, they will not be able to order it from Baker & Taylor or whomever. The customer will go away disappointed, and a sale will have been lost, possibly forever.) For a registration form, write:

Advance Book Information Department
R.R. Bowker
245 West 17th Street
New York, NY 10011
212–645–6700

See sample completed ABI form on the following page.

Baker & Taylor Books

The Baker & Taylor Company is the largest book wholesaler in the United States. They primarily serve the library and bookstore markets. If you want them to handle your book you must register with Baker & Taylor Books. Contact them for a packet which includes a Vendor Profile Questionaire. They also need advance information on forthcoming titles. They suggest you send them, four to six months in advance, a write–up of the book, promotional material, galley copies, and a marketing plan. While Baker & Taylor functions more as an order service organization than an active merchandiser, they sometimes take an inventory

105430

☐ Please keep last copy for your files and return others when requested to:

ADVANCE BOOK INFORMATION
R. R. BOWER DATA COLLECTION CENTER
P.O. BOX 2068, OLDSMAR, FL 34677-0037

TITLE: Photographer's Publishing Handbook

PUBLISHER(Not Printer): Images Press
Address 7 East 17th Street
New York, NY 10003

SUBTITLE: Marketing and Publishing Photographic Imagery and Books

SERIES:

Foreign Language: Translation ☐, from what language:

Telephone 212-675-3707

AUTHOR(S): Harold Davis

EDITOR(S):

DISTRIBUTOR, if other than publisher:
(If you distribute foreign books you must be their exclusive U.S. distributor. Please send us a copy of your documentation for exclusivity)

TRANSLATOR(S):

ILLUSTRATOR(S):

INTRO. BY; PREFACE BY; etc.

IMPRINT (if other than company name):

ILLUSTRATIONS YES ☒ NO ☐

PAGES: 184

THIS WORK IS ESSENTIALLY (Check one):

☐ FICTION	☐ TEXTBOOK
☐ POETRY	☐ BIOGRAPHY
☐ DRAMA	☒ OTHER _____
☐ CHILDREN'S FICTION	Handbook, Manual Specify
☐ ESSAYS	

AUDIENCE(Select Primary Audience):

College Text☐ Young Adult ☐: Grade:

Elhi Text ☐: Grade: Juvenile ☐: Grade:

Original Paperback ☒

Revised ☐ Abridged ☐ 2nd Ed. ☐ Other:

PUBLICATION DATE: May, 1991
Reprint ☐: If reprint, name of orig. publisher & orig. pub. date:

ISBN NOTE: Put full 10 digit number in spaces below. The system requires a separate ISBN for each edition

PRIMARY SUBJECT OF BOOK
(Be as specific as possible):
A complete guide to publishing photography. How to publish promotional pieces, sell stock to textbook publishers, and get photographs published as cards and posters. How to create and shop a photography book proposal. How to publish and distribute your own photography book. Everything you always wanted to know about publishing your photography but were afraid to ask. Includes: Interviews with prominent photographers, publishers, and self-publishers; figures, forms, and contracts; resource listings; bibliography; glossary; index.

ENTER PRICE(S) BELOW:	INT'L STANDARD BOOK NUMBER
On short discount (20% or less) ☐	
HARDCOVER TRADE: _ _•_ _	ISBN _ _ _ _ _ _ _ _ _ _
If juv., is binding guaranteed?	
LIBRARY BINDING: _ _•_ _	ISBN _ _ _ _ _ _ _ _ _ _
HARDCOVER TEXT: _ _•_ _	ISBN _ _ _ _ _ _ _ _ _ _
PAPER TRADE 19.95	ISBN 0-929667-07-7
PAPER TEXT: _ _•_ _	ISBN _ _ _ _ _ _ _ _ _ _
TCHRS. ED.: _ _•_ _	ISBN _ _ _ _ _ _ _ _ _ _
WKBK: _ _•_ _	ISBN _ _ _ _ _ _ _ _ _ _
LAB MANUAL: _ _•_ _	ISBN _ _ _ _ _ _ _ _ _ _
OTHER: **SPECIFY** _ _•_ _	ISBN _ _ _ _ _ _ _ _ _ _
LC#	
Order # (optional):	

Completed by: _____

SAMPLE COMPLETED ABI FORM

position in a book from a small publisher. Reviews are very influential in generating sales to libraries. Since the company's primary market is libraries, good reviews in library periodicals help to get Baker &Taylor's attention.

To receive your information packet and register with Baker & Taylor Books, contact:

Manager of Publisher Services
Baker & Taylor Books
652 East Main Street
Bridgewater, NJ 08807
201–218–3968

Copyright Registration

A copyright provides the owner of a work with a number of exclusive rights. These include the right to prevent others from exploiting the work for commercial purposes, or for using it in away which prevents the creator from realizing expected profits. A copyright notice should appear on the copyright page. For example:

Photographer's Publishing Handbook
Copyright © 1991 Harold Davis. All rights reserved.

Text and photographs may be protected by one notice, or separate notices if copyright ownership of the photographs belongs to the photographer and the text to the author.

While adequate notice protects your work with a "common law copyright", you should also register the book once it has been printed. Complete a Form TX, and send it along with two copies of the book and a $20 to the Copyright Office. Form TX, Circular R1 (*Copyright Basics*), and Circular R2 (*Publications of the Copyright Office*) are available from:

Register of Copyrights
Library of Congress
Washington, DC 20559.

The Copyright Page

The copyright page, usually the title page verso, should contain: the book title; copyright notice; statement of reservation of rights; rights and permissions, if any; ISBN; LCC Number; publisher information; printing history; Library of Congress Cataloging in Publication data.

Photographer's Publishing Handbook
Copyright © 1991 Harold Davis. All rights reserved.
No part of this book may be reproduced in any form or by
any electronic or mechanical means, including information
storage and retrieval systems, without permission in writing
from the publisher, except by a reviewer, who may quote
brief passages in a review.

First Edition. Library of Congress Catalog Card Number:
90-84349

ISBN: 0-929667-07-7

Published by:
Images Press
7 East 17th Street
New York, N.Y. 10003
212-675-3707
Printed and bound in the United States of America

Cover Photograph: *Denali, the Great One, Alaska*
© Harold Davis 1984. This photograph is well-known as a
Wilderness Studio poster.

Edited by: Jeanne Stallman

Designed by: Jennifer Lawson

1 2 3 4 5 6 7 8 9 10

SAMPLE COPYRIGHT PAGE

Book Distributors and Book Wholesalers

There is a distinction between companies that function as distributors and those that function as wholesalers. Within the book industry, wholesalers are companies that buy books from publishers and resell them to the trade. They do not do marketing and they don't have a sales force (although they generally have sales people who answer telephone inquiries). Wholesalers operate on a very small percentage margin and might better be thought of as jobbers. They are order takers: they basically exist to fill demand from libraries and the trade. They undertake little promotional activity other than publishing catalogs. They order books as the need arises, and pay in normal trade fashion. Ingram and Baker & Taylor are the largest wholesalers.

Distributors, on the other hand, handle a full range of services for the publisher, including warehousing, fulfillment, and sales and marketing. They will sometimes work with small publishers to help them come up with marketable titles. Generally, the distributor accepts merchandise on a consignment basis and charges 20 to 25 percent of net proceeds for their services.

Publishers can work with both wholesalers and distributors. Thus, a large publisher might have its own trade sales force, work with wholesalers, and sell through distributors to specialized markets. For example, while Simon & Schuster relies primarily on its own in-house sales force, libraries can buy its books through Baker & Taylor and other wholesalers. In addition, Simon & Schuster distributes appropriate titles through Amphoto to camera stores.

It is also possible for a publisher to sell to the trade through independent sales reps who visit bookstores with the work of more than one publisher.

See listings of wholesalers and distributors in the Resource Section; contact them for information on how they like to be approached by publishers.

Pricing Structure of the Book Industry

Trade stores buy books at a discount off the list price. Generally, depending on quantity, the discount is in the 40 to 47 percent range. Wholesalers buy from publishers at a 50 to 60 percent discount. Of course, if you handle direct sales, you can sell your book at list. Single copy sales to libraries are either at list price if direct or at 20 percent discount if through a distributor.

How to Price Your Book

Your book should be priced so that you will make a profit, but not so high that customers will be driven away. To be profitable, your book's retail price should be no less than six times the cost of production. From a business point of view, eight or ten times production cost would be a better figure.

While you may sell some single copy orders at list price, when a wholesaler sells the book you will be getting 50 percent of the list price. If you are using a distributor, subtract another 25 percent from the 50 percent. If you are paying yourself a royalty (a good idea), or are publishing someone else's work, take off another 10 percent of list. On a $30 book, we are now down to a $8.25 gross profit, from which we have to subtract the actual production costs as well as a pro-rata share of our overhead. If we printed 5,000 books for $25,000 we would have a unit cost of $5, and a very slim profit if we sell all we have printed (this example represents a retail to cost ratio of six to one).

Another way to look at pricing is to compare your book to competitive products. You cannot price your book substantially above comparable ones and expect it to sell.

Do a survey of books that are about the same size and have the same number of reproductions as yours to get a rough price range for your book. Can your book be produced for 20 percent (or preferably less) of the retail price in a reasonably sized initial press run? If not, seriously consider modifying or dropping the project.

Selling is Your Responsibility

As a self–publisher, selling is your responsibility. Whatever path you choose - standard industry routes to trade bookstores, a wholesaler, a distributor, direct mail, or to unconventional markets – you will have to sell your books. All that will be provided for you is a channel. You must make your audience want to buy your books and make sure they will easily be able to do so.

Selling is not a dirty word. There is nothing contradictory about being an artist or a photographer and a good salesperson. Everyone can learn to sell. If you don't want to learn how to sell, do not become a self–publisher.

Marketing Plan

It makes no difference whether your marketing plan is in writing or in your head, but you must know who is going buy your book, why, and how you are going to get it to them. "My work is wonderful so people will buy my book," is not sufficient. Considering the limited market for works of serious photography, a self–publisher must have an ancillary strategy.

Be creative when it comes to developing a marketing plan. Lorraine Tufts, for example, self–published a series of books of her photographs of National Parks which she sells through gift shops in the parks themselves. Perhaps your book contains valuable "how–to" information and can be sold to people interested in the subject.

Courtesy of Lorraine Tufts.

Establishing a Company Identity

Even if you are planning to publish only one book of yobur photography, it is important to establish a company identity. Bookstores and most other trade vendors do not like to buy from suppliers with only one item to sell. While you may not be

able to entirely get around this being the truth of your situation, you can project an expectation of stability.

In the event that you get bitten by the publishing bug, starting out on the right foot will save time and effort down the road. Finally, it is to your benefit for there to be at least the superficial appearance of separation between publisher and photographer.

A business venture can be a sole proprietorship, a partnership, or a corporation. Choose the most appropriate form and register or incorporate your business.

Choose a company name. The name should be recognizable, easy to remember, and sound official. It is also nice if it projects a poetic image with which you identify. Examples in the photography world include Clear Light Publishers, Lustrum Press, Umbra Editions and Wilderness Studio

You'll also need business cards, stationery, a phone number and a space set aside to do office work.

Importance of Product

The most important thing you can do to succeed in self–publishing your work is to create the best product you possibly can. Strive for excellence in photography, editing, design, sequencing and image selection.

The Cover

The aphorism "you can't judge a book by its cover" is not true when it comes to judging potential book sales. The cover is extremely important. It is the first thing your potential customers see and may be your only chance to convince them that your book is worth more than a casual glance.

After the cover, a potential customer will look at material on the back cover, jacket copy, and the spine. He or she will then probably glance at the table of contents (particularly for how–to books), prefaces, and introductions (especially if the introduction is by a known celebrity).

In the case of the photographic book, the choice of cover imagery and design is particularly important. The cover must move the consumer to buy. Ideally, the book cover should not promise anything which the book does not deliver.

The back cover is good place to list "bonus" features such as glossary, appendices, sample forms, resource section, bibliography (e.g., make it known that the book contains useful practical information). A picture and biography of the photographer (author) might go here as well.

Using good taste and quality design, the cover is a good place to go all out. What image works best? Would metallic lettering, embossing, multiple kinds of varnish or lamination, or drop–out type help? Spend time looking at well designed and successful photography books. What do the covers you like have in common?

Obtaining Reviews

Perhaps the most important boost you can give your book is to get it reviewed. The Resource Section contains a list of review media geared to the general book trade, libraries, photography and the art world. *Ulrich's Periodical Directory* contains a complete periodical listing. You will want to design your own Reviewers List based on potential markets for your book. For example, a photography book on Minnesota is a natural review choice for appropriate regional publications. Data processing, electronic imaging, computer, and computer graphic publications might be interested in a book on electronic imaging and photography. Do not be stingy about sending out review copies and press releases. Request copies of any reviews. Review copies should be followed up with a letter or phone call asking if further information is required.

A local newspaper or magazine might be willing to do a review or a feature story on you and the book. Exploit any personal contacts you may have. Photographers are often better connected with the media than they may realize. Giving away copies to these contacts may prove to be extremely cost effective promotion. Do not worry too much about the contents of any reviews. While glowing words are preferable, the old saw that "any publicity is good publicity" is quite accurate.

Preparing a Press Release

Enclose a press release with each review copy. A press release should be limited to one double spaced page. It should include: title of the book; photographer(s) and/or author(s); publication date; ISBN number; whether the book is available in hardcover or softcover; price(s); name and address of publisher; individual ordering information; what makes the book significant; intended market; biography of the photographer; previous books by the photographer.

Keep the release simple. Use quotations from the book itself, and include endorsements from prominent members of the photographic community, or reviewers. Do not make unattributed summary judgement statements about your own book such as "Compares favorably with Robert Frank's *The Americans*". Tell the story behind the book or interesting related anecdotes. For an example, see the sample release (on the next page).

If you are sending the release to solicit for requests for review copies, consider printing overruns of the cover to send along with it.

If you are sending a release to an important or influential reviewer, you might want to include a handwritten note. Follow up to make sure your review copies went to the right people.

The *Photographer's Publishing Handbook*

<u>new from</u>

Images Press
7 East 17th Street
New York, NY 10003
212-675-3707

The *Photographer's Publishing Handbook*, by Harold Davis, is the definitive manual on how to publish photography. Topics covered include promotional publishing, marketing stock photography, and the paper products market. There are chapters on how to present photography book proposals, how to find a publisher, and on designing, producing, and marketing your own book. The structure of the publishing industry is discussed. The nuts and bolts of production are covered. There are interviews with successful publishing photographers such as Ralph Gibson and Marcia Keegan, and prominent figures in the publishing industry. In short, this book contains "everything you always wanted to know about publishing photography but were afraid to ask".

Harold Davis is the founder and president of Wilderness Studio, Inc. He is well known for his cards and photographic posters including the best selling *Dance of Spring* and *Denali, the Great One, Alaska* (which is reproduced as the four-color laminated cover of the *Publishing Handbook*). Davis' previous book, *Publishing Your Art As Cards & Posters*, has been well received in the art and photography communities. He brings to the *Publishing Handbook* the background of a successful insider in photography and publishing. In the *Handbook* he presents interviews with many of the important players in photography and publishing whom the person seeking information about these worlds would want to learn from.

Other topics covered by the *Photographer's Publishing Handbook* include: artists' books, book packaging, the book dummy, negotiating a book contract, working with type, color reproduction, self-publishing and distribution. The *Handbook* is the only book of its kind on the market. It will be of interest to photographers who are interested in publishing their work, and also to anyone interested in publishing, photography, or illustrated books.

The *Publishing Handbook* includes 21 black & white reproductions, sample contracts and forms, charts and figures, a bibliography, glossary, and index. There are extensive listings of resources, publishers, markets, and suppliers.

The *Handbook* is an 8½X11" softcover. It retails for $19.95 and is available directly from Images Press or through bookstores. 184 pp.; ISBN 0-929-667-07-7.

Press Contact: **Peter L. Gould** *(212) 675-3707*

NEWS RELEASE

Make It Easy – The Customer Is Right!

As a self–publisher, you have to make it easy for those people who want your book to get it.

In addition to ensuring that your book is in the appropriate distribution chain, if you are marketing it directly, you may want to get a toll free 800 number and arrange to accept credit cards. Treat your customers with respect, listen to them and serve them well. Further discussion of direct marketing will be found in Chapter 10.

Interview as a one–act play with Roger Straus III

Dramatis personae: Roger Straus III ("RS") is the Managing Director of Farrar, Straus and Giroux. He is bearded, grey–haired, pipe smoking and exudes an aura of intelligence, amiability, and willingness to converse merely for the sake of furthering mutual knowledge. He has a sweet smile.

Farrar, Straus and Giroux, the book trade distributor for Aperture, publishes an occasional photography book. Straus, who is a photographer himself, has an intense personal interest in the publication of photography.

Harold Davis ("HD"), author of the *Photographer's Publishing Handbook*, about midway through the first draft; your intrepid interviewer.

The Setting: Straus' corner office above Union Square Park. While the office is comfortable enough, clearly Farrar, Straus is not a company that believes in putting profits into furnishings. Bookcases, desks and walls on the entire floor have a kind of battered quality as if the company is making the defiant statement: "We publish books that are of lasting literary importance and that sell because of that alone. We do not need to spend our money on anything that might remotely be seen as irrelevant, frivolous or glitzy." Computers are not particularly evident. It appears to be a publishing office circa twenty years ago.

We are sitting across from one another at a table near the center of Straus' office. In dimension it is about like a card table but appears much more stable than a playing table would be.

RS: Actually, I don't qualify for inclusion in your pantheon [of interview subjects]. I am not a publisher of photography books. I've worked for general trade houses such as Times Books, Harper & Row and Farrar, Straus and Giroux. My personal interest in photography is wildcat rather then programmatic.

HD: Those prints on the wall behind you are yours?

RS: Yes. I have a book of my photographs coming out. It is Alternate Currents: Journeys on Highway 1. The publisher is St. Martin's Press and the writer is Andrew H. Malcolm of the New York Times. I did the photography along U.S. 1 from Key West, Florida to Fort Kent, Maine. St. Martin's did a first book on old route 66 which did well; they will probably follow this one with a west coast volume.

HD: I can identify with being both publisher and photographer. Do you feel you are more a photographer or publisher?

RS: As a publisher of photography books I am somewhere between amateur and professional. As a photographer I am somewhere between professional and amateur.

HD: What about photography books at Farrar, Straus and Giroux?

RS: We average maybe one a year. They are fine art monographs. Notable photography books published here include Roman Vishniac's *Vanished World* and Lev Poliakod's collection of portraits of Russians with an introduction by Joseph Brodsky.

The bottom line is that twenty years of trying to publish photography books have been largely a disappointment to me, at least in terms of fine art photography. "How to" books sell well, and I've been involved in a number of good projects of that sort, for example, David Vestal's books. But the artist's vision, works of passion and obsession, have found only a small market. At least, the market is small when you compare it with the hundreds of millions of dollars spent on mid-level photographic equipment such as single lens reflex cameras and enlargers. You'd think that people who were serious enough about photography to, for example, put a darkroom in their house, would also care enough about what makes imagery great to invest in some quality books. I've spent a lot of time trying to rationalize my disappointment about this.

HD: Besides the obvious, that many people buy camera equipment out of adolescent infatuation with the hardware rather than a desire to learn about image creation, why do you think this is?

RS: I can only guess. By and large, photographers are not good book makers. What still photographers tend to be good at is the creation of stand alone imagery and not necessarily at sequencing. Publishers have not been effective at supplying what is missing.

The fact is that there have been very few really good photography books. I am excluding exhibit catalogs which essentially are placebos for people who would like to own the prints that were in the exhibit but cannot afford them. Photography books need a subject. Both publishers and photographers cop out of this need by getting a recognizable authority to write a 1500 word introduction to a group of

pictures and leaving it at that.

Very few photographers come in with a book. As an editor, I get extremely nervous when I see someone come in, sit where you are sitting, and place a yellow box of prints on this table.

HD: What are some examples of photography books that work?

RS: Robert Frank's *The Americans* is probably the greatest photography book ever made. Its real subject is alienation and loneliness. Joseph Kudelka's *Gypsies* is another great book. His vision of gypsies made me care about them passionately. It is depressing to note that in the thirty years it has been in print *The Americans* has sold only about 50,000 copies.

A collection of things that the photographer has taken pictures of simply does not cohere as a book. Joel Meyerowitz' *Cape Light* works because it is geographically connected and evokes bittersweet memories of summer; at the same time it establishes a framework that allows the photographer to explore his interest in large format photography.

The dichotomy between massive sales of seductive hardware and minuscule sales of quality photo books is echoed in the magazine world if one compares the vast circulation of *Popular Photography* with that of *Aperture*. Perhaps part of the problem is that it is easy to reach a certain level of proficiency with photography, far easier than with writing or painting. But then a wall is hit. It is very hard to become a very good photographer.

The book business is rife with elitism. Maybe we have shot ourselves in the foot by not being willing to deal with how to books.

HD: Of course, the Ansel Adams books, such as *The Print*, were technique books which contained first rate imagery. At Amphoto, as the editor there, Robin Simmen, said to me, they are publishing "how to books which approach monographs".

What about the other end of things, the monograph which is obviously not highly commercial and is subsidized (and possibly packaged) by the photographer?

RS: I feel that in the long run subsidies are pernicious to photographic book publishing. It does behoove the photographer to come up with a commercial theme. Otherwise, photo book houses will always be enabled in their claim that they cannot make money with photography books.

We are dealing with a situation where on the one hand there is a large mass market for some kinds of material. On the other hand, there is a minuscule fine art photography market. Art books should be made for the art market, lavishly, and they should be as true to the originals as possible. Photography is about theme and subject matter, not technique.

HD: What about the future?

RS: The media of photography is up in the air. So far, it has had an essentially photo journalistic base. This is changing. How is the disappearance of silver process going to affect things? How is technology going to develop in the future? What will be the impact on the cost of making photography books?

I feel the small press has a role to play. Everyone's erotic fantasy about how to create a publishing house is to find an unknown writer and ride their fame with them. It doesn't work, because as the writer becomes known he always leaves for an established house that can afford to pay him substantially. But, mainstream publishers have failed with photography while they have succeeded with prose. Perhaps success may depend on operating on a small scale.

Coda. After some further discussion, we agree that the fundamental difference between writing, where a popular novelist may sell hundreds of thousands of copies and earn extremely substantial advances, and photography, where book sales are negligible, is narrative. You can lose yourself in fiction and escape, while people tend to browse quickly through picture books. To illustrate the point, Straus brings out two Farrar, Straus and Giroux books, *Where War Lives: A Photographic Journal of Vietnam*, with photographs by Dick Durrance, and a hardcover copy of Scott Turow's *The Burden of Proof*, his latest thriller about legal and emotional entanglements in fictional Kindle County. "Which would you rather have?" Straus asks.

As a fiction addict, it is nolo contendere. I point to Turow's book. Straus laughs. "Point made," he says. "Please take them both."

Finis. ❖

Interview: Marcia Keegan

Marcia Keegan, noted photographer and founder of Clear Light Publishers, is someone for whom self–publishing has worked well. It has given her the ability to publish her own work and the power and resources to publish other work she cares about.

Keegan, together with her husband Harmon Houghton, runs Clear Light Publishers, out of an adobe compound in Santa Fe, New Mexico. She has been involved with numerous publication projects, both with Clear Light and major trade publishers. "When a large company publishes your work," she states, "you often give up substantial control. Your books may not even stay in print. I believe in my books and have wanted to keep them in print.

"Self–publishing offers the rare opportunity to have a direct, positive and visionary impact on the world. Ultimately, self–publishing can lead to publication of books, artists and authors who otherwise might not have had the chance they deserve to get their work out. Some of this work can be important as well as beautiful. For example, Clear Light's publication of the Dalai Lama's *Ocean of*

Wisdom with a foreword by Richard Gere and some of my photographs, is a book I believe in. To me the fact that it is also good business is irrelevant; I am far more impressed that the Dalai Lama and Tibetan monks who are my friends are pleased with it."

Keegan was born and raised in Oklahoma. She obtained her B.A. from the University of New Mexico; following college she worked as first a reporter and then a photographer for a local newspaper. There followed a stint as Home Living Editor for the *Albuquerque Journal* where she started the Sunday Supplement and ran it single handed, doing everything including writing, photography, and layout.

Coming to New York to study photography, Keegan became one of the last protegées of legendary designer Alexey Brodovitch, from whom she learned a great deal about book design. "Brodovitch helped me find my own personal arenas, what I really wanted to do. It is interesting to note that while all of his students have gone on to the top of the field, none of them are alike in style or interests. I also learned from him that one thing the photographer – or designer – must always do is teach, teach the clients. By doing it my way, I am teaching.

"Brodovitch taught me to think of book layout as very different from designing an exhibit. The two page spread, what you see when you open a book, is a total environment and should be a statement in and of itself, whether you go across the gutter, make the picture bleed, or do a large blow up juxtaposed with smaller pictures to give the spread tension and excitement. It's just not very exciting to have simple white borders around your precious photograph. Each book tells you, if you know how to listen, how it wants to be designed."

Keegan was successful in getting free–lance assignments from *Life, Look, Stern, Parade,* and other magazines. She spent some time traveling around the country shooting feature stories which were syndicated nationally by Associated Press.

After her free-lance stint, Keegan published nine books with publishers including Abbeville, Grossman, Lipincott, Oxford University Press and William & Morrow. Her first book project was *Only the Moon and Me* (Lipincott, 1970). She completed the illustrations for the book in only two weeks and "got bitten by the book bug". Her next project was *The Taos Indians and Their Sacred Blue Lake* (Julian Messner, 1971). She became passionately involved in the Taos Indians' struggle to get their beloved Blue Lake back and photographer and tape recorded, and got quotations. Via an agent, Keegan shopped the book which was published as a children's book primarily intended for libraries.

Next came two major and very different projects, each of which she was involved in for a number of years. *Mother Earth, Father Sky* was created under contract in 1974 with Grossman Publishers (now a part of Viking). The text consists of Indian prayers that Keegan selected and edited along with color photographs. She also designed the book. Today, it still sells well as a Clear Light Book with a different cover and a few interior changes.

While Keegan was on assignment for the Office of Economic Opportunity in the rapidly changing Times Square area of New York City, she discovered that many old vaudevillians were being displaced. Keegan spent several years photographing them

in black and white, partially funded by a New York State CAPS grant. The work was exhibited at Lincoln Center in 1973 along with tape recordings of the vaudevillians singing and talking about their lives. Avon, the publisher of *We Can Still Hear Them Clapping*, read about the exhibit in the New York Times. States Keegan: "This was a very rewarding project. These eighty year old people were living in the Times Square area and had been forgotten. If I had not done it, nobody would have. They were very appreciative. It was like inheriting 50 grandparents. They considered me their agent, not a photographer. Through the book they appeared on television. It gave them something to be happy about at the end of their lives."

Keegan's father passed away in 1974 and her widowed mother remained in Oklahoma. Keegan wished to dedicate a book to her mother and neither Indians nor Vaudevillians seemed appropriate subject matter. By creating a book on *Oklahoma*, Keegan could spend time with her mother and dedicate the book to her. This project became Oklahoma (Abbeville, 1979). Comments Keegan: "Mother was delighted. She felt very positively about Oklahoma and got to pick up awards on my behalf after the book was finished. I, myself, had a love affair with Oklahoma as I took the photographs for the book."

In 1979 while working as a photographer at a press conference Keegan met the Dalai Lama of Tibet on his first North American visit. "I felt that he was the man the Hopi people speak about in their prophecy, the spiritual brother. I was very much touched by his presence. I wanted to hear what he had to say. I tape recorded, photographed, and had my Hopi friends meet him in California.

"I wanted to do a book for him. In 1980 I traveled with him and photographed him in Canada. In 1981 I started Clear Light Publishers because I couldn't find the publisher for the book, which I handed to him on his birthday, July 6, 1981. At that time I had no distribution and no awareness of how books actually get out to people."

In 1984, Keegan was hired by Oxford University Press to photograph New Mexico for a book that was one of a series on the different states. When the publisher decided to discontinue the series, Keegan, who knew the book was selling well, understood the market, and by then had a local distributor, bought the plates and film for $1,000 and re–issued *New Mexico* ("changed a little but basically the same book") under the Clear Light imprint. Keegan notes that it is extremely important to provide for the reversion of rights to the author in the contract with the publisher. Since it costs them nothing, publishers will probably be willing to go along. If a publisher lets a book go out of print it provides a way for the photographer to produce it as a self–published book with little or no risk.

Other Clear Light publications include: *Peublo Indian Calendar* (1987); a successful re–issue of Keegan's award winning *Southwest Indian Cookbook (1987); Old Father, Storyteller* (1989), a beautiful re–telling of Native lore written and illustrated by acclaimed Southwest Indian artist Pablita Velarde; *Wildest of the Wild West* (1988), true stories of the frontier west by Howard Bryan.

Clear Light's creative and financial success comes from a variety of factors. Marcia Keegan's artistic ability, experience with publishing and book sense is key, and Harmon Houghton's business background plays an important role. Much of

their material is specific to the Southwestern region and they have an effective distributor in the Southwest as well as a national distributor. As in all human affairs, timing and luck come into play – the Dalai Lama's *Ocean of Wisdom* was published shortly before he was awarded the Nobel Peace Prize. Surely this helped swell the vast sales for this elegant volume. Clear Light has now sold subsidiary rights for translations of the book in 10 different countries. "What we tried to do with this book was bring the essence of a good way of life, having a good heart, pliable mind and good motivation," states Houghton. "You can open this book on any page and get a little affirmation out of it that is the essence of what the Dalai Lama is teaching."

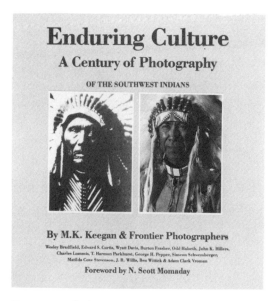

Courtesy of Clear Light Publishers.

Keegan notes that she is involved in so many projects that she can't possibly publish them all through Clear Light. She also works with other publishers. E.P. Dutton will be bringing out a children's book of her color photographs and text about the life of a Peublo Indian child she has known since he was born.

A current Clear Light project that tremendously excites Keegan is *Enduring Culture*, scheduled for release soon. She states: "This book will celebrate the tenacity and strength of the Southwest Indians in holding on to their traditional way of life against all odds. All peoples can learn from this example. I have collected vintage photographs from seven museums; the frontier photographers I have used include Edward Curtis and Adam Clark Vroman. Each two–page spread will have a historic photograph on the left and a contemporary image from my collection on the right which shows the continuity of a culture that has not died or vanished but is alive and well."

Keegan summarizes her theory about her success: "None of my books have been portfolios of my best pictures. That does not work. When I am publishing a book, I wear the hat of publisher and do not let my ego as photographer make the decisions. This is very different than planning an exhibition. I let the book, with its own reason for being, rhythm, and design, determine what pictures have to go in it.

"Do what you believe in. Be persistent. And if you believe in it, usually there are other people who will care about it, too, and they'll want to read it, and look at it, as well. I think everybody wants a good book." ❖

10
Running a Publishing Business

A publishing, or self–publishing, venture should be treated as a serious business right from the start. Substantial amounts of money are involved in the publication of even one photograph book. The most important thing you can do for any venture, however noble or artistic your motivation, is to plan for its survival and success.

To do this, develop business and marketing plans outlining distribution and financing. Have systems in place for accounting and fulfillment. Consider what type of business entity best suits your needs and set it up. Finally, make sure expert legal and accounting help is available. Your lawyer and accountant may be as valuable as your designer.

The Business Plan

A business plan provides a description of your business. It states your form of business organization. It lists officers and/or owners, and briefly indicates their backgrounds. It discusses what you do or make and what you intend to do or make. Discussions of capitalization, sources of financing, and profit margins are included as are manufacturing, marketing and distribution specifics. Competitive products are analyzed. Sales and profit projections based on a variety of (reasonable) assumptions, cash flow analysis, and balance sheets are included.

Often a business plan is used to attract financial backers. If this is the case, include whatever information you think will help you sell potential investors on your publishing venture. Examples include reviews, catalogs, testimonials, or your work.

If the business plan is intended for your personal or internal use, keep it simple. Careful creation of a business plan can help you think through the details of your publishing proposition.

Sources of Finance

Possible sources of financing include: yourself; friends and family; patrons interested in your work; people interested in publishing; trade suppliers; advance

purchasers of your book, such as individuals, stores, or wholesalers; banks; venture capitalists; the Small Business Administration; and corporations with an interest in photography.

More About Producing

The terms "book producer" and "book packager" are interchangeable.

Basically the producer contracts with the publisher to either deliver finished books or provide mechanicals and supervise production. Working with a producer makes a great deal of sense for the publisher of illustrated books because the design and editorial services involved are specialized and complex. With a producer handling these details, the publisher is freed from keeping experts on staff.

The producer's responsibilities include: obtaining, editing and sequencing illustrations (photography), obtaining and editing text and captions, designing the book, creating mechanicals, and overseeing production. (The photographer, writer, designer or editor could also be the producer.) There are two basic operating patterns: (1) The producer contracts with the publisher to deliver a set number of books at a specific price. If the producer is also delivering the book to a foreign publisher (or a soft–cover version to another American publisher) the producer may have to capitalize production costs. (2) More often, the producer delivers all parts of the project up to and including finished mechanicals and supervises production, usually for a fixed fee (although royalties may be involved).

Catherine Chermayeff, one of the principals in Umbra Editions, Inc., a photographic book producer, notes: "It is a real pleasure to be involved with a beautifully illustrated photography book where the initial print run is over 100,000 copies. Large publishers are in a position to capitalize the immense cost of this kind of project."

Umbra Editions was started about a year ago by Chermayeff, May Castleberry, Karen Marta and Nan Richardson. Each participant directs the projects they bring in. Current packaging projects they are involved with include a book on Ellis Island which will serve as the catalog for the new Ellis Island National Museum, a book on the hugely successful Ring of Fire Aquarium in Osaka, Japan, and a book for the Bronx Zoo centennial.

Chermayeff started as picture editor at *Fortune* where she learned how to produce a magazine and worked with an enormous number of photojournalists. She then accepted a position with Magnum (a cooperative agency run by member photographers). There she created a position for herself, "Director of Special Projects". In the past five years at Magnum – she remains as a consultant – Chermayeff has put together between 40 and 50 book projects including *In Our Time* (W.W. Norton, 1989), which served as the catalog for the retrospective exhibition of Magnum photographers. *In Our Time* had an initial print run of over 100,000 and was partially underwritten by Kodak. Chermayeff's involvement in book projects

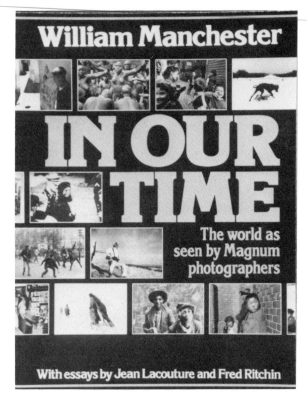

Courtesy of W.W. Norton.

has included editing, producing, and negotiating contracts.

"It's hard to say what makes a good photography book," states Chermayeff. "There aren't that many good ones and different ones are good for different reasons. In many cases the sense of an editor is missing. *In Our Time* is a success by any criterion and is a good general introduction for the public to the work of Magnum photographers. But for the photographically sophisticated audience, it contains too many already well–known images. On the whole, photography books are hard to do. At best, the serious photographic book buying community is 5,000 to 6,000 people.

"I feel that books are the best medium for photography. They have a life of their own. A book is a thoughtful medium. You can sit down with it. Unlike an exhibition, which you pass through, a book remains with you."

Both modes of packaging put the producer (who may also be the photographer) in a position to function as a self–publisher without having to finance the venture. At worst, if you are being paid for x copies at y price, you may have to arrange bridge financing for the printing. But your downside risk is gone. Olivia Parker's *Weighing the Planets* (Little, Brown and Friends of Photography, 1987, see interview pp 64-66) is an example of a book successfully created with bridge financing by a photographer\packager. Of course, the economics of the arrangement should be looked at carefully. By the time you pay for all the services you have agreed to deliver, you may not be making any money. Will you do well if the project does well? Who has final control of the content? Is the project you have in mind the same book that is in the mind of the publisher? Having a finished dummy prior to going to final contract with publishers will help on this last point.

Another advantage of producing is that it helps you to involve multiple publishers in the same project. One publisher might handle the hardcover edition and one the softcover. Or, one might responsible for domestic and one for foreign editions. Photography books are especially well-suited to foreign editions because there may not be much text that needs translation. The trade shows, A.B.A. and Frankfurt, are valuable sources for making the connections that help to put together this kind of package.

Working with Stores

As a publisher, most of your business will come from a few key accounts. A rule of thumb is that 90 percent of your business will come from 10 percent of your accounts. These key accounts might include several major wholesalers, chain stores, a specialty distributor, and a few independent stores. It is important to keep in touch with these accounts. Let them know whenever you are publishing a new book. Carefully consider the target market for a given book. Is it regional? Then concentrate on stores in the area involved. Is it a serious photography book? Then focus on stores and channels of distribution that specialize in serious photography.

Get to know the people who run the stores that are your accounts. Make it clear that you are both in the book business together. Let your delight in beautiful, important books show. Leave behind effective promotional material. Be prepared to go the extra mile. Give away actual samples when appropriate. If you are traveling on sales calls, bring books so you can fill orders immediately. Usually, store owners like meeting the "artist", you will probably be effective in selling your own books. For further suggestions, see John Kremer's *1001 Ways to Market Your Books for Authors & Publishers*, pp. 268–291.

In addition to catalogs and press releases for new publications, you might want to design direct mail pieces aimed at buyers for stores. *The American Book Trade Directory* lists numerous bookstores, and lists are available for rental from the American Booksellers Association and other trade groups. Establish a regular schedule, format, and style for mailing.

The more important an account is, or the more likely you are to sell to an account, the more money it is worth spending on soliciting the account. Your catalog, which, apart from your books themselves, is your most costly and important sales tool, should not be sent out in a blanket fashion. Use your direct mail flier for marginal inquiries.

Establish standard terms and conditions and create an attractive order form. When you send out business documents such as invoices and statements, include promotional material.

Make sure your catalog is well organized and that the books are easy to find. Include a title and photographer index as well as complete bibliographic information: title, subtitle, photographer, author, price, ISBN, LCC number, number of pages, trim size, binding, type and number of reproductions, back matter. Describe the book and its audience, and include anything else that will help sales.

The catalog should also include: an easy to use order form; a statement of terms and conditions; and a list of the addresses and phone numbers of sales representatives, distributors and wholesalers who handle your books.

If you are selling both to the trade and directly to consumers, consider designing separate catalogs for the two functions.

You will also need to consider such selling techniques as point of purchase displays, complimentary bookmarks, and co–op advertising.

It is possible to sell to retail stores that are not bookstores. Camera and photography supply stores are the obvious candidates for photography books. The

market is pre-qualified (most people who come into these stores are already interested in photography) and your book will not have to compete with the full range of books in a normal bookstore. Therefore, your book will have a better chance of catching the attention of the casual browser.

Selling to the Chain Stores

There are quite a few bookstore chains, but the field of retail book selling is dominated by two giants, B. Dalton and Waldenbooks, which together have more than 2,000 stores nationwide.

While these two giants move an enormous volume of books, selling to B. Dalton and Waldenbooks stores may be a mixed blessing. The taste represented in the stores is homogenized, and the small publisher of the photography book may not fit in. There is also the issue of dealing with a corporate bureaucracy: a substantial amount of record keeping and nagging of accounts payable offices is involved. The chains are notorious for over-ordering and then returning books, often after your allowable period for returns. Publisher and printer Lloyd Morgan notes that, paradoxically, some success with chain store orders can put a small publisher out of business due to inordinate paper work, processing costs, and inflated orders followed by massive returns. This can result in a situation where gross sales look good, but your business is actually not making money.

One way to avoid this problem is to sell through a distributor such as Publishers Group West or Consortium.

If you do attempt to deal directly with the chains, get into their central listing system so that stores can order books by ISBN on their computers. Addresses of the central offices will be found in the Resource Section. Some small self-publishers that have successfully done this are now in a programmed re-order situation – automatic purchase orders are placed on a regular basis. You will need a great deal of persistence and repeated phone calls and regular promotional mailings to get hold of centralized chain store buyers.

One final point. Although individual stores belonging to a chain will often claim they do not have authority to make purchases, this is generally not true. Managers of individual stores generally have considerable independent purchasing authority.

Selling to Libraries

Libraries are a huge, diverse potential market. There are many different types of libraries, ranging from community libraries through specialized art libraries to military libraries. Some libraries are public, some are private, and some are in schools. They all buy books. Having your book in libraries stimulates other sales. People who check your book out at the library may later buy it for their own use or pleasure.

The typical library orders books from publishers one copy at a time. Most orders go through Baker & Taylor, Ingram, or other wholesalers. Quality Books and Unique Books are two distributors of small press titles to the library trade (see Resource Section).

Librarians like to order books that help them answer questions they are asked. A reference or how–to book is easier to sell to libraries than a photography book.

Librarians are very review conscious. They pay particular attention to *Publishers Weekly, Library Journal, American Library Association Booklist, Choice,* and *The New York Times Book Review.* It has been estimated that a good review in *Library Journal* will sell 1,200 copies of a nonfiction book. If you are attempting to sell directly to librarians, make sure you include reproductions of positive reviews in your sales literature. Various lists of library buyers can be rented from R.R. Bowker (see Resource Section).

Librarians prefer to buy books that have an ISBN, an LCC number and an index. Participation in the Cataloging in Publication program is important as is a solid informative title and subtitle. It also helps if the title is printed on the spine and the book fits on library shelves.

Fulfillment

Fulfillment is the warehousing, packing, and shipping of inventory.

There are three basic ways to handle book fulfillment:

1. a book distributor such as Publishers Group West or Consortium can do it for you; **2.** you can contract with a fulfillment company, generally affiliated with a printing or warehousing company; **3.** or you can do it yourself.

No method is free. If you use a distributor, their fee will be included in the overall percentage they get for each sale. You are locked into making sales through the distributor. A fulfillment house's fee will be expressed as a unit fee per book (sometimes plus a monthly minimum and/or a monthly rent). Fulfillment should not work out to much more than $2 per book.

Doing it yourself is at first glance the least expensive option. But you may have to hire help and rent storage space for your bulk inventory. It is no bargain if you end up spending all your time packing your photography book in boxes for shipment. How will you find the time to take the photographs for the next one?

A good listing of fulfillment services can be found in John Kremer's *Book Publishing Resource Guide.*

New Markets

There are many more markets for photograph books than you or I can think of right now. Be open to them. Keep educating yourself. Read *Publishers Weekly* and *Photo District News* and *The New York Times.* Ask questions. Join trade associations.

Look around, and when you see a new possibility, research it. Learn how the business involved works. What is the pricing structure? What are the systems of distribution?

Trade Shows

A number of significant trade shows are listed in the Resource Section. Particularly important to the book publishing industry are the A.B.A. trade exhibit and the Frankfurt Bookfair.

These are the places to meet people in the publishing industry and keep up with the industry. If you are a book creator, you can float book proposals, qualify possible targets for book proposals, and try to line up book packaging, co-publishing and distribution deals. For the small publisher the agenda will be much the same, except that book projects may be sought rather than sold.

Subsidiary Rights

When you sell subsidiary rights, you are selling rights to everything besides the initial publication of your book. Subsidiary rights sales can produce more revenue than the actual book publication itself. They can also result in good promotional material for the book.

Realistic rights sales for the photography book include: serial rights to newspapers and magazines; paperback rights (if your book is hardcover); book clubs; and foreign edition rights. Clear Light Publishers' *Ocean of Wisdom* is an example of success with subsidiary rights sales (see interview with Marcia Keegan, pp 128-131). Keegan self-published the book under the Clear Light label. She then sold paperback rights to HarperCollins for a very substantial advance. She has also sold rights to produce 10 foreign editions in translation.

Solicit serial rights sales to magazines with a letter, news release, and some kind of sales package. The photography magazine are the best bet for photography books, but other possibilities exist. Do not neglect art magazines or general lifestyle magazines such as Esquire. If your book is a photography book of cats, consider specialty publications on cats and pets. Use *L.M.P.* for research; often it will indicate if a publication is interested in purchasing serial rights.

An advance sales to a book club (contact them six months before the publication date) is a potentially lucrative possibility. In addition to such well-known organizations such as Book-of-the-Month Club, there are quite a few specialty book clubs. A few of these specialize in art and photography books (see Resource Section).

It is possible to sell softcover rights for a self-published photograph book to a major trade house. But first, you must demonstrate success with the hardcover version. The same holds true for foreign rights sales. It may be easier to market foreign rights to a photograph book because less words are involved that need to be

translated. If you don't have the necessary contacts, an agent who is experienced in foreign rights is probably the best bet. For a listing see *L.M.P.* and Kremer's *Book Publishing Resource Guide*, p.70.

Corporate Sponsorship of Publishing Projects

Corporate subsidization may the best, or only, way to get an elaborate photography book published.

You will have to persuade the corporation that publication of your book serves the public interest and that the corporation will benefit from the publication. This is easiest if your book is connected to a broader project, for example, the reconstruction of Ellis Island.

Also, pay attention to the corporation's constituency of customers and sense of community. Kodak has an interest in supporting important photography projects. A company based in Minnesota might have an interest in publication projects about Minnesota. What is your book about? What company might be willing to support it because of their interest in its topic?

Corporations that support the arts won't subsidize a project unless they have a genuine belief in its integrity. Bear this in mind when you present your project.

Submit funding proposals to personal contacts at the top level of the company or to the Director of Corporate Communications.

How to Run a Publishing Business

Don't try to do everything yourself. Automate, delegate and sub–contract. Find good people to work with. Plan carefully. Don't be afraid to try new things. To continue producing photography books your business must survive. Create your photographs, and your books, out of love; and love the process of running a photography publishing business as well.

Interview: David Godine
Publisher

Shortly after graduating from Dartmouth College, David Godine started a commercial letterpress printing business in a family barn near Boston using his trust fund for capitalization. Soon, due to the exceptional quality of the work he produced, Godine was attracting favorable notice as a printer of exhibit catalogs for

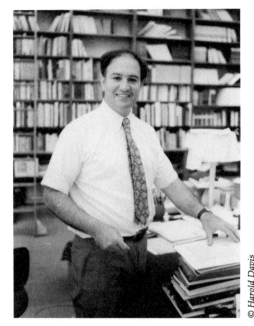

© Harold Davis

such institutions as the Metropolitan Museum of Art. He also published "handsome books" simply because he and his friends liked them.

In 1973 Godine ceased operating as a printer and became a full-time book publisher. A sojourn in New York with Book of the Month Club taught Godine "the meaning of the word `publish', which is to make something public. Most books are `privished'. ... I realized how hard publicists, promotion people, advertising people, and editors all had to work to really publish a book."

Godine observes in the David R. Godine 1990 trade catalog:

[Publishing] never works when it grows too large; it never works when the owners are unfamiliar with what they are actually publishing; it never works when the head of the house cannot, at sales conference, give a fairly clear synopsis of what books are being published and the reasons the house has taken them on. ... It can work ... when the books that are chosen have real reasons for existing, when they are not the result of fads and fashions, but rather of forethought, insight and intelligence.

... We are still a small and personal house, still committed to the ideals that have governed this noble and eccentric profession for four hundred years. ... [W]e will manage a second two decades of committed and independent publishing, producing books that matter for people who care.

"Our mandate," Godine states, "is to publish fine books that sell" across a broad intellectual spectrum. Photography books however, have become increasingly expensive to create and in terms of resource allocation, less justifiable over the long term because the cost of reprinting is almost as high as the initial run cost. One reason for high costs is his insistence on superb production standards; Godine's notes that black-and-white is reproduced in duotone 300 line screen on Mohawk Superfine paper. There is only one release in the 1990 New Titles catalog that is a straight photographic monograph, Martha Casanave's *Past Lives*.

"We will rarely do photography books without the financial help of corporate sponsorship," continues Godine. "I believe that the future of photography book publishing is in format publishing. This means books designed to a standard size which will enable us to achieve economies of purchasing and scale as well as to fit more pages on the printing sheet. Also, the series itself should achieve its own identity and salability. In the '12 format' that I am planning – the purpose of which is

to enable us to print on a 28X40" sheet with 12 plates rather than eight – I have sent a design spec sheet to potential contributors. I should like to publish or re–issue in this series books of classic photographs by Arnold Newman, George Tice, Paul Caponigro and Lee Freidlander."

Godine does not make substantial sales to the chain stores. For one thing, he does not feel his books do well in a mass market environment. Also, returns of merchandise, always endemic in the book industry, are particularly a problem with the chain stores. His major markets are independent retailers, and such institutions as libraries and schools. He also markets through direct mail to a carefully cultivated list.

Godine says that he left printing for publishing partly because he liked taking on "exciting risk projects". Despite his current negativity about the feasibility of publishing contemporary photography books, for the right project (one with intellectual and visual clarity as well as potential financial viability) he is the rare kind of publisher who just might go for it simply based on a seat of the pants faith in quality and his own judgement. ❖

Interview: Lloyd Morgan

President, Morgan Press

The history of the Morgan family has been intertwined with the history of photography and photographic printing since 1930. Today, Morgan Press Incorporated is a quality commercial printer and specialty publisher in Dobbs Ferry, New York. The publishing company, founded in 1935 as Morgan & Lester by Willard Morgan, is run today by his sons, Douglas and Lloyd Morgan. Several members of the third generation, Willard and Barbara Morgan's grandchildren, work at Morgan Press, founded by Douglas and Lloyd Morgan in 1958.

Sitting in a restaurant in Dobbs Ferry, several blocks from his printing plant and office, Lloyd Morgan, a distinguished well–spoken man, reminisces about the past. "The history of my parents, Barbara Morgan and Willard Morgan, is the history of the years 1930 through 1960 in photography. A major retrospective and catalog based on the Willard Morgan archives is being planned by The Rochester Institute of Technology in collaboration with Kodak and other Rochester institutions. Historians of 20th century photography, who too often have been those interested only in "art" photography, will have to re–write Willard's role."

An early advocate of 35mm photojournalism, Willard Morgan was using a Leica as early as 1925. Following a lecture to Steiglitz' Camera Club of New York in 1930, Morgan went to work for Leitz as their National Sales Manager with the mission of establishing the use of 35mm cameras for serious photography. When Time, Inc. started *Life* Magazine in 1936, they hired Willard to organize the photographic staff and to be an early picture editor.

About this time Willard started the Morgan publishing company, as a vehicle for the *Leica Manual*, which was to sell over one million copies. Meanwhile, Willard Morgan also performed various distinguished roles in the photography world including curating and organizing the FSA archives (along with Roy Stryker). In 1943 he became the first Director of Photography at the Museum of Modern Art, a position he left to become Photo Editor at *Look* Magazine.

The two Morgans, Barbara and Willard, were tremendously involved with photographers and photography. They felt that "photography would be recognized as the universal twentieth century language." Barbara Morgan had a particularly close relationship with Minor White. Ansel Adams was a frequent visitor at their Scarsdale home.

Meanwhile, the Morgan publishing company continued to publish successful technical books on photography. Friends suggested to Willard that he publish "art" photography books, but he rejected the suggestion on the grounds that most such books were not profitable to the publisher unless start–up costs were shared by a corporation.

Unlike most printers who limit themselves to printing, the Morgans also have experience in photography, writing, marketing, and publishing. As printers of photography, their interest was to come as close to the original image via offset. In pursuit of excellence in black-and-white printing, they developed an extended tone range double dot system they called "quadrodot". As printers, in addition to early editions of *Aperture*, they also worked for distinguished publishers including Abrams, Crown, and Random House. As publishers and distributors, in addition to the technical books that were their bread and butter, they were involved with various important projects including Ansel Adams monographs, the Time–Life *Library of Photography* series, and miscellaneous books such as William Crawford's *The Keepers of Light* ("A History & Working Guide to Early Photographic Processes").

Over time, changing economic realities have caused Morgan & Morgan to rethink its directions. They are no longer interested in publishing unsubsidized monographs. Today, most illustrated books are printed in the Far East, and Morgan Press, no exception, will send most book jobs, including their own, abroad. For example, *Crying for a Vision* (100 years of of Indian life on the Rosebud Reservation photographed by 3 Jesuit priests using glass plate negatives) was originally published by Morgan Press 20 years ago and printed in–house using their quadrodot system. Today the book is being re–printed in Hong Kong using funds made available by the Nebraska Historical Society. It will be distributed by Morgan Press.

Today, Morgan Press and Morgan and Morgan are profitable businesses thanks to publishing products that sell on a continuous basis and fine commercial printing. Morgan continues to publish and distribute textbooks and technical books on photography for the college market and to market them by direct mail.

❖

Interview: Eelco Wolf

Vice President, Agfa Corporation

Eelco Wolf is Vice President, Corporate Communications at Agfa Corporation. Agfa hired him in 1989 to create a corporate identity for Agfa similar to the well–known program he was instrumental in organizing at Polaroid. The Polaroid cultural program exchanged supplies for imagery and gave photographers access to specialized equipment such as the Polaroid 20X24" camera. Polaroid also gave out–right grants to artists and subsidized publication projects.

"From the very beginning," Wolf states, "I believed that the photographic industry had an obligation to sponsor artists involved with photography. After all, we are selling our products to photographic artists at a profit. Considering what artists have to go through, how difficult it is for them to get their work out, there is at least a moral obligation to support "struggling" artists in a non–commercial way. In the long run, in fact, what we are selling is imagery, not cameras, film or paper. So to not support the development of photography as an aesthetic medium is dangerously shortsighted. By providing materials, or access to equipment, or actual financial support, we create a situation of good will for the company with the artist and, in return, he or she will hopefully say good things about the company without any prompting. These photographers tend to teach, lecture and publish, so they are talking to lots of people, and, not only do we fulfill our moral obligation, we are reaching an incredibly powerful constituency."

When asked about book publication programs at Polaroid, Wolf responds "Connie Sullivan, of course, produced *Legacy of Light*, probably the best and most comprehensive book on Polaroid photography ever published. I didn't do overview books. As I said before, my preference was and is not for obvious projects. The only real requirement was that our materials were used. For example, with *City Limits*, Kelly Wise, photographic critic, teacher and photographer came to me with a project about Boston neighborhoods in transition. We provided equipment and materials and funded four photographers' shooting time. We also paid for the exhibition, paid the book designer and made a contribution to the publisher (Northeastern University Press). The resulting book is very special.

"*Samaras* was published by Aperture," he continues. "This artist, [Lucas Samaras] exclusively uses Polaroid materials for his photographic work. We collaborated closely with the publisher and gave a contribution. Most photographic publishing today must be underwritten. At Polaroid we were involved in supporting many projects including Sandi Fellman's *The Japanese Tatoo* with Abbeville, Neil Slavin's *The Britains*, published here in the United States by Aperture, and Martha Casanave's *Past Lives* a very special book on David Godine's current list.

"I have started an Agfa photography collection. Imagery included must incorporate Agfa materials, such as film or paper. As time goes on, and it is a multiple year process, I am committed to a publishing program involving serious

photographic art. We are currently conceptualizing an imaging journal, perhaps titled *Writing With Light*. It will showcase imagery and talk about important subjects that are current in the photographic art community such as electronic imaging. We will certainly support publishing projects. I am clear that while I had 25 years at Polaroid this needs to happen here within five years." ❖

Interview: Peter L. Gould

Publisher, Images Press

Peter L. Gould is the Publisher of Images Press and of this book, the *Photographer's Publishing Handbook*.

Gould states, "Images Press publishes how–to books for those interested in photography. They are not picture books like the ones published by traditional houses such as Aperture. A recent example is Jeanne Stallman's *Winning Photo Contests.*"

According to Gould, Images Press is actively looking for book ideas and proposals. "We are not inclined to publish monographs," he says. "Basically, our area of expertise is how–to books aimed at those who are excited by photography as a medium. We would consider, if it were commercially viable, a collection of photographs in one area such as aerial, special effects or underwater photography. Publishing a photograph book is a very substantial investment. I am more interested in publishing books that fill a specific need rather than promoting a particular photographer's work. I consider myself both a business person who is interested in books that are commercially viable as well as someone who is excited by the art of photography.

"All of the books we have published fall into a niche and have been successful. Feedback from our readers indicates that they are relevant to the marketplace and meet a need which hasn't otherwise been filled."

Like most other publishers, Gould prefers to receive proposals by mail. "A query letter indicating previous credits would be fine," he says.

Gould holds a B.F.A. in Photography from Rochester Institute of Technology, but feels that he learned more about the art and business of photography by going out into the marketplace and working as an assistant and free–lance photographer.

Gould Trading distributes photography books to camera stores, bookstores, and publishes a direct mail catalog which contains one of the world's largest collection of photograph books for sale. It includes traditional photograph books from publishers such as Little, Brown and Co.; Aperture; W.W.Norton; and Abrams. Gould also spends a great deal of time looking for remaindered, over–stocked and out–of–print books. "In many cases," he explains, "these so–called bargain books might be a few years old and dated from the point of view of the mass market, but they are still relevant to our customers."

Many of the Gould Trading titles are unique and not widely available. The list

includes small press and self–published books, for instance, Lorraine Tufts' books on the National Parks and books by Studio Press. Gould is well known to photography book publishers in Europe and imports books that cannot otherwise be obtained here, for example, Helmut Newton's *Private Property*. He buys photograph books from university presses including the University of New Mexico and the University of Chicago. Gould also distributes books published by the A.S.M.P., the *Superstock* catalogs which "give photographers an idea of what pictures work in the marketplace", and an extensive list of photography videos. These include how–to tapes, video monographs on artists such as Ansel Adams and Ernst Haas, and glamour videos.

While Gould is interested in distributing self–published photograph books, he is constantly being offered books with little commercial viability. He feels strongly about not taking on books for distribution that won't work. A self–publisher of a photograph book who is interested in the possibility of distribution by Gould Trading should send a review copy.

I ask Gould how he got into publishing. "Partly, it was my experience of marketing my own work. I knew what was needed. The first book, *The Photo Marketing Handbook*, was successful and led to more such as *The Photographer's Business and Legal Handbook* and this book, the *Photographer's Publishing Handbook*. We are in the process of releasing books on gallery exhibitions and workshops, and on the Nikon system. I also have a number of book projects in development but a small press can only do so many at a time.

"Eleven years ago Bill Owens wrote and self–published *Publish Your Photo Book*. Owens is no longer in the photography or publishing business, his book is out of print and out of date, but I do want to acknowledge that his book was the spark that created the idea for this book. I was the exclusive distributor for the remaining copies of Owens' book. It was clear that my customers had a need for and were interested in a book on this topic. I considered re–publishing the Owens book, but realized that with the time that had passed, it needed to be written from scratch.

"Photographers need to go about marketing their work," Gould concludes. "Publishing is an important part of marketing. Printing is a natural vehicle for photography." ❖

11
Artists' Books

An artist's book is one created by an artist for its own sake and not for the information it contains. Most often these books are produced in limited quantities. Reproduction methods, the look of the book and production costs vary tremendously. Generally, traditional book distribution is not used.

Artist books may be created on a small scale, by hand processes, and in idiosyncratic ways that don't require a great outlay of funds. While traditional routes are not used, it is possible to distribute artists' books, mainly to libraries and collectors. In fact, artists books from the early sixties – the beginning of the period of interest in this sort of publication – have become quite valuable. This kind of book creation can also serve the photographer as a manageable learning tool and preparation for the publication of other kinds of books.

At one end of the spectrum a single book might be created by hand using photographic prints. Further down the line letter press or offset might be used. At the far pole are books like those in May Castleberry's exquisite Artists and Writers Series which are published by the Library Fellows of the Whitney Museum. Featuring pairs of artists and authors such as Barbara Kruger and Stephen King, Eric Fischl and Jamaica Kincaid, and Tina Barney and Tina Howe – these signed and numbered limited edition books have been sold for substantial sums to collectors to benefit the Whitney Library.

The only rule for an artist's book is that the artist be involved in some way in the conception, design and production of the project. Any rigid definition will clearly exclude some artists' books that should be included. As publisher of artists' books Dick Higgins explains:

> [I]t doesn't contain a lot of works, like a book of poems. It is a work. Its design and format reflect its content – they intermerge, interpenetrate. It might be any art: an artist's book could be music, photography, graphics, intermedial literature. The experience of reading it, viewing it, framing it – that is what the artist stresses in making it.[2]

Is this a form that makes sense for you as a creator? An artist's book can be created inexpensively. You can put one together yourself and use it as a sample to show mainstream publishers. There is an important tradition of photographic artists' books. However, these works tend to get more attention from those

[2] *Artists' Books: A Critical Anthology and Sourcebook*, Peregrine Smith Books, Utah, 1987, p.11.

interested in "book art" rather than photography per se since artists' books are often more concerned with the form rather than the content of imagery. Distribution of artists' books is specialized and very limited.

Interview: John Goodwin
Director of Printed Matter at DIA

John Goodwin is the Director of Printed Matter, a not–for–profit corporation dedicated to the promotion of artists' books. Printed Matter maintains a large street level store and display area in New York's Soho area and also distributes via catalog.

Goodwin states: "I am really tired of defining artists' books. There is great variety and a huge vocabulary in books by artists. An artists' book can take any form. At Printed Matter we don't publish and we don't attempt any exercise of control. This is an exciting area with artists making `inexpensive' publications. People can get their hands on them. Ironically, at the same time much of the material is inaccessible as work that is difficult to understand. Generally, these books are not narrative.

"We aim to distribute these works as widely as possible. The primary purchasers are libraries, art colleges and collectors.

"We actively look for appropriate material to stock. Additionally, we receive about twenty unsolicited submissions a week. Last year we added 750 books to the collection. These came from all over the world including Europe, Canada and some from Japan. We are open to all kinds of things.

"In the last few years sales have been steadily rising. It is exciting for artists who make books to reach people. Historical artists' books from the 1960s are becoming quite valuable – and these are objects that often were originally made to be given away. However, we try to stay away from the really precious collectors market. Our wholesale market, via our catalogs, is becoming increasingly important. We also take booths at the major trade shows such as A.B.A., Frankfurt and Basel.

"It has been important to us to keep the organization small. I like to be right out here in the store so I can see what is going on. There is a curatorial element in what I do, for example, helping a librarian build a collection of artists' books. Libraries should have important works as a cornerstone. The store has a huge cross–section of works from weak to strong. We have a close personal connection with a number of libraries and have helped them build compelling collections.

"Many of our books use photography, but they are not about photography any more than they are about typography, binding or their other component elements. Larry Clark is specifically a photographer who has created artists' books. Ed Ruscha uses photography in an unusual way. Obviously, Barbara Kruger's work is essentially photographic. Some of Richard Long's `books' are entirely photographic.

"Artists make books. Not monographs. Not exhibition catalogs. Just wonderful special things." ❖

In fact, photographic sequences are natural material for artist book's. Critic Alex Sweetman notes:

Photobookworks are a function of the inter–relation between two factors: the power of the single photograph and the effect of serial arrangements in book form. Such arrangements may be viewed as worlds which the individual photographs inhabit and, therefore, as their context. Individual pictures may act as expressive images and/or as information; combinations of these can produce series, sequences, juxtapositions, rhythms, and recurring themes.

The photobookwork, then, is a series of images – that is, a tightly knit, well–edited, organized group or set of images in a linear sequence presented in book form. Linearity is important because it gives the imagery its temporal quality. Events occur, stories unfold, things are shown and said; through the progression of the construct, we view the conditions of being in the world, the flow of time as an experience.[3]

Sweetman cites various photographers beginning in the 1920s who have been involved the production of what he terms "photobookworks", or artist books by photographers. They include Laszlo Moholy–Nagy, Eugene Atget, Walker Evans, Weegee, Paul Strand, Ralph Gibson, Robert Frank, Larry Clark and William Klein. Gibson "seems so proud of his editorial achievements that he appears on the back cover (of *Deja–Vu*) taking a handstand while wearing nothing but a bathing suit and a top hat. ... Gibson's Lustrum Press produced some of the most original photobookworks of the seventies, including Larry Clark's *Tulsa* ..." and others.

A "photobookwork" is a great deal more than a portfolio between covers, however elegant, worthwhile or sought after the imagery in the portfolio may be.

For example, Larry Clark's self-published *Teenage Lust* (1983) combines family snapshots, newspaper clippings, handwritten captions, a court order charging Clark with assault and an autobiographical text to locate his photography in the rocky course of his life. Richard Long's books document the walks he takes. Sol LeWitt's self-published *Autobiography* (1980) presents every object in the artist's New York home and studio in grids of black-and-white photographs, nine to a page.

Fundamentally, artists' books can be produced in three ways: as a one–of–a–kind object; as a hand–made atelier production; or mass produced, probably via offset. The one–of–a–kind functions as a sort of sketch book and allows the creator to quickly develop ideas. It also allows for experimentation with materials and processes that would be prohibitively costly in any form of production.

The atelier–production book can reach a broader audience than a one–of–a–kind without being prohibitively expensive. It can be marketed as a book rather than as art and distributed in a way that avoids the gallery world. While initial costs are probably going to be greater than for a one–of–a–kind book, they will certainly be

[3] *Ibid.*, p.187.

far less than for genuine mass production. The hand–produced multiple book can also involve processes such as binding by hand, coloring and cutting pages, and exotic reproduction techniques that require individual attention.

While mass reproduction via offset will be the most expensive of the alternatives to start with, ultimately unit costs of books can be the lowest, leading to the widest distribution of the three forms. Book artist George Gessert notes:

> *Offset is the single most important tool available to book artists, and the greatest frontier of book art. Unlike letterpress or handmade artists' books, offset work is located solidly in the present. As a means of communication, offset rivals television in its worldwide importance.*
>
> *Book artists generally treat offset as a neutral conveyor of images and texts. Up to a point, this approach can work. Offset is a remarkably versatile and forgiving medium. But like every medium, offset has unique qualities, and when these are ignored, an element of unreality, falseness, or violence may be infused into whatever else is being communicated. In glossy magazines, for example, offset is used in a way that encourages audiences to see images but not paper, ink and the printing process. In other words, glossy magazines teach audiences to ignore context. On a large scale, ignoring context gives us entertainers and CIA agents for leaders.[4]*

Controversial issues aside, offset is remarkably suited to excellent and flexible reproduction of photography. Artist books created using offset have the possibility of crossing over and achieving mainstream book distribution.

A polemical and problematic form, artists' books, photobookworks, and photographic artists' books, are here to stay. They are valuable and wonderful in and of themselves, as a laboratory for artists, and for the iconoclastic impact they have on mainstream thinking about the concept and meaning of the photography book. ❖

[4] "Look Again: Artists' Books in 1990", *Reflex,* volume 4, number 3, June 1990, p.8.

12

Conclusion

While it is not always easy to get photographs published, particularly in a quality fashion, there are numerous publication options. Photographs can be published as part of promotional pieces. They can be marketed as stock to textbook publishers and others. They can be used to create cards, posters or other paper products.

Once a proposal for a photography book has been created, the book can be sold to a trade publisher. You can also take the book to a packager. Or, you can package the book yourself, and sell the packaged product to a publisher. Finally, you can self–publish your book.

A glass may be perceived as half full or half empty. While the road to photographic publication, particularly of the serious monograph, or quality photography book, is fraught with grave difficulties, it is also true that there are many options. Furthermore, there is a tremendous interest on the part of the general public in photography.

Photographers must acknowledge this widespread enthusiasm for their media as an extremely helpful phenomenon. A very substantial proportion of the coffee–table art books published each year are photography books.

We stand on the shoulders of giants, the pioneers of the first century of publication of photography. Those who forget the past are doomed to repeat it. While we must not lose sight of the history of photographic publishing, it is a history that is yet young. This is a great time to be a photographer, and a particularly great time to be a photographer concerned with publication.

Let us go forward and build from what the giants have left us. The future is sure to bring changes in our relationship to both the technology and art of photography. The coming decade may well see silver process film replaced by computer storage media, which will probably also render some kinds of books obsolete. Keep abreast of changes, and be open to innovation.

Whether you self–publish, go to trade publishers, or make your own artist book, do not regard business people or acquisitions editors at the major publishers as the enemy. They are doing their job, often under difficult conditions. Simply do the best work you can at whatever level you are. Less is often more. Be self–reflexive and learn to critically edit your own work.

Photographers, and those interested in the publication of photography, are all in this together. Building a sense of community, and participating with others, is extremely important. Share your knowledge and resources and you will be rewarded many times over.

As with any creative endeavor worth doing, giving birth to a photography publishing project is not easy. There will be times when you will wish you never started down this particular road. But at the end of the path, roadblocks by–passed, frustrations forgotten, gestation period complete, will be your published photographs, your book, an entity with a life of its own. So long as civilization survives, books will, and you can be proud to have made a contribution.

The best is yet to come. ❖

13
Sample Contracts and Forms

Harold Davis
Wilderness Studio, Inc.
2673 Broadway, Ste. 107
New York, NY 10025
Service 212-642-5123
FAX 212-663-6144

Delivery Memo

Date:

TO:

Enclosed Please Find:

Subject/Description	Format:	35mm	4X5	Contacts	Other	Value

Kindly check count and acknowledge by signing and returning one copy. Count shall be considered accurate and quality deemed satisfactory for reproduction if said copy is not immediately received by return mail with exceptions duly noted.

Total Black & White:
Total Color:

Terms of delivery:
1. After 14 days the following holding fees are charged until return: $5.00 per week for color transparency and $1.00 per week per print. 2. Submission is for examination only. Photographs may not be reproduced, copied, projected, or used in any way without (a) express written permission on our invoice stating the rights granted and the terms thereof; and (b) payment of said invoice. The reasonable and stipulated fee for any other usage shall be three (3) times our normal fee for such usage. 3. Submission is conditioned on return of all delivered items safely, undamaged, and in the condition delivered. Recepient assumes insurer's liability, not bailee's, for such return prepaid and fully insured by bonded messenger, air freight, or registered mail. Recipient assumes full liability for its employees, agents, assigns, messengers, and freelance researchers for any loss, damage or misues of tthe photographs. 4. Reimbursement for loss or damage shall be determined by the value of the photographs, which recipient agrees shall be no less than a reasonable minimum of $1500.00 for each transparency except as noted above. 5. Objection to these terms must be made in writing within five (5) days of the receipt of this Memo. Holding the material referenced herein constitutes acceptance of these terms. Article 2 of the Uniform Commercial Code is hereby incorporated by refernce into these terms. 6. Any dispute in connection with this Memo including its validity, interpretation, performance or breach, shall be arbitrated in New York, NY pursuant to the rules of the American Arbitration Association and the laws of the state of New York. Judgement on the Arbitration award may be entered in the highest Federal or State court having jurisdiction. Recipient shall pay all arbitration and Court costs, reasonable Attorney's fees, plus legal interest on any award or judgement. 7. Recipient agrees that the above terms are made pursuant to Article 2 of the U.C.C. and agrees to be bound by the same, including specifically the above Clause # 6 to arbitrate disputes.

***ACKNOWLEDGED AND ACCEPTED:_____

SAMPLE DELIVERY MEMO

Harold Davis
Wilderness Studio, Inc.
2673 Broadway, Ste. 107
New York, NY 10025
Service 212-642-5123
FAX 212-663-6144

INVOICE

DATE

Picture Buying Co., Inc.
100 Fantasy Drive
Corporate Drive, CA. XXXXX

Attn.: Paula Researcher

Account # Lo1417

Invoice # 12295 Terms: Net 30 Days; Past Due Invoices will be charged 1.5% interest per month or fraction thereof.

[Description of photograph(s) and exact usage licensed goes here]

TOTAL AMOUNT DUE:

Except as otherwise specifically provided herein, all photographs remain the property of the Photographer, and all rights therein are reserved to Photographer. Any additional uses require the prior written agreement of Photographer on terms to be negotiated. Unless otherwise provided herein, any grant of rights is limited to one(1) year from the date hereof for the territory of the United States. The grant of the license stated above is conditioned upon (1) an appropriate credit line; and (2) payment of this invoice in a timely fashion.

SAMPLE INVOICE

STANDARD RELEASE FORM

Date:_____ Job:_____

For value received, I consent to the publication of my photograph used by Harold Davis whether or not with my name or any text, captions, illustrations whatsoever, and I release him from any liability for such use in any and all media.

I am over 21 years of age.

_____ _____
Signature Date

Address

I am the parent or guardian of the minor named above and release, for the minor and myself as stated above,

_____ _____
Signature Date

Address

SAMPLE MODEL RELEASE

BOOK CONTRACT - *following three pages.*

Reproduced from *The Photographer's Business and Legal Handbook*, Images Press, New York, 1985, courtesy of Leonard Duboff, used with permission, pp 103–105

BOOK PUBLISHING CONTRACT

Agreement made on [full date] between [name of publisher] (hereinafter referred to as "the publisher"and [name of photographer] (hereinafter referred to as "the photographer").

The Photographer hereby grants to the Publisher, and the Publisher hereby agrees to, a limited license to reproduce, publish and vend a hardcover edition of a book presently entitled [name of book] (hereinafter referred to as "said Book"), containing certain photographs by the Photographer (hereinafter referred to as "said photographs") upon the following terms and conditions:

1. The Publisher's rights hereunder shall be for a period beginning [date] and ending [date], unless discontinued sooner as provided herein.

2. The license granted to the Publisher hereunder is exclusively for the Publisher's hardcover edition of said Book. The license granted hereunder is for one - time, nonexclusive, reproduction use of said photographs in English-language printing in the following countries [list of countries].

The photographer shall present to the publisher [number] photographs (whether black and white or color, or any combination) on or before [date]. The Publisher will choose the photographs to be used in said book in [number] months from the receipt of said photographs, with those photographs not chosen to be returned promptly to the photographer. Upon return of the photographs, the photographer will be notified which photographs have been chosen, and an inventory of such photographs shall then be placed in this agreement by reference thereto. The photographer shall have freedom to use all unchosen photographs in any manner whatsoever without limitation; all unchosen photographs shall be excluded from the scope of this agreement.

All photographs so chosen by the Publisher for use in said Book will be returned to the Photographer no later than thirty (30) days after the plates are made. Such plates are to be made by [date] . Said book is to be published no later than [date], with a minimum of [number] copies so published and distributed.

The Publisher shall not acquire any right, title, or interest in or to said photographs and shall not create, entitle, or permit any use of said photographs other than as specified herein. Without circumscribing the generality of the foregoing, said photographs may not be used in any way, including, without limitation, projections, layouts, sketches, and photostats, except on the terms designated herein.

3. The Publisher shall publish and distribute said Book at its own expense, in the style and manner and at the price which it deems best befits its sale.

Before publication, however, said Book shall be submitted in its entirety to the Photographer, including, without limitation, the text, its title, its photographs, and the contents of its covers, and said Book shall only be published in the form approved by the Photographer. Any approval by the Photographer, shall not in any way limit, negate, or affect the provisions contained in this agreement.

4. The Publisher shall pay to the Photographer, or his duly authorized representative specified in writing by the Photographer, upon the execution of this agreement, the following nonreturnable advance, which shall be charged against the Photographer's royalties set forth the following paragraph hereof [amount of advance.]

5. The Publisher shall pay to the Photographer the following percentages of the Publisher's U.S. suggested retail list price:

Ten (10%) on first 5,000 copies sold.

Twelve and One Half (12 1/2%) on next 5,000 copies sold.

Fifteen (15%) percent on all copies sold in excess of the aforesaid 10,000 copies.

It is understood that the suggested retail list price shall be deemed to be not less than $ [amount] for the purpose of computing the royalties to be paid hereunder.

6. The Photographer shall be paid accrued royalties semiannually, within thirty (30) days after June thirtieth and December thirty-first of each calendar year, with payment to be accompanied by detailed statements of all sales, licenses, accrued royalties, and deductions.

Books of accounts containing accurate records of all transactions involving the subject matter of this agreement and of all sums of money received and disbursed in connection therewith, shall be kept by the Publisher in its place of primary business. The Photographer or his duly authorized representative shall have the right at any time and without limitation to examine and audit the Publisher's books, records, and accounts in order to authenticate or clarify any and all such statements, accounting, and payments. The photographer shall carry the cost of such inspection, unless errors of accounting total five (5%) percent or more of the total sums paid or payable to the Photographer shall be found to his detriment, in which case the Publisher shall carry the expense of such inspection.

Publisher shall pay the Photographer any advances or royalties received by Publisher from book clubs or

other licensees (if applicable) within thirty days after Publisher receives such payments, included with a copy of the statement of account provided by such licensee to Publisher.

Regardless of anything in this paragraph to the contrary, any sum of One Thousand ($1,000) Dollars or more which may become due to the Photographer (after the Publisher shall have recouped its advance hereunder) shall be paid by the Publisher to the Photographer within thirty (30) days after the Publisher shall have received such sum.

7. The Publisher shall be responsible for the safe return of all photographs to the Photographer and shall indemnify the Photographer against any loss or damage to such photographs (including those not selected for use in said Book) in transit or while in possession of the Publisher, its agents, employees, messengers, printer, or assigns.

The monetary figure for loss or damage of an original transparency or photograph shall be determined by the value of each individual photograph. The publisher and Photographer concur that the fair and reasonable value of such lost or damaged transparency shall be One Thousand Five Hundred ($1,500.00) Dollars for a color transparency or black and white negative. The Publisher shall be liable for all acts of its employees, agents, assigns, messengers, printer, and freelance researchers for all loss, damage, or misuse of said photographs by the Photographer hereunder. Any such payment shall not, however, entitle the Publisher to any right, title, or interest in or to said Materials so lost or damaged.

8. No books or other material related to said Book shall be distributed without the Photographer's credit as approved by him. The Photographer shall be credited on the dust jacket, cover, title page, and interior of said Book, as well as in advertising under the control of the Publisher, all in size, type, and prominence not less than that afforded any other person or part appearing thereon, and all subject to the Photographer's final and absolute approval.

9. Said Book shall be published with due notice of copyright in the name of the Photographer and shall be duly registered in the Copyright Office of the United States of America. Without limiting the foregoing, all copyrights under the Berne Convention, the Universal Copyright Office of the United States of America, and the Buenos Aires Treaty will be secured. In no event shall said Book be published without a copyright of the photographs in the name of the Photographer. The Publisher will take all steps necessary, without cost to the photographer, to secure such copyrights, including any renewal copyrights, if applicable, as well as to prosecute or defend any infringement actions as stated within with agreement.

10. The Publisher shall provide the Photographer with twenty (20) copies of said Book as published, free of any cost or charge to the Photographer whatsoever, for the photographer's own use. If the Photographer needs additional copies to those above, the Publisher shall provide such additional copies to the Photographer at a reduction of forty (40%) percent from the retail selling price or at the Publisher's actual publishing cost for same, whichever is less.

11. All notices which either party may request or be required to relay to the other shall be sent by prepaid registered mail and addressed to the parties as follows:

Publisher:

Photographer:

12. Only when copies are obtainable and offered for sale in the U.S. through normal retail channels and listed in the catalog issued to the trade by the Publisher shall Said Book be deemed "in print". Reproduction of copies by reprographic processes or availability by any medium or means other than the hardcover edition referred to above shall not be deemed "in print".

If Publisher neglects to keep Said Book in print, the Photographer may at any time thereafter request in writing that the Publisher place the Book in print. The Publisher must notify the Photographer within sixty (60) days from receipt of such request, whether it plans to comply with said request. This agreement shall automatically end and all rights granted to the Publisher shall thereupon automatically revert to the Photographer if Publisher fails to give such notice, or having done so, fails to place the Book in print within six (6) months after receipt of said request by Photographer.

If, after the first printing and distribution of said Book, the Publisher determines to cancel any further publication of said Book, it shall give immediate notice of such determination to the Photographer, and the Photographer shall have the right to purchase from the Publisher the plates for said Book at one-fourth (1/4) of the original amount, including the initial compositions, and the Publishers's stock at one-quarter (1/4) of the list price thereof. If the Photographer shall not take over the said plates, engravings, illustrations, and/or copies of said Book and pay for same within ninety (90) days, then the Publisher shall destroy the items not taken and shall supply the Photographer with an affidavit of destruction thereof. In any event, the Publisher's contract for payments hereunder to the Photographer shall nevertheless persevere.

13. The Publisher agrees and understands that the Photographer makes no warranty, express or implied, and the Publisher hereby agrees to indemnify, defend, save, and hold harmless the Photographer, his successors, and assigns, against any and all claims, losses, costs, damages, or expenses, including

reasonable counsel fees and expenses, which shall accrue or be claimed against the Photographer or his successors and assigns, or any others, by reason of the use of said photographs hereunder or other conduct by the Publisher in connection with any rights granted by the Photographer hereby, as indicated by the Publisher's acceptance of the photographs hereunder.

14. Photographer and Publisher shall have the right to act jointly in an action for an infringement by a third party of any rights granted to the Publisher hereunder. The costs of the action will be shared equally if both Publisher and Photographer participate and they shall recoup such costs from any sums recovered in the action, with the balance of the proceeds to be equally divided between them. Each party will inform the other of infringements coming to its attention. If the Photographer decides not to participate in such action, the Publisher will continue and will carry all costs and expenses which shall be recouped from any damages recouped from the infringement, and the balance of such damages shall be distributed equally between the parties.

15. Any dispute or claim originating out of or regarding this agreement or the violation thereof shall be settled by arbitration in [name of state], in accordance with the rules of the American Arbitration Association, and judgement upon the award rendered by the Arbitrator(s) may be registered in any court having jurisdiction thereof.

16. The Photographer may independently assign his right to acquire income under this agreement. The Publisher may not assign this agreement, either voluntarily or by operation of law, without the prior written consent of the Photographer. Any such assignment, if approved of by the Photographer, shall not relieve the Publisher of its responsibilities hereunder.

17. In acknowledgment of the importance of punctuality in the performance by the Publisher of its obligations hereunder, the Publisher agrees that if it neglects to pay promptly the royalties hereunder, or if the Publisher neglects to conform or comply with any other terms or conditions hereunder, the Photographer shall have the right, either personally or by his duly authorized representative, to advise the Publisher of such default. If fourteen (14) days pass after the sending of such notice without the default's having been rectified, this agreement shall thereupon discontinue without affecting the Photographer's

rights to compensation or damages regarding any claims or causes of action the Photographer may have.

18. All rights not specifically granted herein to the Publisher are retained for the Photographer's use and disposition without any limitation whatsoever, regardless of the extent to which same are competitive with the Publisher or the license granted hereunder. This includes, without limitation, all individual uses of the photographs hereunder.

19. Nothing enclosed in this agreement shall be deemed to constitute the Publisher and the Photographer as partners, joint venturers, of fiduciaries, or give the Publisher a property interest, whether of a legal or an equitable nature, in any of the Photographer's assets.

20. A waiver by either party of any of the terms and conditions of this agreement shall not be deemed or construed to be a waiver of such terms or conditions for the future, or of any subsequent breach thereof. All remedies, rights, undertakings, obligations, and agreements enclosed in this agreement shall be cumulative, and none of them shall be in limitation of any other remedy, right, undertaking, obligation, or agreement of either party.

21. In case of the Publisher's bankruptcy, receivership, or assignment for benefit of creditors, the rights of publication shall revert to the Photographer.

22. This agreement and all its terms and conditions, and all rights herein, shall insure to the benefit of, and shall be binding upon, the parties hereto and their respective legal representatives, successors and assigns.

23. All rights not specifically granted herein to the Publisher are retained for the Photographer's use and disposition without any limitation whatsoever, regardless of the extent to which same are competitive with the Publisher or the license granted hereunder. This includes, without limitation, all individual uses of the photographs hereunder.

24. This agreement and all matters or issues collateral thereof shall be interpreted under, and governed by, the laws of the state of [name of state].

This agreement constitutes the complete agreement between the parties hereto and cannot be altered or discontinued verbally. No alterations, amendments or assignment thereof shall be binding except in writing signed by both parties.

This agreement is not binding on the Photographer unless and until a copy thereof actually signed by both the Photographer and the Publisher is delivered to the Photographer and payment of the advance is made.

In witness whereof, the parties hereto have executed this agreement as of the day and year first written above.

By: (publisher)_____ By [photographer]: _____

Title: _____ Title: _____

14
Resource Section

INTRODUCTION (Chapter 1.)

A. Books

Particularly important to me in researching the *Photographer's Publishing Handbook* were a number of books that give a broad overview of photography and/or publishing. While I will refer to these books again in the Resource Section for the appropriate chapter, these are books that belong in the library of any photographer interested in publication.

ASMP Stock Photography Handbook, 2d ed., American Society of Magazine Photographers, New York, 1990.

The Complete guide to Self–Publishing, Tom & Marilyn Ross, Writer's Digest Books, Cincinatti, OH, 1985.

Getting It Printed How to Work with Printers and Graphic Arts Services to Assure Quality, Stay on Schedule, and Control Costs, Mark Beach, Steve Shepro, Ken Russon, Coast to Coast Books, Portland, OR, 1986.

Photo Marketing Handbook, 2d rev. ed., Jeff Cason & Peter Lawrence, Images Press, New York, 1990.

The Photographer's Source A Complete Catalogue, Henry Horenstein, Simon & Schuster/Fireside, New York, 1989.

Professional Photographer's Survival Guide, Charles E. Rotkin, Amphoto, New York, 1982.

The Self–Publishing Manual, 5th ed., Dan Poynter, Para Publishing, Santa Barbara, CA, 1989.

Sell & Re–Sell Your Photos, Rohn Engh, Writer's Digest Books, Cincinnati, OH, 1981.

Of course, no research in the publishing industry would be possible without *Literary Market Place (L.M.P.)*, published annually by R.R. Bowker, New York. Those who wish to keep abreast of what is happening in book publishing will wish to read *Publishers Weekly*, 249 W. 17th St., New York, NY 10011, 212–463–6758.

John Kremer's books, *Book Publishing Resource Guide* (1990), *Directory of Book, Catalog, And Magazine Printers* 4th ed., (1988), *1001 Ways to Market Your Books For Authors and Publishers* (1988), all published by Ad–Lib Publications of Fairfield, IA, are invaluable resource books for those interested in printing or publishing.

Finally, *Photographer's Market*, published annually by Writer's Digest Books of Cincinnati, OH, contains thousands of photograph buyer listings. While the accuracy of its listings is not always what it could be, it remains the standard reference work in this field and important to those who wish to market their photography.

The best way to learn about what goes into a great photography book is by looking at examples. I suggest starting with:

The Americans, Robert Frank, Pantheon, New York, 1986.

Cape Light, Joel Meyerowitz, Little, Brown and Company, Boston, 1979.

Family of Man, rev. ed., Edward Steichen, Simon & Schuster, New York, 1987.

In Our Time The world as seen by Magnum photographers, William Manchester, W.W. Norton, New York 1989.

Photography Until Now, John Szarkowski, Museum of Modern Art, New York, 1990.

The following books contain interesting discussions of important issues involving photography and publication:

In Our Own Image The Coming Revolution in Photography, Fred Ritchin, Aperture Foundation Inc., New York, 1990. How computer manipulation of digitized photography is changing the way we view the world.

On Photography, Susan Sontag, Farrar, Straus & Giroux, New York, 1989. A series of essays concerning the impact of photography on our world view (and vice versa).

The Right Picture, Ken Heyman and John Durniak, Amphoto, New York, 1988. An interesting book on the important art of editing photography.

EFFECTIVE SELF-PROMOTIONAL PUBLISHING (Chapter 2.)

A. Books

How to Master the Art of Selling, Tom Hopkins, Warner Books, New York, 1982.

The Photographer's Guide To Marketing and Self-Promotion, Maria Piscopo, Writer's Digest Books, Cincinnati, OH, 1987. An excellent general book on this topic.

B. Lists specifically aimed at the creative visual arts community are available from Creative Access Corporation. There are many other sources of lists. Trade Associations are a good place to inquire. John Kremer's Book Publishing Resource Guide (Ad-Lib Publications, Fairfield, IA, 1990), lists sources of Mailing Lists on pp. 242-49.

Creative Access
415 W. Superior Street
Chicago, IL 60610
312-440-1140

C. Some printers who specialize in inexpensive pre-formatted products such as cards and brochures are:

McGrew Color Graphics
1615 Grand Avenue
Kansas City, MO 64141
816-221-6560

MWM Dexter, Inc.
107 Washington
Aurora, MO 65605
800-641-3398

PatePoste
43 Charles Street
Boston, MA 02114
800-356-0002

Serbin Communications Inc.
614 Santa Barbara Street
Santa Barbara, CA 93101
805-963-0439

Triangle/Expercolor, Inc.
3737 West Chase Avenue
Skokie, IL 60076
312-465-3400

Portfolio Lithography
152 West 25th Street
New York, NY 10001
212-255-4378
Specializes in printing promotional and exhibition cards for artists.

HOW TO SELL STOCK TO PUBLISHERS (Chapter 3.)

A. Books

ASMP Stock Photography Handbook, 2d ed., American Society of Magazine Photographers, New York, 1990.

How to Shoot Stock Photos That Sell, Michal Heron, Allworth Press, New York, 1990.

Photographer's Market, Writers Digest Books, Cincinnati, OH. Published annually.

Photo Marketing Handbook, 2d rev. ed., Jeff Cason & Peter Lawrence, Images Press, New York, 1990.

Pictures That Sell A Guide To Successful Stock Photography, Ray Daffurn and Roger Hicks, Fotobank Books Ltd., London, 1985.

Shooting for Stock, George Schaub, Amphoto, New York, 1987.

B. Professional Associations

American Society of Picture Professionals (A.S.P.P.)
Box 5283
Grand Central Station
New York, NY 10163
212–732–0977

American Society of Magazine Photographers (A.S.M.P.)
419 Park Avenue South
New York, NY 10016
212–889–9144

THE PAPER PRODUCTS MARKET. (Chapter 4.)

A. Books

The Art and Craft of Greeting Cards, Susan Evarts, Writers Digest Books, Cincinnati, OH, 1985.

Publishing Your Art As Cards and Posters, Harold Davis, The Consultant Press, New York, 1990.

B. Some Card Publishers Making Extensive use of Photography

American Greetings
10500 American Road
Cleveland, OH 44144
800–242–2737

Avanti
800 Penobscot Building
Detroit, MI 48226
800–2–Avanti
Submissions to:
 Avanti
 Attn. Susan Carolonza, Picture Editor
 84 Wooster 5D
 New York, NY 10012

Fotofolio
536 Broadway
New York, NY 10012
212–226–0923

Hallmark
2501 McGee
Kansas City, MO 64108
816–274–5111

Impact
4961 Windplay Drive
El Dorado Hills, CA 95630
916–933–4865

Museum Graphics
P.O. Box 2368
Menlo Park, CA 94025
415–429–1452

Palm Press
1442A Walnut Street
Berkeley, CA 94709
415–486–0502

Portal Publications
770 Tamalpais Drive
Corte Madera, CA 94925
415–924–5652

C. Major Poster Distributors

Bruce McGaw Graphics, Inc.
230 Fifth Avenue
New York, NY 10001
212–679–7823

Graphique de France
46 Waltham Street
Boston, MA 02118
617–482–5066

New York Graphic Society, Ltd.
P.O. Box 1469
Greenwich, CT 06836
203–661–2400

D. Trade Shows

Artexpo is the leading trade show for fine art posters. It takes place in New York at the end of March. Contact:

Art Expo
747 Third Avenue
New York, NY 10017
212–418–4288

National Stationary Show is the leading trade show for all sorts of paper products. It is held in New York in May. Contact:

George Little Management
2 Park Avenue
New York, NY 10016
212–686–6070

HOW TO CREATE A PHOTOGRAPHY BOOK PROPOSAL (Chapter 6)

A. Books

The Elements of Style, 3rd ed., William Strunk, Jr. and E.B. White, Macmillan, New York, 1979. Classic handbook of writing style.

Getting Published The Writer in the Combat Zone, Leonard S. Bernstein, William Morrow, New York, 1986.

How to Become a Bestselling Author, Stanley J. Corwin, Writer's Digest Books, Cincinnati, OH, 1984.

How to Get Your Book Published an insider's guide, Herbert W. Bell, Writer's Digest Books, Cincinnati, OH, 1985.

How to Write a Book Proposal, Michael Larsen, Writer'sDigest Books, Cincinnati, OH, 1985.

The Photographer's Business and Legal Handbook, Leonard D. DuBoff, Images Press, New York, 1989.

12 Keys to Writing Books That Sell, Kathleen Krull, Writers Digest Books, Cincinnati, OH, 1989.

A Writer's Guide to Book Publishing, 2nd ed., Richard Balkin, Hawthorne/Dutton, New York, 1981.

B. Trade Associations

American Booksellers Association (A.B.A)
137 West 25th Street
New York, NY 10001
212–463–8450; 800–637–0037

American Book Producers Association
41 Union Square West, Ste. 936
New York, NY 10003
212–645–2368

The Author's Guild Inc.
234 West 44th Street
New York, NY 10036
212–398–0838

C. Some Book Producers Who Handle Photography Books

Stephen R. Ettlinger
225 East 28th St, Ste. 1
New York, NY 10016

New Image Press
111 Fifth Avenue
New York, NY 10003

Sarah Lazin Books
302 West 12th Street, #11B
New York, NY 10014

Madison Square Press
10 East 23rd Street
New York, NY 10010

Ed Marquand Book Design
506 Second Avenue, Ste. 1201
Seattle, WA 98104

Soderstrom Publishing Group Inc.
PO Box S
Shenorock Drive
Shenorock, NY 10587

Somerville House
24 Dinnick Crescent
Toronto, Ontario, Canada, M4N 1L5

Umbra Editions, Inc.
288 West Street
New York, NY 10013

Welcome Enterprises, Inc.
164 East 95th Street
New York, NY 10128

Floyd Yearout
316 Wellesley
Weston, MA 02193

DESIGN AND PRODUCTION (Chapter 8)

A. Books

The ABC's of Typography: A Practical Guide to the Art and Science of Typography, Sandra Ernst, Art Direction Book Co., New York, 1984.

The Art of Typography, Martin Soloman, Watson–Guptill, New York, 1985.

Bookmaking: The Illustrated Guide to Design, Production, and Editing, Marshall Lee, R.R. Bowker, New York, 1979.

The Design of Books, Adrian Wilson, Perigrine Smith, Layton, UT, 1974.

Directory of Book, Catalog and Magazine Printers, 4th ed., John Kremer, Ad–Lib Publications, Fairfield, IA, 1988. Lists printers in all parts of the country together with their capabilities and a compiled indication of user satisfaction.

Getting it Printed How to Work with Printers and Graphic Arts Services to Assure Quality, Stay on Schedule, and Control Costs, Mark Beach, Steve Shepro, Ken Russon, Coast to Coast Books, Portland, OR., 1986. In a word: "wonderful".

How to Typeset from a Word Processor, Ronald Labuz, R.R. Bowker, New York, 1984.

Paper For Printing How to Choose The Right Paper At the Right Price For Any Printing Job, Mark Beach, Ken Russon, Coast to Coast Books, Portland, OR, 1989.

The New Vision Photography Between the World Wars, Maria Morris Hambourg, Harry N. Abrams, Inc., New York, 1989.

Photographic Printmaking Techniques, Deli Sacilotto, Watson–Guptill Publications, New York, 1982. Fine art printmaking via photo processes including gravure.

A Publisher's Guide to Printing in Asia, 1988 ed., Roy Howard, Travel Publishing Asia Limited, Hong Kong, 1988.

The Type Encyclopedia: A User's Guide to Better Typography, Frank Romano, R.R. Bowker, New York, 1984.

Words Into Type, 3rd ed., Marjorie F. Skillin, Robert M Gay, Prentice–Hall, Inc, Englewood Cliffs, NJ, 1974. Manual for designers, proof readers and copy editors with suggestions for appropriate text layouts.

B. Miscellaneous

Photographic Emulsion Cleaner PEC–12 is available from Photographic Solutions, 7 Granston Way, Buzzards Bay, MA 02532, 508–759–2322. Follow directions carefully.

C. Printers

This book, the *Photographer's Publishing Handbook*, was printed by The John D. Lucas Printing Company. For further information, contact:

Ron Pramschufer
New York Sales Office
The John D. Lucas Printing Company
421 Seventh Avenue
New York, NY 10001
212–947–6006

Some printers who are well known for their high quality photography book printing are:

Acme Printing Company
30 Industrial Way
Wilmington, MA 01887
508–658–0800

Dai Nippon Printing
2 Park Avenue
New York, NY 10016
212–686–1919

Franklin Graphics
85 Corliss Street
Providence, RI 02904
401–351–1540

Gardner Lithograph Company
8332 Commonwealth Avenue
Buena Park, CA 90621
213–489–3727

Meriden–Stinehour Press
P.O. Box 159
Lunenberg, VT 05906
802–328–2507

HOW TO SELF–PUBLISH (Chapter 9.)

A. Books

The Complete Guide to Self–Publishing, Marilyn A. Ross and T.M. Ross, Writer's Digest Books, Cincinnati, OH, 1985.

A Guide to Book Publishing, rev. ed., Datus C. Smith Jr., University of Washington Press, Seattle, 1989.

The Self–Publishing Manual, 5th ed., Dan Poynter, Para Publishing, Santa Barbara,CA, 1989.

B. Wholesaler/ Distributors

For further listings of wholesalers and distributors, see *American Book Trade Directory* [R.R. Bowker, Annual], *L.M.P.*, and John Kremer's *Book Publishing Resource Guide*.

I. Wholesalers, General

Advanced Marketing Services
4747 Morena Boulevard #200
San Diego, CA 92117–3469
619–581–2232

Baker & Taylor Books
652 East Main Street
Bridgewater, NJ 08807
201–218–3968

Blackwell North America
1001 SW Jean Road
Blackwood, NJ 08012
609–629–0700

Bookazine Company
303 West 10th Street
New York, NY 10014–2599
212–675–8877

Bookpeople
2929 Fifth Street
Berkeley, CA 94710–2776
415–549–3030

Brodart
500 Arch Street
Williamsport, PA 17705–0001
717–326–2461

Distributors International
1150 18th Street
Santa Monica, CA 90403–5612
213–453–4643

Eastern Book Company
131 Middle Street
P.O. Box 4540
Portland, ME 04112–4540
207–774–0331

Gordon's Books
2323 Delgany Street
Denver, CO 80216–5129
303–296–1830

Ingram Book Company
1125 Heil Quaker Boulevard
Lavergne, TN 37086
615–793–5000

Inland Book Company
P.O. Box 261
254 Bradley Street
East Haven, CT 06512
203–467–4257

Pacific Pipeline
19215 – 66th Avenue S.
Kent, WA 98032–1171
206–872–5523

Small Press Distribution
1814 San Pablo Avenue
Berkeley, CA 94702–1624
415–549–3336

Yankee Book Peddler
Maple Street
Contoocook, NH 03229
603–746–3102

II. General Book Trade Distributors

Associated Booksellers
P.O. Box 38
Green Farms, CT 06436–0038
203–366–5494

Bookslinger
502 N. Prior Avenue
Saint Paul, MN 55104
612–649–0171

Consortium Book Sales
287 East Sixth Street, Ste. 365
St. Paul, MN 55101
612–221–9035

The Handelman Company
500 Kirts Boulevard
Troy, MI 48084
313–362–4400

Independent Publishers Group
814 N. Franklin Avenue
Chicago, IL 60610
312–337–0747

Kampmann National Book Network
226 West 26th Street
New York, NY 10001
212–727–0190

Publishers Group West
P.O. Box 8843
4065 Hollis Street
Emeryville, CA 94662
415–658–3453

Quality Books
918 Sherwood Drive
Lake Bluff, IL 60044–2204
708–295–2010

Talman Company
150 Fifth Avenue
New York, NY 10011–4311
212–620–3182

III. Specialty Photography Book Distributors

Amphoto
Watson–Guptill Publications
1515 Broadway
New York, NY 10036
212–536–5124

Edward Weston Graphics
19355 Business Center Drive
Northridge, CA 91324–3503
818–885–1044

Gould Trading\Images Press
7 East 17th Street
New York, NY 10003
212–243–2306
(See interview with Peter L. Gould, pp 144-145.)

International Center of Photography
1130 Fifth Avenue
New York, NY 10128
212–860–1767

Light Impressions
P.O. Box 940
439 Monroe Avenue
Rochester, NY 14603–0940
716–271–8960

The Maine Photographic Resource
Rockport, ME 04856
207–236–8581

C. Bar Code Conversion (Bookland EAN from ISBN)

GGX Associates
11 Middle Neck Road
Great Neck, NY 98407
516–487–6370

Ask them for a free copy of *Machine Readable Guidelines for the U.S. Book Industry.*

D. Review Periodicals

The following list is a sample. It is intended for use for the *Photographer's Publishing Handbook*, and therefore includes periodicals whose focus is art, photography, publishing, and reference works. Compile your own list. For research, start with *Ulrich's International Periodicals Directory* (R.R. Bowker, Annual), *L.M.P.*, and John Kremer's *Book Publishing Resource Guide.*

Ad–Lib Publications
Attn.: John Kremer
51 N. Fifth Street
Fairfield, IA 52556
515–472–6617

American Bookseller
American Bookseller Association
137 West 25th Street
New York, NY 10001–7201
212–463–8450

American Libraries
American Libraries Association
50 E. Huron Street
Chicago, IL 60611–2729
312–944–2117

American Photo
1633 Broadway
New York, NY 10029
212–719–6000

Art Business News
777 Summer Street
Stamford, CT 06901
203–356–1745

Art in America
980 Madison Avenue
New York, NY 10021
212–734–9797

Art News
48 W 38th Street
New York, NY 10018
212–398–1690

ASMP Bulletin
American Society of Magazine Photographers
419 Park Avenue South
New York, NY 10016
212–889–9144

Booklist
American Library Association
50 East Huron Street
Chicago, IL 60611–2795
312–944–6780

Book News
1602 Willowview
Longview, TX 75604
214–297–8319

Choice
100 Riverview Center
Middletown, CT 06457
203–347–6933

Decor
408 Olive Street
St. Louis, MO 63102
314–421–5445

Entrepreneur
2392 Morse Avenue
Irvine, CA 92714
714–261–2325

Fine Print
P.O. Box 3394
San Francisco, CA 94119–3394
415–776–1530

Guide to Reference Books
American Library Association
50 E. Huron Street
Chicago, IL 60611–2795
312–944–2117

Kirkus Reviews
200 Park Avenue South, #1118
New York, NY 10003–1543
212–777–4554

Library Journal
249 West 17th Street
New York, NY 10011–5301
212–463–6819

New York Review of Books
250 West 57th Street #1321
New York, NY 10107–0169
212–757–8070

New York Times
Attn.: Andy Grundberg, Camera Column
229 West 43rd Street
New York, NY 10036–3959
212–556–1234

New York Times Book Review
229 West 43rd Street
New York, NY 10036–3959
212–556–1234

Personal Publishing
6006 Second Avenue, NW
Seattle, WA 98017
206–782–4915

Petersen's Photographic
6725 Sunset Boulevard
Los Angeles, CA 90028
213–854–2200

Photo/Design
1515 Broadway
New York, NY 10036
212–764–7300

Photo District News
49 East 21st Street
New York, NY 10010
212–677–8418

Popular Photography
1633 Broadway
New York, NY 10029
212–767–6000

Publishers Weekly
249 West 17th Street
New York, NY 10011–5301
212–463–6780

Studio Photography
PTN Publishing Company
210 Crossways Park Drive
Woodbury, NY 11797
516–496–8000

Village Voice
Attn.: Fred McDarrah
842 Broadway
New York, NY 10003–4846
212–475–3300

Washington Post Book World
1150 15th Street, NW
Washington, DC 20071–0001
202–334–7559

RUNNING A PUBLISHING BUSINESS (Chapter 10)

A. Books

American Book Trade Directory, R.R. Bowker, New York (published annually, 36th edition, 1990–91).

Book Publishing Resource Guide, John Kremer, Ad–Lib Publications, Fairfield, IA, 1990. Includes a Bibliography of over 500 Books.

"The Decline and Rise of Publishing", Jason Epstein, *New York Review of Books*, March 1, 1990, p. 8.

In Cold Type Overcoming the Book Crisis, Leonard Shatzkin, Houghton Mifflin Company, Boston, MA, 1982. A book about what is wrong in the publishing industry.

1001 Ways to Market Your Books For Authors & Publishers, John Kremer, Ad–Lib Publications, Fairfield, IA, 1986.

B. Chain Bookstore Central Purchasing Offices

B. Dalton
122 Fifth Avenue
New York, NY 10011–5605
212–633–3300

Crown Books
Corporate Offices
3300 75th Avenue
Landover, MD 20785
301–731–1263

Doubleday Book Shops
Buying Offices, 245 Park Avenue
New York, NY 10167–0034
212–984–7561

Waldenbooks
Corporate Headquarters
201 High Ridge Road
Stamford, CT 06905–3417
203–352–2018

C. Trade Shows

The American Booksellers Association Convention & Trade Exhibit takes place annually in late May or early June. For further information contact:

Eileen Dengler
American Booksellers Association
137 West 25th Street
New York, NY 10001
212–463–8450; 800–637–0037

The American Library Association annual book fair takes place in mid–summer and is primarily attended by librarians. A.L.A. is located at 50 East Huron Street, Chicago, IL 60611, 312–944–6780.

Frankfurt Bookfair takes place the first week in October. For further information, contact:

Boerseuverein eedes Deutchen Buchhandels
P.O. Box 100442
6000 Frankfurt 1
Germany
Telephone: 011–49–69–13060

D. Libraries

Various mailing lists of purchasers at libraries are available from:

R.R. Bowker
245 West 17th Street
New York, NY 10011
800–521–8110

Two active distributors of small press titles to libraries are:

Quality Books
918 Sherwood Drive
Lake Bluff, IL 60044–2204
312–295–2010

Unique Books
4200 Grove Avenue
Gurnee, IL 60031
312–623–9171

E. Specialty Book Clubs

Graphic Artist's Book Club
1507 Dana Avenue
Cincinnati, OH 45207
513–531–2222; 800–543–4644

Limited Editions Club
118A East 65th Street
New York, NY 10021
212–737–7600
This book club is interested in high quality books that are made in limited editions; they might be interested in a superb artist's book.

Photography Book Club
Watson–Guptill Publications
1515 Broadway
New York, NY 10036–5703
212–764–7300

ARTISTS' BOOKS (Chapter 11)

A. Books

Artists' Books: A Critical Anthology and Sourcebook, edited by Joan Lyons, Gibbs M. Smith, Inc., Peregrine Smith Books in association with Visual Studies Workshop Press, Layton, UT, 1987. An anthology of critical essays that give an excellent idea of what artists' books are all about.

Off the Shelf A Marketing and Distribution Guide for Independent Literary and Artist Book Publishers, edited by Joan Murray, Writers & Books, Rochester, N.Y., 1989. An outstanding resource for anyone interested in distributing their own artist book.

B. Periodicals

Umbrella is a newsletter which presents news and reviews about artists' books, including distributors, dealers and developments. Write Umbrella Associates, P.O. Box 40100, Pasadena, CA 91114.

C. Miscellaneous

The Center for Book Arts, 626 Broadway, New York, NY 10012, 212–460–9768, gives classes in the art of bookmaking, printing and papermaking.

Franklin Furnace Archive has a collection of 11,000 artists' books. They are located at 112 Franklin Street, New York, NY 10013, 212–925–4671.

Printed Matter operates an artists' book store/exhibition place, publishes a catalog, and distributes artists' books. They are located at 77 Wooster Street, New York, NY 10012, 212–925–0325.

15
Glossary

ABI: Advanced Book Information form. This form is filed by publishers with R.R. Bowker. Bowker uses the information to include the book in their various databases and compilations including *Forthcoming Books* and *Books in Print*.

Accounts Receivable: Money owed a company based on valid invoicing.

Acquisitions Editor: A person in a publishing company responsible for acquiring new book projects.

Advance: Money paid to a photographer, creator, or author as an advance against royalties.

Art: A phrase used in book production that refers to anything other than text i.e. photographs, illustrations, charts, etc.

Artist's Book: A book where the artist has involvement and control of conception, design, creation and publication.

Backlist: Previously published books that are in print and available from a publisher; distinguished from front list books which have been recently published.

Back Matter: Everything in a book that comes after the main text; this includes but is not limited to an afterword, appendices, bibliography, glossary, index, and colophon page.

Back Up: Printing on the second side of a sheet that has already been printed on.

Bindery: Department of printing company, or separate business, that finishes paper products, including trimming, folding, scoring, binding, and packing.

Binding: To bind books together; to fasten sheets or signatures and adhere covers.

Blanket: A fabric coated with rubber which is wrapped around the cylinder and serves to transfer ink from plate to paper in the offset printing process.

Bleed: A photograph or other image that extends to the trim edge of the page.

Blue Print: A pre–press proof used to check the positioning of the assembled elements of an offset printing job. The Blue Print, also called a Blueline, is a photographic print made using the cyanotype process. All colors show as a blue image on white paper.

Book: A bound compilation of printed pages. According to the Library of Congress, a book must be at least 49 pages. Neither of the above sentences necessarily apply to artists' books.

Book Contract: A written agreement between a publisher and a book creator which sets forth the rights and obligations of both parties.

Book Producer: Also termed a Book Packager, works with photographers, writers, editors and other vendors to create books for publishers as contractually agreed. Arrangements may call for the producer to deliver to the publisher anything from camera–ready mechanicals to finished books.

Camera–Ready Material: Mechanicals, photographs, and other art that is fully ready to be photographed for plate making.

Case Binding: Binding in which the cover is made separately and consists of covered boards; same as hardcover.

CD–Rom: Compact Disk – Read Only Memory. This storage media is appropriate for storing large quantities of digital information that is intended to be viewed but not altered, such as encyclopedias

or catalogs of digitized stock photographs.

Chrome: A chrome is a photographic transparency. It can be any size, ranging from 35mm (also termed a "slide") to 20X24" and beyond.

CIP: Cataloging in Publication Program

Coated Paper: Paper with a chemical clay based coating, with either a glossy or matte finish, which reduces ink absorption.

Coffee–Table Book: A lavish, oversized, heavily illustrated book.

Colophon Page: A page sometimes found at the end of a book which lists production information about the book.

Color Correction: Improving color rendition of separations by any process, including masking, dot–etching, and digital manipulation of post–scanned computer files.

Color Key: 3M's proprietary color proofing system which uses overlays of colored acetate.

Color Separation: Set of four halftone negatives, one for each of the three primary colors and black, for making plates for four–color process printing.

Contact Print: A same–size photographic print made by exposing a negative in direct contact with paper.

Continuous Tone: Art, including photography or other visual material, which has not been screened and contains gradient tones from black to white.

Co–publishing: A joint publishing venture, where one book is published by more than one party. For example, a book might be published jointly by American and British companies. Or, a packager might create a book and co–publish it with a conventional trade publisher who is responsible for financing and distribution.

Copyright: A copyright provides the owner who is, in the absence of a specific work–for–hire agreement, the creator, with a number of exclusive, important rights in the copyrighted work. The creator may be a photographer, writer, or other artist. Copyrights may be registered with the U.S.

Copyright Office in which case certain presumptions benefit the registrant. Even without registration, however, the creator holds a "common–law" copyright in the work.

Copyright Page: Page in a book containing copyright notice and information.

Credit: Indicates the photographer and agency, if any, and accompanies most editorial usages. A list of a photographer's credits is a list of where his work has appeared.

Cromalin: Dupont's proprietary integral color proofing system.

Crop: To eliminate portions of a photograph in order to make it communicate better, for aesthetic reasons, or to fit in a layout.

Crop Marks: Lines indicating cropping, usually placed on a photostat or xerox copy which has been magnified or reduced appropriately, sometimes directly applied to a print or slide.

Crossover: Material that continues from one page of a publication across the gutter to the opposite page.

Delivery Memo: The legal document which accompanies a submission of artwork or photography.

Designer: Person responsible for the style and format of a book or other product.

Digitize: To convert imagery, or other complex analog information, to binary form so that it can be manipulated by a computer.

Direct Mail: Advertising or promotional material mailed directly to potential customers.

Distributor: A wholesale company that purchases goods from various sources and resells them to the trade.

Dot Etching: Color correction done by hand on screened color separations.

Double–dot Printing: A duotone printing process in which both plates are printed in black.

Dull: A low gloss or matte finish.

Dummy: (1) A preliminary layout showing the

positions of text and illustrations as they are to appear in the final reproduction. A dummy of this sort is used for communication between creator and publisher, and creator and printer. (2) A set of blank pages made up to show the size and format of the eventual printed piece using the paper specified for the job.

Duotone: A two–color halftone reproduction from a monochrome original, requiring two halftone negatives, one for each end of the gray scale. One plate usually is printed in dark ink, the other in a lighter one.

Editorial Use: Use of a photograph in a book or magazine.

Electronic Retouching: Using a computer to enhance, correct, or alter a scanned photograph which has been digitized.

Exhibition Catalog: Material prepared in book form to accompany an exhibition.

Fair Use: The allowable and legal use of small quantities of copyrighted materials without obtaining permission.

Fine Art Graphic Poster: An offset piece combining image and graphics designed to be sold as art.

Flat: In printing, an assembly of negatives stripped together, ready for plate making, and designed to be printed on one sheet.

Font: A complete collection of type of one size and face containing all the characters necessary for ordinary composition.

Foreign rights: Rights to reproduce or publish in a foreign country.

Format: A specification of the standard elements of the page, including size, style, type, margins, and photograph positioning, going into the layout of a printing project.

Four-Color Process: A technique printing of that uses the four process colors of ink (yellow, cyan, magenta and black) to reproduce color photographs.

Front Matter: All pages before the main text of a book, including, but not limited to, dedication, foreword, introduction, copyright page, table of contents, table of illustrations, and title page.

Fulfillment: The warehousing, packing and shipping of finished merchandise.

Generation: A first generation is the original image; a second generation is made from the original; a third generation is made from the second generation; and so on.

Ghosting: The undesired appearance of a faint image on a printed sheet.

Gloss: Paper, ink, or varnish that is glossy reflects relatively large amounts of light and presents the appearance of shine.

Gravure: Method of printing using etched metal cylinders, used both for extremely high–quality short runs and, with web presses, for high quantity "roto–gravure".

Gutter: Space where pages in a book meet at the binding.

Halftone: The conversion of continuous–tone artwork using a screen to an image made up of dots. The term is a verb; however, the resulting negative or positive is also called a halftone.

Hard Cover: A book bound with a case of binder's board; see Case Bound.

Hickey: Small blemish or flaw in printing, most visible in areas with heavy ink coverage.

Holding Fee: Charge for holding photographs submitted on approval beyond the agreed upon amount of time specified in the Delivery Memo.

How–to Book: A book which offers advice on how to do something.

Image Manipulation: Changing the content of imagery, usually via electronic retouching, but also photographically.

Imposition: Arrangement of pages, as specified in the mechanicals, to ensure proper sequence following printing, folding and binding.

Impression: In printing, one pressing of paper against type, plate, or blanket.

Imprint: (1) An identifying name for a division of a publishing company. (2) To print on a previously printed sheet by running it through the press again.

Integral Proof: Proof of color separation negatives exposed in register and appearing on one piece of paper.

Inventory: Product, such as books, on hand, or in the warehouse, available for sale.

Invoice: An itemized bill. An invoice for reproduction rights to photography will include terms and conditions of the license.

ISBN: International Standard Book Number, assigned by the book's publisher using a system administered by R.R. Bowker Company. Without an ISBN, both trade and consumers will have a great deal of difficulty locating specific books.

Jobber: A jobber is a wholesaler or a distributor, one who buys in quantity for resale to the trade.

Kill Fee: Cancellation fee, paid when a picture or project is contracted for but not used.

Large–format Camera: Camera that makes negatives 4X5" or larger.

Laminate: (1) To coat with clear plastic, either liquid or film. In a gloss or matte finish. (2) To glue two separate sheets of paper together.

Layout: Sketch or drawing of a design for a printed piece intended as a working diagram for a printer to follow.

LCC: The Library of Congress Card Number is assigned to books by the Library of Congress and used by libraries in their cataloging process. The LCCN usually appears on the copyright page.

Leading: The amount of space between lines of type, measured from baseline to baseline and expressed in points.

Letterpress: Method of printing from raised surfaces.

License: The right to use imagery in a specified way.

Line art: Art containing no grays or middle tones, and can be reproduced without the use of halftone techniques.

Liquid laminate: Clear plastic applied to paper as a liquid, then bonded and cured to form a high gloss or matte surface.

Lithography: The generic term for a method of printing which uses a chemically treated surface that attracts ink to image areas and repels it from non–image areas.

L.M.P.: *Literary Market Place*, published annually by R.R. Bowker Company, is the most complete directory of the American book publishing industry.

Loose proof: Proof of one color separation.

Makeready: (1) All activities required to set a press up before a production run begins including adjustments, inking and cleaning plates. (2) The paper consumed in this process.

Margin: The border of a page or sheet.

Matchprint: 3M's proprietary integral color proof.

Matte: (1) Slightly dull finish on coated paper stock. (2) Ink or varnish that appears dull when dry.

Mechanical: Camera–ready art consisting of type, graphics, and other line copy, showing the exact placement of every element, complete with instructions to the printer.

Medium format Camera: Camera that makes 2 ¼ X 2 ¼" negatives.

Metallic ink: Inks which contain metallic powder mixed with the ink base and appear highly reflective.

Montage: A combination or sandwich of a group of images, stripped together photographically or digitally.

Negative: Film that records images in negative or reverse form. Black appears as white, white as black.

News Release: A one or two page article written for promotional purposes.

North American Rights: Publication rights limited to the United States and Canada.

Offset: Short for offset lithography, which is the most common form of lithographic printing. In this process, ink is offset from the plate to a rubber blanket and then to the paper.

One-time Rights: The right to reproduce a photograph once, in one edition of one publication, in a specified agreed upon geographic area.

Overrun: Copies printed in excess of the specified quantity.

Page Proof: Sample page showing what finished product will look like.

Pantone Matching System: Pantone Matching System, or PMS, is a proprietary system designed for uniform specification of non-process colors in the reproduction process.

Paper Distributor: Wholesaler of paper to printers and other large buyers.

Paper Products: Consumer products, other than books, which are created by printing on paper, for example: calendars, cards, and posters.

Perfect Binding: A method of binding sheets together by trimming them at the spine and gluing them to a paper cover.

Picture Editor: Individual who analyzes, assigns, edits, and selects photographs.

Picture researcher: Expert in finding sources of photographs and other artwork. Does preliminary editing. May also function as a picture editor.

Plate: A thin sheet of metal that carries the printing image, the surface of which has been treated so that only the desired image is receptive to ink.

Point: A unit used for designating type size. There are about 72 points to the inch.

Positive: A photographic image on film or paper which corresponds to the original, i.e. whites are white and blacks are black; also, the original itself.

Press Okay: The approval by the client of a press sheet before the actual production run begins.

Press Proof: Proofs made on an actual press.

Printer: Person who runs a printing business.

Printing Broker: Agent who supplies printing from various companies for a markup.

Process Printing: See Four-color Process.

Progressive Proof: Press proof showing each color of a job separately and in progressive combinations.

Promotional Piece: A printed piece which is designed to promote the creator.

Proofs: Test materials which are designed to predict how a printing job will appear.

Proposal: A detailed plan for a proposed new enterprise, including a book, that is used to sell the project.

Prospect: A possible purchaser of goods or services.

Publish: To produce and sell, or distribute in some fashion, printed material.

Publisher: Someone who publishes.

Query Letter: A short letter intended to interest an editor or publisher in a project.

Quotation: Printer's estimate of the cost of doing a specific job.

Recto: A right-hand page.

Reflected Art: Art viewed by means of light reflected off its surface; art that is not transparent.

Register: Accurate alignment of printing plates and paper.

Release: Written permission to publish, utilize, or offer for sale the likeness of a person or private property.

Research Fee: Service fee charged by photographer or stock agency for searching and/or filling a picture request; sometimes deductible from actual usage fees.

Retail: (1) Price paid by consumers, the list price. (2) A retail business, such as a book store, buys from wholesalers or distributors and sells to the general public.

Returns: Books which have not been sold and are sent back to a publisher for credit or a cash refund. The book publishing industry is unique in its widespread acceptance of returns as standard policy.

Review: A critical evaluation of a book. Reviews are extremely important in generating book sales.

Right Reading: An image or copy that reads correctly, e.g. from left to right.

Rotogravure: Gravure printing using a web press.

Royalties: Money paid to book creators, photographers, and authors by publishers for the right to use their work; usually calculated as an agreed upon percentage of the price per copy sold, but sometimes a percentage of the publisher's net receipts. Generally the advance paid out must be recouped before royalties are paid.

Sales Commission: A commission based on a percentage of sales paid to manufacturer's representatives.

SASE: A self–addressed stamped envelope.

Scale: To state the percent by which photographs are to be enlarged or reduced to fit.

Scanner: A scanner is an electronic device which uses laser technology to digitize transparent or reflected art. Color separation film may be output, or the digitized image may be transmitted to a computer for electronic re–touching and manipulation.

Score: To crease heavyweight paper or card stock so as to allow folding.

Screen: A network of crossing lines at regular intervals which, when photographed with a continuous tone image, break up the image to form a pattern of dots.

Self–Publish: To be the publisher of one's own work.

Separation: Color separation.

Serif: The short cross–lines at the top and bottom of many letters in some typefaces. A sans serif typeface does not have these strokes at the ends of letters.

Sheet–fed Press: A Press that print sheets of paper, as opposed to the continuous roll used on a web press.

Short Run: A small printing job; generally, a press run of between 100 and 2,000 copies is considered a short run.

Signature: A sheet of printed pages is folded into one signature (generally four, eight, 12, 16, or 32 pages, depending on what size sheets are used).

Signatures: are bound together to form books.

Single Copy Order: An order for one copy of a book.

Smythe Sewn: One pattern of sewn binding for hardcover books.

Spine: The back of a bound book connecting its front to the back.

Spine Out: Books placed on shelves so that only the spine shows.

Spot Varnish: Varnish applied on a press to a portion of the sheet, as opposed to an overall application of varnish.

Stock Agency: Business that maintains a library of existing works by photographers and markets them. Stock agencies license the use of the photographs in their files for a percentage of the fees collected.

Stock Photograph: Any photograph that already exists that may be licensed for usage.

Stripping: Assembly of negatives in flats in preparation for making printing plates.

Subsidiary Rights: Additional rights, such as book club, serial, or foreign rights, which can be sold in addition to a book itself.

Submission: A selection of stock photographs in response to a request from a potential buyer. Submissions should be accompanied by a delivery memo.

Subsidy Publisher: A subsidy publisher produces vanity books which are paid for by the creator at no real hope of profit to anybody but the subsidy publisher.

Subtitle: A second or additional title below the main title further explaining the book's content.

Symbolic Element: Something in a photograph that brings an idea to mind.

Table of Contents: Lists the title and beginning page number of each section in a book; sometimes includes descriptive material for each chapter.

Target: A prospect that has expressed interest in one's product or service.

Tearsheet: Page from an actual publication showing a photographer's or author's work.

Textbook: Book planned for use in a classroom in a specialized area.

Tip In: To glue one sheet of paper to another; for example, a photograph plate might be tipped in to heavy textured stock not suitable for photographic reproduction.

Title: (1) The name of a book. (2) Any one of the books a publisher has in print.

Title Page: Right-hand page listing the book's title, author(s) or editor(s), publisher, and place of publication.

Title Page Verso: The left–hand page on the back of the title page, usually used as the copyright page.

Trade: A business that does not generally sell to the public.

Trade Paperback: A large sized paperback.

Trade Publisher: A conventional publishing house, publishing books for a mass audience, selling primarily to bookstores and libraries. Generally, a trade publisher has acquisitions editors on staff and pays book creators with advances and royalties. Self–publishers and subsidy publishers are not trade publishers.

Trade Shop: A specialty printer whose customers are other printers or printing brokers and who does not generally work with the public.

Trade Show: A business exposition, convention, and fair for a specific industry, or subset of that industry.

Transparency: A photographic positive, usually color, on film, viewed by allowing light to pass through it. See chrome.

Transparent Art: Art that is viewed by transmitted rather than reflected light; see transparency.

Trim Size: The final size of a book or other printed product after last trim is made.

Tritone: Black and white photograph reproduced with three separations and plates.

Type Face: A set of characters with design features making them similar to each other and different from all other faces.

Type Family: All styles of a particular type face.

Type font: A complete assortment of any one size and style of type.

Typography: The art of setting type; also, designing printed pieces with type.

Typositor: A machine that sets type.

Uncoated Paper: Paper on which the printing surface consists of the paper stock itself.

Unit Cost: What it costs to produce each unit of a product; for example, if 10,000 photograph books cost $20,000, the unit cost is $2.00. Unit cost does not include allocations for overhead expenses or the cost of capital.

Use: Description of the intended or actual use of a stock photograph by a buyer.

Varnish: A thin, protective coating applied to printed sheet on press for beauty and protection. Varnish appears to shine, but less so than lamination. It is less expensive than lamination. It normally comes in either dull or gloss varieties.

Vanity Press: See Subsidy Publisher.

Vendor: A supplier who sells goods or services.

Verso: A left–hand page in a book.

Web Press: Printing press that uses paper on a roll; generally used in higher volume applications than a sheet-fed press.

Wholesale: The price at which books or other products are sold to stores.

Wholesaler: A company that is in the business of distributing at wholesale to the trade. In the book industry, wholesalers are perceived of as order takers without a sales force, as opposed to distributors, who are actively involved in selling and take a larger sales commission.

Work For Hire: A relationship in which all right, title, and interest in a creative work, including the copyright, is owned by the creator or commissioning party.

Index

About the Author

Harold Davis is a photographer, author and publisher. He is the President of Wilderness Studio, Inc. His previous book is *Publishing Your Art as Cards & Posters*. His photographs are widely exhibited, collected and published.

Mr. Davis holds degrees in Computer Science and Law. He lives on the Upper West Side of Manhattan.

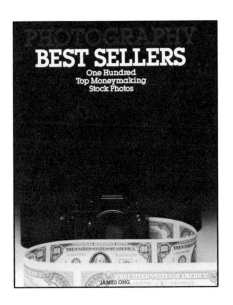

PHOTOGRAPHY BEST SELLERS. By Ong.

The one hundred images in this book have sold for more than two million dollars: A fascinating look into the stock photo business, a real eye-opener: An insiders view of the stock photography business showing exactly what sells.
Originally H $29.95 **Special H $18.95**

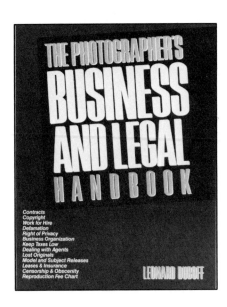

THE PHOTOGRAPHER'S BUSINESS AND LEGAL HANDBOOK. By Leonard Duboff, lawyer.

How do you protect yourself legally as a photographer? What you don't know can hurt you. This new authoritative book deals with copyright, your rights, tax tips, legal forms, contracts, reproduction fee prices, etc. **Only $18.95**

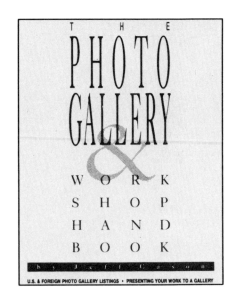

THE PHOTO GALLERY AND WORKSHOP HANDBOOK. By Jeff Cason.

U.S. & International gallery guide and workshop directory. Detailed listings, interviews with gallery and workshop directors, photo investing, price guides of collectible photo art, auctions, and how to present your photographs to galleries. **Only $19.95**

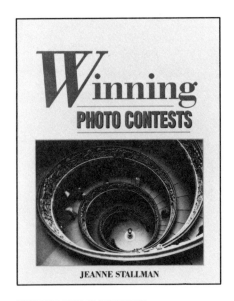

WINNING PHOTO CONTESTS. By Jeanne Stallman.

Your guide to entering and cashing in on contests of all kinds. Included are:

- Prize-winning photos from various contests.
- Detailed contest listings with information on entry requirements and awards.
- Interviews with judges and prize winners.
- Advice on graphic impact, timing, composition, and color.

Expert advice is offered to the reader on:

- Finding the right contest for your photos.
- How to make your entry stand out.
- Model releases.
- Editing and presentation of photos.
- Contests to avoid. **Only $14.95**

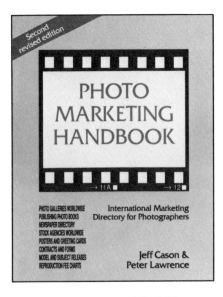

THE PHOTO MARKETING HANDBOOK - 2ND EDITION. By Cason & Lawrence.

- Detailed market listings, publishers, paper product companies, domestic and foreign agencies, telling you exactly what editors and agents are looking for.
- In depth profiles with professional photographers, editors and agents, telling you what it takes to succeed.
- Sample business forms, photographer-agency agreement, and book publishing contracts.
- A chapter on how to publish a photo book detailing the process of both commercial and self-publishing.
- Newspaper listings worldwide.
- Reproduction fee chart. **Only $19.95**

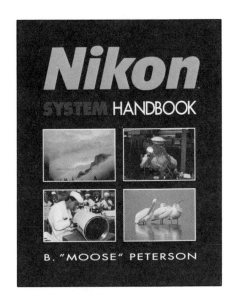

NIKON SYSTEM HANDBOOK. By B. Moose Peterson.

Complete Nikon guide to current and older models. Lens production and comprehensive discussion of all Nikkor slr lenses produced. Guide to Nikon accessories and illustrated everything you ever wanted to know about the Nikon system. Price guide to current and older Nikon cameras and lenses included.

Only $19.95

Ask for these Images books at your local camera shop, bookstore, or order directly from:
Images Press • 7 East 17th Street, New York, N.Y. 10003 • 800-367-4854 or 212-243-2306